ART GUIDE TEXAS

UNIVERSITY OF TEXAS PRESS　　AUSTIN

REBECCA
S. COHEN

MUSEUMS ART CENTERS ALTERNATIVE SPACES NONPROFIT GALLERIES

ART GUIDE TEXAS

Publication of this book was aided by a generous subsidy from Mary Ross Taylor.

∞ The paper used in this book meets the minimum requirements of ANSI/NISO Z39.48-1992 (R1997) (Permanence of Paper).

LIBRARY OF CONGRESS
CATALOGING-IN-PUBLICATION DATA

Cohen, Rebecca S.
Art guide Texas : museums, art centers, alternative spaces, and nonprofit galleries / Rebecca S. Cohen.—1st ed.
 p. cm.
Includes index.
ISBN 0-292-71230-8 (pbk. : alk. paper)
1. Art museums—Texas—Guidebooks. 2. Art centers—Texas—Guidebooks. I. Title.
N511.T4C64 2004
708.164—dc22
2003025803

For my mother and father

CONTENTS

"Sometimes if there's a book you really want to read, you have to write it yourself."

—ANN PATCHETT[1]

PREFACE

ONE OF MY GREATEST PLEASURES IN LIFE IS LOOKING at art, whether revisiting a favorite fifteenth-century painting or encountering new and challenging contemporary work. The museums and art centers in Texas, my home for more than thirty-five years, offer a rich assortment of changing exhibitions and art collections, from the Kimbell Museum's European masterpieces to the Chinati Foundation's cache of Minimalist sculptures. But despite the fact that there are more than a hundred museums and nonprofit galleries within Texas' borders, there has never been a guidebook dedicated exclusively to visual arts institutions. Not until now.

This guide describes the collections and exhibition history of each institution, as well as its origin and architecture. It also provides readers with Web sites and phone numbers so they can keep abreast of current exhibitions, holiday closings, and changes in admission fees and hours.

As a means of organizing this information, I have divided the state into seven regions based on my own travel strategies. Within these boundaries, it is possible to make reasonable, albeit Texas-size, forays from one museum to the next. Brief essays at the beginning of each chapter examine the common threads that bind these institutions.

The shared purpose of these museums and galleries is to exhibit art and to create and educate audiences. Most museums take on the additional responsibility of procuring and caring for artworks. Museums and art centers alike serve their respective

communities by providing cultural opportunities, education, and, in many cases, economic benefit, attracting tourists and helping to revitalize surrounding neighborhoods, even, on occasion, the entire city or town. All listed facilities are wheelchair accessible unless otherwise noted. Many also offer significant literary, musical, and performing arts programs. And while admission is free at many of these museums and art centers, donations are welcomed, and even suggested in a number of cases. Visitors who wish to further support individual venues should have no trouble finding membership information in the galleries.

Quotations about art and architecture are interspersed throughout to provide an additional layer of texture. At the end of each chapter, the guide lists galleries that are not discussed in depth but may be of interest to readers with the time and inclination to explore a broader range of aesthetic experiences. Commercial galleries do not appear in this guide, although there are a number of good ones throughout the state.

Finally, for those who want additional insight into the Texas art scene, the following introduction attempts to distinguish among various types of visual arts institutions and includes personal observations about the history, role, and status of art museums, art centers, alternative spaces, and nonprofit galleries in the state today.

ACKNOWLEDGMENTS

I OWE A HUGE DEBT OF GRATITUDE TO THE DIRECTORS and staff members of museums and art centers across the state who have helped me compile the information in this guide. Thanks to all for returning my phone calls and E-mails, setting aside time to visit with me, and providing support materials. Ultimately it is their vision and hard work that shape the institutions I've written about here; they set the standard for our experience of the arts in Texas.

I also want to thank a number of individuals for their contributions: Theresa May, the editor who so quickly approved this project and waited so patiently for its completion; Jan McInroy, who simultaneously edited the text and calmed the author; Mary Willis and Dinah Chenven, who pushed and pulled me toward the completion of this book; and Lisa Germany, who made it infinitely more readable. Thanks, too, to Jack Nokes, director of the Texas Association of Museums, for his advice and support.

And finally, my thanks go to my wonderful daughters: Mara, who assisted me with the book's photographs; Tobin, who was an early reader and editor; and Rachel, who supplied the music I listened to while driving hundreds of miles across Texas. Their love and encouragement fueled this project. Very special thanks to my dear husband, Gary, for underwriting my travels, bringing me coffee, and sharing my enthusiasm for art.

ART GUIDE TEXAS

INTRODUCTION

"NATURE MADE TEXAS RICH. TIME WILL MAKE HER powerful. Only the Arts can make her great."[1] These words, adapted here to include the entire state, have been attributed to both John Ankeney, director of the Dallas Museum of Fine Arts, and James Chillman, Jr., director of the Museum of Fine Arts, Houston. They were spoken roughly eighty years ago, and the sentiment was prescient. They anticipated a time when Texas museums and art centers would enjoy international prominence. And now that time has come.

Visitors from all over the world flock to Marfa to see Donald Judd's Minimalist sculptures posed across the West Texas landscape and Dan Flavin's last-realized light installation in a series of old army barracks. They fly to Fort Worth to ogle Louis Kahn's Kimbell Art Museum and the Modern Art Museum of Fort Worth, Tadao Ando's larger and no less impressive homage to Kahn. They gather in droves at the Nasher Sculpture Center in Dallas to see one of the most impressive private collections of Modern and contemporary sculpture ever assembled. At the Menil Collection in Houston they seek out, in particular, the Surrealist works displayed in a magnificently modest building designed by Italian architect Renzo Piano. At the Museum of Fine Arts, Houston, they meander through James Turrell's light tunnel, a visual sorbet separating the experience of architect José Rafael Moneo's Beck building from that of the Ludwig Mies van der Rohe–designed edifice next door. Texas has become a truly great destination for those who want to look at art. This achievement is

all the more laudable given the relative youth of the state's cultural institutions.

All of Texas' major museums and art centers were either created or substantially upgraded within the last thirty-five years. The Kimbell Art Museum, the Nasher Sculpture Center, the San Antonio Museum of Art, the Menil Collection, and Chinati did not exist before 1970. The Modern Art Museum of Fort Worth, the Dallas Museum of Art, the Meadows Museum, and the El Paso Museum of Art occupy facilities that were built in the last two decades. The Amon Carter Museum, the Museum of Fine Arts, Houston, and the Marion Koogler McNay Art Museum have been substantially enlarged and their collections expanded during the same period. Museums in smaller cities, such as the San Angelo Museum of Fine Arts and the South Texas Institute for the Arts, have experienced similar growth and change.

Some in the art world speculate that Texas' shift from a rural to an urban economy set the stage for these very recent developments. It has taken time for the personal wealth accumulated by Texans in the late nineteenth and early to mid-twentieth centuries from oil, cattle, land development, banking, and insurance to be converted into cultural institutions benefiting the public. Entire museums have been built around artworks accumulated by Amon Carter, John and Dominique de Menil, Ima Hogg, Kay and Velma Kimbell, Algur Meadows, Sid Richardson, and Lutcher Stark, among others. More recently the private collections of Margaret and Trammell S. Crow, Harris and Carroll Masterson, and Raymond and Patsy Nasher have been shared with the public.

Texas artists have also played a part in the rapid growth of nonprofit galleries. They followed the lead of colleagues

throughout the country who, beginning in the late sixties, created alternative exhibition venues where artists could exert authority. Their interest was in expanding the audience for new art in a way that museums had traditionally been unwilling to do, and they were abetted in their efforts by government funding made available to the arts during this period. Art spaces such as Lawndale Art Center and DiverseWorks in Houston, the Center for Contemporary Art in Dallas, Women and Their Work in Austin, and the Bridge Center for Contemporary Art in El Paso began as artist-run organizations. Unlike most museums, alternative spaces and art centers tend to focus their efforts on presenting changing exhibitions rather than on collecting and preserving works of art.

In small towns, the effort to create museums and art centers derives from civic pride and a desire to provide communities with big city–style cultural amenities, albeit on a smaller scale. In places like Albany, Laredo, Longview, Lufkin, McAllen, Midland, and Tyler, museums and art centers pay particular attention to educating young audiences, even, on occasion, exhibiting their work in the galleries.

This urge to provide art education for children and adults is also evident in museums and art centers located in large metropolitan areas. "If a museum doesn't do that, I don't think it should be a tax-exempt institution," says Peter Marzio, longtime director of the MFAH, which runs a nationally recognized educational outreach program.

And finally, in the last thirty-five years, art departments within the state's colleges and universities have established exhibition galleries and, in a few cases, museums to complement classroom instruction and to exhibit student and faculty work. Some of

these galleries are mentioned in detail in the following pages. Others are described briefly at the end of each chapter. No doubt I have missed some. Sadly, too many are hidden away in poorly identified buildings on campus. Convenient parking is rare, as are easily accessible, up-to-date Web sites and direct lines to galleries to call for information. You have to work hard to discover these arts venues and experience what they have to offer.

But experiencing art often requires work. It is as likely to confound, irritate, and challenge those who seek it out as it is to delight and intrigue. This, I believe, is its role. The enjoyment of art is only tangentially connected with an artist's facility with a brush or a chisel. Rather, art should make the observer think and, at its best, should stir up emotions and creative instincts. The ability to enter into a relationship with art completes us as human beings. On the most profound level it offers comfort and inordinate pleasure to those who are open to that possibility. Texas towns and cities have done their part by providing a wealth of museums, art centers, alternative spaces, and university galleries where such revelations may take place. Individuals attuned to the visual arts would do well to explore the nonprofit galleries in the great state of Texas.

NORTH CENTRAL TEXAS

NORTH CENTRAL TEXAS, AT LEAST FOR THE PURPOSE of this guidebook, is synonymous with the Dallas/Fort Worth Metroplex, a relatively small area within the state that is dense with cultural advantage. Rather than offering a sampling of secondary works by famous artists, which is the recourse of less affluent institutions, museums in Dallas and Fort Worth hold in-depth collections that include signature works by individual artists. Dallas offers important groupings of African American folk art (African American Museum), Modern sculpture (Nasher Sculpture Center), Spanish art (Meadows Museum), and Asian art (Trammell and Margaret Crow Collection of Asian Art). The Dallas Museum of Art, the area's only general, or encyclopedic, museum, owns and exhibits thousands of objects dating from ancient times to the present, with a particular interest in European and American art of the last 150 years. Fort Worth museums own a broad range of American art and photography through 1950 (Amon Carter Museum), Western art (again, the Amon Carter and also the Sid Richardson Collection), and Modern and contemporary painting and sculpture (Modern Art Museum of Fort Worth). And Fort Worth's Kimbell Art Museum, though modest in size, is internationally recognized for the overall quality of its European and Asian holdings and its exceptional Louis Kahn–designed building.

Two archives are also included in this chapter. The Jerry Bywaters Collection on Art of the Southwest at Southern Methodist University contains materials that offer invaluable insight into the North Central Texas art scene during the early and mid-twentieth century. Bywaters was a Dallas Museum of Fine Arts director, SMU professor, and artist. In addition to his work, the collection includes the art and artifacts of other

artists of the period. The Texas African American Photography Archive is a unique collection of community-based images dating from 1870 to the present. It includes works by both known and unidentified photographers. These two collections are open to the public by appointment and occasionally constitute the basis for exhibitions presented in collaboration with other institutions.

Also important are the area's non-collecting art centers and university galleries created to serve working artists (who are also plentiful in the Dallas/Fort Worth area), art students, and smaller communities. In Denton, Irving, Arlington, and Dallas it is these smaller, nonprofit venues such as the galleries at the University of North Texas, the University of Texas at Arlington, and the University of Dallas that encourage experimentation and discovery by audiences and artists alike. The Irving Arts Center, the Center for the Visual Arts in Denton, and the McKinney Avenue Contemporary in Dallas include under their roofs theater, music, and dance as well as the visual arts. The Arlington Museum of Art, a small non-collecting facility, focuses almost exclusively on work by contemporary Texas artists. The Dallas Center for Contemporary Art (formerly known as the Dallas Visual Arts Center), begun in the early eighties by a group of artists, continues to nurture artist-members while presenting challenging exhibitions to the public. It is curious to note that in Fort Worth, where interesting artist-run exhibition spaces do appear from time to time, there are in fact no enduring nonprofit alternative spaces.

Together Fort Worth and Dallas offer the oldest and newest major museums in the state. The Modern Art Museum of Fort Worth traces its roots to the Fort Worth Public Library and Art Gallery Association chartered in 1892. One hundred and ten

years later, it celebrated the opening of a new building designed by Tadao Ando, the prizewinning Japanese architect's first major project in the United States. The Nasher Sculpture Center in Dallas, the newest nonprofit to open to the public, was designed by Italian architect Renzo Piano and American landscape architect Peter Walker. Its galleries and garden are filled with works from the Nasher Collection, touted as the finest assemblage of Modern sculpture in private hands anywhere in the world. Convenient access to these and the other major museums in Dallas and Fort Worth is another hallmark of the region; within designated cultural districts in each city, visitors can easily walk from one major institution to another. It is possible to crisscross the entire Metroplex by car in a day. What is difficult is staying long enough at individual museums and art centers and returning often enough to take full advantage of all the available collections, temporary exhibitions, compelling architectural settings, and programs.

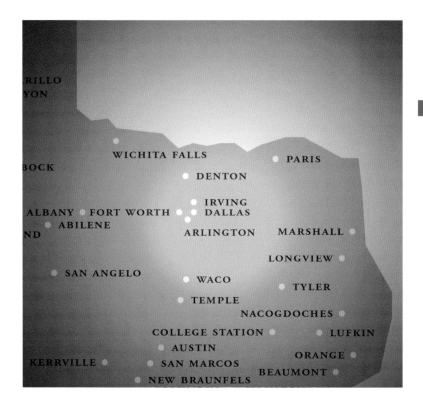

ARLINGTON
ARLINGTON MUSEUM OF ART
GALLERY AT UTA

DALLAS
AFRICAN AMERICAN MUSEUM
DALLAS CENTER FOR CONTEMPORARY ART
DALLAS MUSEUM OF ART
JERRY BYWATERS COLLECTION ON ART OF THE SOUTHWEST
 AND MILDRED HAWN EXHIBITION GALLERY

MCKINNEY AVENUE CONTEMPORARY (MAC)
MEADOWS MUSEUM, SOUTHERN METHODIST UNIVERSITY
NASHER SCULPTURE CENTER
POLLOCK GALLERY, SOUTHERN METHODIST UNIVERSITY
TEXAS AFRICAN AMERICAN PHOTOGRAPHY ARCHIVE
TRAMMELL AND MARGARET CROW COLLECTION OF ASIAN ART

DENTON
CENTER FOR THE VISUAL ARTS
UNIVERSITY OF NORTH TEXAS ART GALLERY

FORT WORTH
AMON CARTER MUSEUM
KIMBELL ART MUSEUM
MODERN ART MUSEUM OF FORT WORTH
SID RICHARDSON COLLECTION OF WESTERN ART

IRVING
IRVING ARTS CENTER
UNIVERSITY OF DALLAS HAGGERTY GALLERY

Also of Interest

DALLAS
BIBLICAL ARTS CENTER
CITY OF DALLAS CULTURAL CENTERS
 THE BATH HOUSE
 THE ICE HOUSE
 SOUTH DALLAS CULTURAL CENTER

PARIS
WILLIAM AND ELIZABETH HAYDEN MUSEUM
 OF AMERICAN ART AND PLAZA GALLERY

201 W. Main, Arlington 76010
817-275-4600
www.arlingtonmuseum.org

Non-collecting fine arts museum

The Arlington Museum showcases work by emerging and
established contemporary Texas artists.

Thu.–Sat. 10 a.m.–5 p.m. (Wed. till 8 p.m.)

Free

ARLINGTON MUSEUM OF ART

DETAILS

The Arlington Museum of Art's large ground-floor gallery (named after museum founder Howard Joyner) is used for group shows assembled by the museum, such as "Domestic: Artists Transforming the Everyday"; exhibits that have traveled from other venues, such as those assembled by Arthouse (formerly the Texas Fine Arts Association); and the museum's annual art auction and exhibition. The Allan Saxe Mezzanine Galleries provide a more intimate setting for exhibits by individual artists and independent curators. Exhibits throughout the museum routinely challenge visitors by exploring site-specific art, digital/video installations, and so on, as well as more traditional media.

In the mid-eighties, Joyner, chairman of the art department at the University of Texas at Arlington, and a small group of artists organized the Arlington Art Association, which offered art classes, workshops, and opportunities for members to exhibit their work. The current museum building, once a downtown J. C. Penney department store, was purchased in 1987 and opened to the public two years later.

From the beginning the 20,000-square-foot space comfortably accommodated contemporary art exhibitions, but in 2002 construction began on the three-tiered space (basement, main floor, and mezzanine galleries) to make it accessible for handicapped visitors and to provide a more commodious setting for educating children and adults. Architect Kenneth H. Loose, with Cauble, Hoskins, and Loose of Fort Worth, designed new windows and an entrance facing a small city park nearby. A secondary entrance remains on Main Street. With a glass elevator now moving people from belowground education areas to the new rooftop gallery and the addition of interior curves and natural light filtering into the basement level, the museum acquired a bit of pizzazz while resolving long-standing accessibility issues. The $900,000 project replaced an earlier, more extensive renovation plan that failed to garner sufficient support.

HELPFUL HINTS

The museum is easy to find and well worth a visit as you travel I-20 or I-30 between Dallas and Fort Worth. Don't forget to stop as well at the nearby Gallery at the University of Texas at Arlington.

"Art is like air or water.
It is needed to survive and to enjoy life to its fullest.
Without it, we cease to see ourselves as we are,
we cease to exist."

—RAYMOND NASHER, COLLECTOR[1]

GALLERY AT UTA

University of Texas at Arlington Fine Arts Building
502 S. Cooper, Arlington 76019
817-272-3110
www.uta.edu/gallery

The Gallery at UTA provides contemporary exhibitions and installations as well as residencies for artists.

Mon.–Fri. 10 a.m.–5 p.m., Sat. noon–5 p.m.

One entry leads to ramped access to the gallery, but not the other.

Free

DETAILS

For nearly two decades the Gallery at UTA has provided stimulating exhibitions of contemporary art, varying slightly in tone depending on the curator or director in place. From the beginning, the mission of the Gallery, originally dubbed the Center for Research in Contemporary Art, or CRCA, was to go against the grain with regard to traditional art forms and to explore new methods and media. Artists whose works have been featured in the Gallery over the past several years include Tré Arenz, Frances Bagley, Celia Alvarez Muñoz, Vincent Falsetta, and Casey Williams.

Previous gallery directors include Al Harris, former director of the Bridge Center in El Paso, and Sue Graze, subsequently hired to head the Texas Fine Arts Association (now called Arthouse) in Austin. During their tenure, three issues of *CRCA,* a magazine devoted to dialogue about the arts, were published before funding for the gallery and its programs was cut back. Today, despite a smaller budget, current curator and artist Benito Huerta continues to maintain a high standard.

The approximately 4,100 square feet of exhibition space include two gallery bays with sixteen-foot ceilings, which provide more than adequate space to present the one- and two-person shows that this curator favors, as well as group exhibitions. The director enjoys virtual autonomy in planning two fall and two spring exhibitions each year. In addition, at the end of each semester the work of students receiving the Bachelor of Fine Arts degree is shown in the galleries. The art faculty presents a biennial exhibition.

HELPFUL HINTS

The gallery is usually closed during the summer and during school holidays. If you're uncertain of the school calendar, call first. When visiting Arlington, don't forget to include the Arlington Museum of Art on your itinerary as well.

AFRICAN AMERICAN MUSEUM

Fair Park
3536 Grand Ave., Dallas 75210
214-565-9026, 214-823-7644 to book guided tours,
www.aamdallas.org

Fine arts museum

The African American Museum collects and exhibits fine
art, folk art, and historical artifacts that explore the black
experience in Dallas and beyond.

Tue.–Fri. noon–5 p.m., Sat. 10 a.m.–5 p.m., Sun. 1 p.m.–5 p.m.
Call for summer hours.

Free (fee charged for groups of ten or more)

Museum shop

Top: African American Museum (exterior)
Bottom: *Vampire Driving Wagon* by Sultan Rogers, paint on wood.
Gift of Sylvia and Warren Lowe. Courtesy of African American Museum.

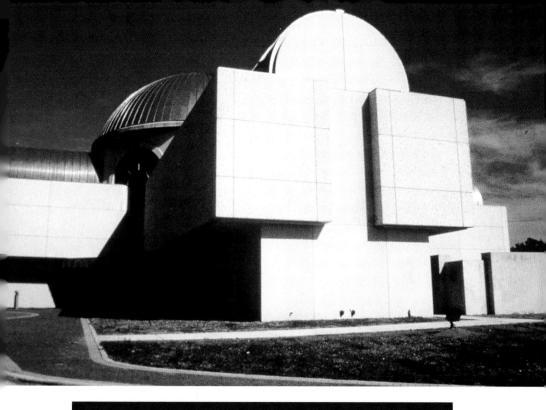

DETAILS

Since it was created in 1974 as a project of the now defunct Bishop College, the African American Museum has assembled a number of significant collections of art, historical artifacts, and archives. Stanley Marcus, the museum's first donor, contributed African art that forms the basis of a collection of nineteenth- and twentieth-century works from the Zaire, Nigeria, Ivory Coast, Ghana, Mali, and Upper Volta regions of the African continent. The Billy R. Allen Folk Art Collection began with the support of founding board member Billy R. Allen and has since grown to become one of the largest collections of African American folk art in the country. The annual Carroll Harris Simms National Black Art Competition and Exhibition (named after a Texas sculptor and Texas Southern University professor) has resulted in the purchase of many contemporary works by established and emerging artists, and the museum's curator brings additional works by young regional artists into the galleries through an exhibition series called "Fresh Beginnings." The museum also owns paintings by such nationally recognized artists as Sam Gilliam, Romare Bearden, and Jacob Lawrence and has attracted exhibitions of work by Robert Colescott and an installation by Annette Lawrence to its galleries.

It also holds the archives of *Sepia Magazine,* which began publication in 1947 in Fort Worth, and the Freedman's Cemetery Artifact Collection of items recovered from the 144-year-old Dallas cemetery where newly freed African Americans honored their deceased loved ones. In fact, nearly as many exhibitions present objects of historical or cultural significance as focus on art. Founding director Harry Robinson explains, saying, "African Americans don't compartmentalize their life experiences as Europeans do. We felt we had to deal with the entire life experience." He refers to the museum as a "transformation center."

The transformation of attitude toward the African American population in Dallas is reflected in the museum's history, which in a sense actually began in 1936, when the city's Fair Park played host to the Texas Centennial Exposition. A. Maceo Smith, executive secretary of the Dallas Negro Chamber of Commerce, had lobbied the city's leadership to build a hall to show the contributions of Negroes to Dallas. He was turned down by both local and state officials, but the federal government agreed to provide $100,000 for the project, half to construct the building and half for programs and exhibitions. The Hall of Negro Life and Culture, a 14,000-square-foot

building, opened on the site where the current museum is now located. It was completed in time for the exposition and torn down afterward, although other so-called temporary centennial buildings still remain. Not until 1985, when a bond election set aside $1.2 million toward construction of the current building, was an African American cultural institution restored to the park.

The remainder of the $6.5 million necessary to complete the 38,000-square-foot structure was raised through private donations. The architect for the project, Arthur Rogers of Dallas, selected the Dogon symbol for life in Mali, West Africa, as the predominant visual theme. The shape—it looks something like the capital letter "I" with a curved serif on top—appears throughout the building in the design of the windows, floor tiles, and portals to the four galleries on the second floor. A fifth gallery, smaller than the others, is located on the first floor, along with the reception area and museum shop.

HELPFUL HINTS

Fair Park, in addition to being a National Historic Landmark (it has the largest collection of 1930s Art Deco exposition-style architecture in the United States), is also home to the Women's Museum (which occasionally exhibits art), the Dallas Aquarium, and, of course, the annual State Fair of Texas.

"I think of this museum as a transformation and liberation center. We provide new information that we hope will lead to new attitudes that will lead to new behavior."

—HARRY ROBINSON, DIRECTOR,
AFRICAN AMERICAN MUSEUM[2]

DALLAS CENTER FOR CONTEMPORARY ART

2801 Swiss Ave., Dallas 78204
214-821-2522
www.thecontemporary.net

Art center

The Contemporary is an artist-based organization that presents challenging exhibitions of contemporary art with the goal of fostering greater awareness of Texas artists.

Tue.–Sat. 10 a.m.–5 p.m.

Free

Gift shop

DETAILS

Begun in 1981 by a group of working artists, the Contemporary was first known as D'ART and then as the Dallas Visual Arts Association. There have been other changes as well, including a move in 1999 to a newly constructed upscale facility with sealed-concrete floors and lovely natural light. Using the two inside galleries and a small sculpture garden, the Contemporary presents about fifteen exhibitions a year, including the annual membership exhibition, theme shows, and shows featuring individual emerging and midcareer regional artists. These include a series of one-person exhibits called "Mix!" (formerly "Mosaics"), a program that began in 1993 to include the work of artists of color who used ethnicity in their work. The framework was then expanded to include "any artist who incorporates issues of their ethnicity—whatever it may be—in their work." "Mix!" artists have included Stefan Chinov, Kaneem Smith, and Vincent Valdez. Another annual event worth noting is the Legend Award program, which recognizes one Texas artist, one arts professional, and one arts patron each year. Artists who have been honored—Benito Huerta, Melissa Miller, Linda Ridgway, and James Surls, to name only a few—are also invited to exhibit their work in the galleries.

D'ART began in an old warehouse down the street from its current location. In the early days, artists who presented shows were charged a fee to help cover expenses. In 1988, when the economy of Dallas foundered, the board auctioned the group's assets and shut the organization down. A year later, with substantial operating support from the Meadows Foundation, the gallery reopened as part of the newly designated Wilson Historic District. In September 1999 the Contemporary moved rent-free into the current foundation-owned arts space under a ten-year nonrenewable lease.

HELPFUL HINTS

Those not familiar with Dallas may have difficulty finding the building on the corner of Swiss Avenue and Texas because of a series of cropped and one-way streets in the Wilson Historic District. But visitors to the Contemporary, especially those who also stop at the MAC on McKinney Avenue and commercial galleries in the vicinity, will be rewarded for their perseverance.

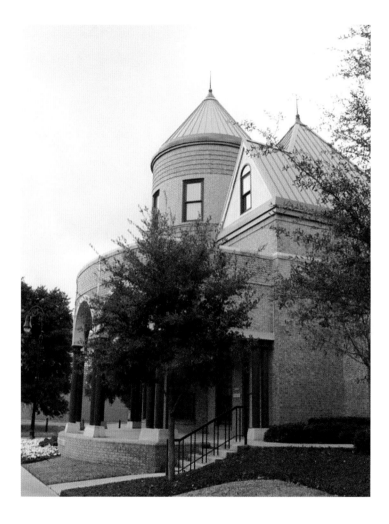

Dallas Center for Contemporary Art (exterior)

DALLAS MUSEUM OF ART

1717 N. Harwood, Dallas 75201
214-922-1200
www.dallasmuseumofart.org

Fine arts museum

The Dallas Museum of Art is a general art museum with ample collections that range from pre-Columbian to contemporary art with an emphasis on European and American art of the last 150 years.

Tue.–Sun. 11 a.m.–5 p.m. (Thu. till 9 p.m.)

Adults $6, seniors and children 12 and older $4. Members free; first Tue. of the month and each Thu. 5 p.m.–9 p.m. everyone free.

Atrium Café open Tue.–Sun. 11 a.m.–2 p.m. (Thu. till 8 p.m.), beverage and snack service till 4 p.m. Seventeen Restaurant open Tue.–Fri. 11 a.m.–2 p.m. Available for private parties in the evening.

Museum shop

Top: Dallas Museum of Art, Hamon Wing, 1993,
Edward Larabee Barnes, architect. © DMA, photo by Tom Jenkins.
Bottom: *Fox in the Snow* by Gustave Courbet, 1860, oil on canvas.
© DMA, Foundation for the Arts Collection, Mrs. John B. O'Hara Fund.

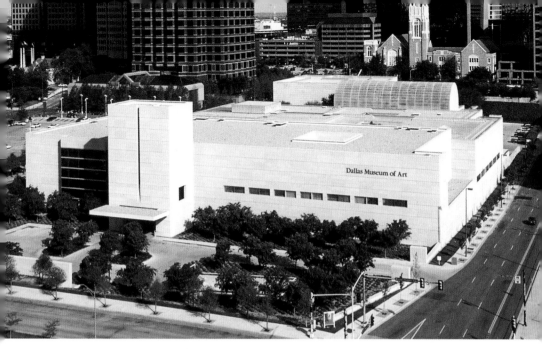

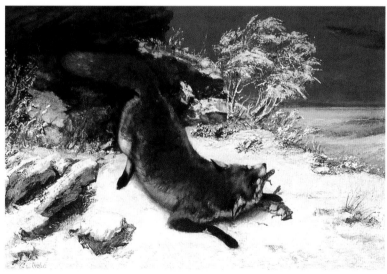

DETAILS

"This is one of America's thirty big museums," says the Dallas Museum of Art's current director, John R. Lane. Visitors who want to experience all of the museum's collections in roughly chronological order should begin on the fourth floor with Art of the Americas. The antiquities there are presented so beautifully that it is hard to look away. Next, stroll through the Spanish Colonial, British Colonial (furniture, portraits, and silver), African, Pacific, and Asian collections. Don't miss Frederic Church's masterpiece *The Icebergs* (bought at auction for $2.5 million, the highest price ever paid for an American painting at the time), which was donated to the museum anonymously in the early 1980s. The museum's ground level is used primarily for major temporary exhibitions such as the Thomas Struth retrospective (2002), "Sigmar Polke: New Work" (2002–2003), and the sculpture of Henri Matisse, all organized by the DMA (the Matisse in partnership with other nationally prominent museums), and smaller exhibits. First-floor galleries also display the DMA's rapidly expanding collection of contemporary art, which includes site-specific works commissioned for the opening of the first phase of the building: Ellsworth Kelly's sculpture for the sculpture garden, Claes Oldenburg and Coosje van Bruggen's *Stake Hitch* (removed from the soaring Barrel Vault Gallery in 2002 in advance of the museum's centennial celebration), and *The Courtyard,* by Richard Fleischner.

Designed by architect Edward Larabee Barnes, the original 210,000-square-foot building was completed in 1984. From a distance its distinctive barrel vault served as a beacon for the newly proclaimed Downtown Arts District. But Dallas wanted more. In 1985 a new decorative arts wing opened to house more than 1,400 objects from the Wendy and Emery Reves Collection, displayed per the donors' request in a replica of the Reveses' Villa La Pausa in Southern France. The Impressionist and Post-Impressionist paintings and decorative art objects were soon joined by the Faith P. and Charles L. Bybee Collection of American Furniture and numerous other collections and individual works from ancient times to the present. With the 1993 addition of the Jake and Nancy Hamon Wing's additional 140,000 square feet, the flow of the museum became problematic.

The DMA is still tinkering with internal traffic patterns and exhibition strategies. Those who need an elevator to move from one level to the next will find themselves doubling back through galleries even more than visitors who are able to use the stairs. Certainly the museum has come a long way

since 1903, when the Dallas Art Association was formed to oversee a second-floor gallery within the city's Carnegie Public Library, and even later when the Dallas Museum of Fine Arts, as it was then called, was located in Fair Park.

The DMA is the only general art museum in North Central Texas and, as is frequently the case with such a sprawling facility, leaves visitors who attempt to see all that the museum has to offer in one day feeling over-stuffed and empty at the same time. It is better to concentrate on one or more temporary exhibitions and select portions of the permanent collection. At the very least, plan on resting midday in the upscale upstairs Seventeen Restaurant or the Atrium Café on the first floor before resuming the trek. Save time as well for the Gateway Gallery and the sizable museum shop.

HELPFUL HINTS

Perhaps the most important change affecting the DMA in recent years is external to it. The opening of the Nasher Sculpture Center across the street signals great potential for collaboration between the two institutions in terms of exhibitions, educational programming, and administrative issues such as shared parking and entry tickets.

Parking is available under the DMA, with access from either St. Paul or Harwood, and fees of $2 for the first hour and $1 for each subsequent half hour. Some street parking is also available.

"The museum is an architectural composition involving time— the measured unfolding of the collection in quiet, supportive space."

—EDWARD LARABEE BARNES, ARCHITECT[3]

THE JAKE AND NANCY HAMON ARTS LIBRARY, SOUTHERN METHODIST UNIVERSITY

6100 Hillcrest, Dallas 75275
214-768-2303 or 214-768-1859
www.smu.edu/cul/hamon
University collection and gallery

The Hamon Arts Library's Special Collections Wing holds and exhibits materials donated by Jerry Bywaters, SMU art professor and director of the Dallas Museum of Fine Arts, and those of other artists working in the Southwest during the first half of the twentieth century. The Mildred Hawn Exhibition Gallery, on the first floor of the library, exhibits work from the university's special collections and supports other university interests.

Mon.–Thu. 9 a.m.–5 p.m. Appointment recommended.

MILDRED HAWN EXHIBITION GALLERY

Mon.–Sat. 9 a.m.–5 p.m., Sun. 1 p.m.–5 p.m.

Free

JERRY BYWATERS COLLECTION ON ART OF THE SOUTHWEST / MILDRED HAWN EXHIBITION GALLERY

DETAILS

The Bywaters Collection includes letters, catalogs, clippings, correspondence, photographs, slides, and works of art on paper amassed by Bywaters and other artists, including Charles Bowling, Otis and Velma Davis Dozier, E. G. Eisenlohr, Mary Doyle, DeForrest Judd, William Lester, Octavio Medellin, and Janet Turner. A number of studies for murals, some that were realized and others that were not, by Bywaters, Otis Dozier, Alexander Hogue, and others document Texas' early history of mural competitions for post offices and other public spaces.

The Jerry Bywaters Collection on Art of the Southwest was established in the fall of 1990 in the new Jake and Nancy Hamon Arts Library on the Southern Methodist University campus. It was constructed with funds from the McDermott Foundation of Dallas to serve as a repository for works on paper and archival materials illuminating the cultural history of the Southwest. In addition to visual arts materials, the university holds collections pertaining to theater and music.

HELPFUL HINTS

Appointments must be made in advance to use archival research materials. Hours for the Jake and Nancy Hamon Arts Library are available by calling 214-768-2894.

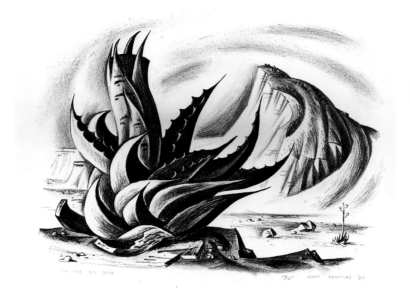

In the Big Bend by Jerry Bywaters, 1939, lithograph.
Photograph from the Jerry Bywaters Collection on Art of the Southwest,
Jake and Nancy Hamon Arts Library, Southern Methodist University.

MCKINNEY AVENUE CONTEMPORARY (MAC)

3120 McKinney Ave., Suite 100, Dallas 75204
214-953-1622
http://www.the-mac.org

Multidisciplinary art center

The MAC, which maintains two performance spaces as well as three distinct exhibition galleries, shows work by emerging and established artists in all disciplines.

Wed.–Sat. 11 a.m.–10 p.m., Sun. 1 p.m.–5 p.m.

Free (admission charge for various performances, but not for galleries)

Coffee bar (evening and daytime hours vary)

Gift shop

DETAILS

In the McKinney Avenue Contemporary's small projects gallery, where individual artists are encouraged to experiment and take aesthetic risks, exhibits change as often as every three to four weeks. Exhibitions in the two larger galleries—usually programmed as one—change eight to ten times a year. They include, perhaps surprisingly, an annual Texas historical show featuring the likes of Jerry Bywaters, Otis Dozier, and Everett Spruce, as well as contemporary fare such as the works of John Alexander, Kara Walker, and William Wegman.

The *Dallas Observer* has described the MAC as a "mini-arts district under one roof." It developed as a result of the coming together of an artist group known as Dallas Artists Research and Exhibit (DARE) and Claude Albritton, a wealthy businessman and community-minded collector. Both saw the need in Dallas for an alternative space where artist-driven, cutting-edge performances and exhibitions could occur.

The Albritton family purchased a building, formerly the Potts Longhorn Leather Company, in the Uptown area of Dallas, and renovated it in 1994, creating an attractive and flexible facility with a number of intimate and interconnected spaces, including three galleries and two small theaters. In the dark middle of the building's interior, visitors can gather at small tables, visit the gift shop, or surf the Internet at the CyberCafé. The lobby has a cool, nearly cavelike feel in contrast to the well-lighted galleries with their thirteen-foot ceilings and concrete floors, reminiscent of L.A.'s Bergamot Station or New York's Chelsea.

DARE has evolved into an advisory committee for exhibitions in the facility, which is still owned by the Albritton family and leased to the MAC for a dollar a year. The family also contributes toward operating expenses and plays an active role in programming. Claude Albritton maintains an office in the building, and Rick Brettell, former DMA director, continues a longtime involvement with exhibitions. The staff includes directors for both the visual arts and the performance areas.

HELPFUL HINTS

The MAC, painted bright blue, is relatively easy to spot from the street. There's plenty of daytime parking in the lot and numerous nearby eateries. The galleries remain open later than most so theatergoers can enjoy the art as well as whatever performance they've come to see.

*"In one fell swoop,
Dallas has received a sculpture collection
it couldn't afford to buy,
in a facility it couldn't afford to build,
with an art history and education program
it couldn't afford to support."*

—JAY GATES, FORMER DIRECTOR,
DALLAS MUSEUM OF ART, COMMENTING ON
THE NASHER SCULPTURE CENTER[4]

Southern Methodist University
5900 Bishop Blvd., Dallas 75275
214-768-2516
http://meadowsmuseum.smu.edu

University fine arts museum

The Meadows Museum, part of the Meadows School of the Arts at Southern Methodist University, houses this country's second-largest collection of Spanish art of high quality. It also holds a small selection of Modern sculpture and presents a broad range of temporary exhibitions to campus and community audiences.

Mon.–Tue. and Thu.–Sat. 10 a.m.–5 p.m. (Thu. till 8 p.m.), Sun. 1 p.m.–5 p.m.

Admission varies for temporary exhibitions; permanent collection galleries are free.

Gates Restaurant open Mon.–Fri. 11 a.m.–2 p.m. Reservations recommended (214-768-3928).

Museum shop

DETAILS

The Meadows Museum holds one of the largest collections of Spanish art outside of Spain. It was created as a result of the largesse of Algur H. Meadows, who made his fortune in the oil business and had a deep passion for the art of Spain. In 1962 the Meadows Foundation gave Southern Methodist University money in memory of Meadows's first wife, Virginia, to create a facility within the new Owens Arts Center on campus to house his personal collection. Meadows then provided the impetus and the funds for acquiring additional works. In the late sixties, after it was discovered that a number of the pieces in the museum's collection were fakes, the museum, to its credit, hired a director/curator to delete questionable objects and acquire additional work of the finest possible quality. William B. Jordan served for ten years as director and dean of the art faculty, guiding the purchase of $10 million worth of acquisitions to expand and reshape the Meadows Museum collection. This included masterworks such as Goya's *Yard with Madmen* (oil on tin-plated iron, 1794) and *Female Figure (Sibyl with Tabula Rasa)* (ca. 1648), by Velázquez. Today the collection comprises nearly 700 works, including paintings, sculptures, and works on paper from the tenth through the twentieth centuries. Familiar to many will be names like El Greco, Miró, Murillo, Picasso, Ribera, and Tápies. In 1969 Meadows also gave the museum American and European Modern sculptures (a passion of his second wife, Elizabeth), including works by Alberto Giacometti, Aristide Maillol, Henry Moore, Auguste Rodin, and David Smith.

In 1998, the Meadows Foundation gave the school more than $20 million to design and build a freestanding art museum for the Meadows collection as well as two other university collections. The Chicago-based firm Hammond Beeby Rupert Ainge was selected to produce a building consistent with the existing Georgian-style campus architecture. The 66,000-square-foot facility, built for roughly $25 million, is six times as large as the museum's previous space and houses a collection now valued at more than

Top: *Mujer (Sibila con tábula rasa) (Female Figure [Sibyl with Tabula Rasa])* by Diego Rodríguez de Silva y Velázquez, ca. 1648, oil on canvas. Meadows Museum, Southern Methodist University, Dallas, Algur H. Meadows Collection 74.01.
Bottom: *Corral de locos (Yard with Madmen)* by Francisco José de Goya y Lucientes, 1794, oil on tin-plated iron. Meadows Museum, Southern Methodist University, Dallas, Algur H. Meadows Collection 67.01.

$110 million. Outside the stern red-brick edifice, south of the grand staircase leading to the main entrance, *Wave,* a fountain designed by Spanish architect and artist Santiago Calatrava, marks the beginning of the museum experience.

Inside, the building's first floor offers a small but lively museum shop and a restaurant reputed to be the best eating spot on campus. Upstairs, the permanent collection has at last found a worthy home, one that shows off each treasure to its best advantage. High ceilings, natural light balanced with museum lighting, intensely colored walls, and wood floors laid in a herringbone pattern create a formal atmosphere that reinforces and is reinforced by the work itself. There are six galleries reserved for the collection. A like amount of space on the opposite side of the staircase is allocated for temporary exhibitions. These have included "La Tauromaquia" and "Los Disparates" (January–April 2002), featuring two of Goya's rarely seen print series from the collection. All prints held in the collection are first editions. Temporary exhibits are not restricted to Spanish art. "The limit is the sky," says curator Mark Roglán, a native of Madrid. "The exhibitions can include anything that is art." Temporary exhibitions change approximately three times a year, and most are accompanied by an aggressive schedule of lectures and programs to which the public is invited. The museum's future is now being shaped by the current director, Edmund P. (Ted) Pillsbury, former director of Fort Worth's Kimbell Art Museum.

HELPFUL HINTS

This is one of those rare instances in which a university facility provides ample free underground parking and an elevator to take visitors directly to a covered portico. Located near the Gerald J. Ford Stadium at Mockingbird Lane, it is also easy to find. The Gates Restaurant takes its name from a set of iron gates that once served as the entry to the original museum building.

Top: *Les Trois Nymphes (The Three Graces)* by Aristide Maillol, 1937–1939, lead. Meadows Museum, Southern Methodist University, Dallas, Elizabeth Meadows Sculpture Collection 69.05. (Note: Sculpture has been moved to an indoor location.)
Bottom: *Imposición de la casulla a San Ildefonso (The Investiture of Saint Ildefonsus)* by Juan de Borgoña, 1508–1514, tempera and oil on wood panel. Meadows Museum, Southern Methodist University, Dallas, Algur H. Meadows Collection 69.03.

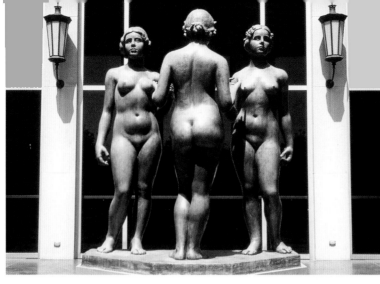

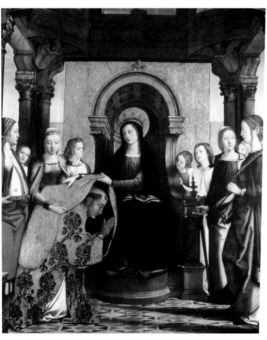

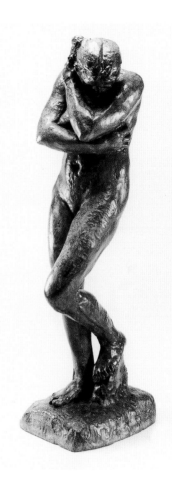

Left: *Le Deviseur II (The Gossiper II)* by Jean Dubuffet, 1969–1970, painted polyester resin, 120"
x 81¾" x 85¼". Raymond and Patsy Nasher Collection, Dallas, Texas. © 2004 Artists Rights
Society (ARS), New York/SABAM, Brussels.
Right: *Eve* by Auguste Rodin, 1881 (cast before 1932), bronze, 68" x 17¼" x 25½". Raymond and
Patsy Nasher Collection, Dallas, Texas.

2001 Flora, Dallas 75201
214-242-5100
www.NasherSculptureCenter.org

Sculpture garden and research center

This two-and-a-half–acre urban oasis features rotating selections from the world-renowned Raymond D. and Patsy Nasher Collection of Modern European and American Sculpture.

Tue.–Sun. 11 a.m.–6 p.m. (Thu. till 9 p.m.)

Adults $10, seniors $7, students $5, children and members free. All admissions include free audio tour.

Café Mansion overlooking the sculpture garden is open during museum hours. No reservations accepted.

Museum shop

NASHER SCULPTURE CENTER

DETAILS

Art museums throughout the world courted the affections of Dallas businessman Raymond D. Nasher and his late wife, Patsy, preeminent collectors of pre-Columbian art and Guatemalan textiles (the textile collection now resides at the Dallas Museum of Art), contemporary prints and Modern and contemporary paintings and sculptures. The couple's greatest enthusiasm was reserved for Modern and contemporary sculptures, both large and small. Many were installed on tree-shrouded acreage surrounding their North Dallas home or in Northpark shopping center and other commercial properties developed by Nasher. The collection includes masterworks that range from Auguste Rodin's *The Age of Bronze* (ca. 1876) to contemporary sculptor Magdalena Abakanowicz's *Bronze Crowd* (1990–1991). It also includes in-depth concentrations of work by such sculptors as Raymond Duchamp-Villon, Alberto Giacometti, Henri Matisse, Joan Miró, and Pablo Picasso. An exhibition titled "A Century of Modern Sculpture: The Patsy and Raymond Nasher Collection" first stirred excitement in 1987–1988 at the Dallas Museum of Art and the National Gallery of Art in Washington, D.C., and later in Florence, Madrid, and Tel Aviv. A decade later, New York's Solomon R. Guggenheim Museum and the California Palace of the Legion of Honor in San Francisco presented selections from the collection, which at that time encompassed more than 300 major works.

By the early nineties it appeared that the sculptures would go to a Dallas museum that would be built and owned by the city. But in April 1997 the collector announced that he himself would build a public sculpture garden for the work. Nasher, who made his fortune as a real estate developer, purchased a $20 million site across Harwood Street from the Dallas Museum of Art and selected Renzo Piano (the Pritzker Prize–winning Italian architect who designed Houston's Menil Collection and Twombly Gallery) and landscape architect Peter Walker to design the facility.

Because only a portion of the collection (which continues to be owned by the Nasher Foundation rather than the Nasher Center) can be artfully displayed at one time, the remainder of the work will be loaned to other institutions or remain on display elsewhere rather than being put in storage. "I want to see the art becoming a fundamental catalyst in people's lives," Nasher has said, pointing out that works shown at Northpark shopping center are likely to be seen by more people than works exhibited in a museum. Sculptures will rotate in and out of the garden over time (except perhaps for

Richard Serra's fifty-ton *My Curves Are Not Mad*), and those in the interior galleries will be changed out more frequently.

The Nasher Center's 54,000-square-foot building is a modest yet elegant structure, a sculptural wonder in its own right. Five equal-size pavilions stretch along Flora Street, each distinguished by a shallow barrel-vaulted glass ceiling (covered with a unique egg-crate-style metal canopy to mitigate the sun and rough weather) and side walls clad in travertine. Glass endwalls facing the Crow Museum of Asian Art across the street allow passersby to peer into and beyond the street-level sculpture galleries to the garden. Also located on street level are the museum shop, restaurant, and director's office. Visitors may exit the sculpture galleries and gambol on the greens (the specially engineered lawn allows for quick drainage so the area can be usable within twenty minutes after a hard rain), or they can proceed downstairs to the building's lower-level gallery, reserved for delicate works on paper.

The director selected to run the new sculpture center is Steven A. Nash, who was co-curator, when he was with the Dallas Museum of Art, of the earlier exhibition of the collection. Other staff members have come from the DMA as well, helping to strengthen the ties that bind the two institutions through educational programming, exhibitions, marketing, and—perhaps most important for visitors—fees and parking.

HELPFUL HINTS

Expect the relationships among the three neighboring art museums—the Crow, the DMA, and the Nasher Center—to change and mature over time. For now, parking in the DMA garage is free for Nasher Sculpture Center members.

POLLOCK GALLERY

Southern Methodist University
Hughes-Trigg Student Center
3140 Dyer, Dallas 75205
214-768-4439
http://meadows.smu.edu (click "Art" and then "Pollock Gallery")

University gallery

The gallery exhibits Meadows School of the Arts faculty work, MFA and BFA student shows, and a diverse assortment of one-person exhibitions and excerpts from private collections.

Mon.–Tue. and Thu.–Fri. 11 a.m.–5 p.m., Sat. 1 p.m.–5 p.m. Closed summers.

Wheelchair accessible, but not via the student center's front and most visible door.

Free

DETAILS

The Pollock Gallery presents six or seven exhibitions each year in the Hughes-Trigg Student Center gallery and several in the Mildred Hawn Gallery in the Hamon Arts Library. Art faculty and student shows are joined by an unpredictable but always satisfying assortment of other exhibits aimed first and foremost at expanding the experience of SMU students. Notable examples include "Contemporary American Drawings from the Sarah-Ann and Werner H. Kramarsky Collection" (2000), which attracted positive community-wide attention, and "Jean-Michel Basquiat: Works from the May Collection" (2003). An exhibit of visionary drawings of self-taught artist Chelo González Amezcua (1903–1975) and abstract drawings by Burgoyne Diller (1906–1965) also were exhibited in the student center during the 2002–2003 school year.

The gallery was built in 1990 as part of the Hughes-Trigg Student Center and later named for Lawrence and Shirley Pollock (he died in 2000), generous contributors to SMU. All buildings on the SMU campus tend to be austere brick edifices, and the Hughes-Trigg Center is no exception with its formal staircase leading to the main entrance. But inside, the center is teeming with the usual undergraduate commotion—food concessions, video games, and chatter. The gallery's picture windows front on a busy interior thoroughfare, but are occasionally covered to accommodate particular exhibitions. It is a flexible though not fancy space with movable walls and high ceilings. Plans are under way to move the gallery into the Meadows School of the Arts complex, but no date has been set.

HELPFUL HINTS

The best day to visit campus may be Saturday, because weekday parking is routinely scarce. Then again, football Saturdays are probably even worse. If the weather is good, park under the Meadows Museum (easy to do any day of the week), visit the galleries, and then stroll through campus to find the Hughes-Trigg Center.

*"When you have all the answers about a building before you start building it, your answers are not true.
The building gives you answers as it grows and becomes itself."*

—LOUIS KAHN, ARCHITECT[5]

115 N. Augusta, Dallas 75214
214-823-8824
www.docarts.com

Photography archive

The TAAP Archive collects and catalogs works by identified and anonymous photographers who have documented Texas' African American community from the 1870s to the present. Other works by African American photographers from around the country—some dating from the late 1840s—are also included. The archive makes this material available to researchers and to the general public through touring exhibitions.

Open to the public by appointment only

Free

TEXAS AFRICAN AMERICAN PHOTOGRAPHY ARCHIVE

DETAILS

Author and filmmaker Alan Govenar and artist Kaleta Doolin founded the Texas African American Photography Archive in 1995. It is administered by Documentary Arts, a nonprofit organization whose stated mission is "to broaden public knowledge and appreciation of the arts of different cultures in all media." The archive is housed in a state-of-the-art, climate-controlled facility built by the couple in Old East Dallas.

With some 33,000 prints and 18,000 negatives (and assorted tintypes, daguerreotypes, albumen prints, crayon portraits, newspapers, magazines, oral histories, business records, and related ephemera), the collection is unique in its in-depth investigation and documentation of work by black photographers in Texas and the vibrant life of the African American community in the twentieth century. Photographers represented include A. B. Bell, Marion Butts, S. Rodney Evans, Elnora Frazier, Earlie Hudnall, Jr., Curtis Humphrey, Alonzo Jordan, Benny Joseph, Herbert Provost, Carl Sidle, Juanita Williams, and Robert Whitby.

Although Govenar initially scavenged photographs and negatives from flea markets and garage sales, most objects in the archive have been donated by photographers and their families. Excerpts from the collection have appeared throughout the country, and a number of exhibits, including "The Early Years of Rhythm and Blues: The Photography of Benny Joseph" and "Portraits of Community: African American Photography in Texas," have been assembled, crated, and made available to travel to other institutions. Brochures and books are available to accompany each touring exhibition.

Visitors to the archive might also want to take note of the building across the street at 5501 Columbia Avenue, another Govenar/Doolin project. In the early nineties, architect Dan Shipley turned the neighborhood's 1918 brick firehouse into a prizewinning bit of contemporary architecture to serve as an exhibition and performance hall, the couple's offices, and a research center. Ultimately, public programming at the 5501 Columbia Arts Center was discontinued.

HELPFUL HINTS

If you're planning to visit the African American Museum or commercial galleries in Deep Ellum, the TAAP Archive could easily be included. Call in advance for an appointment. The archive is intended primarily for researchers, but others are welcome. You might begin by asking to see a copy of *A Guide to the Collections*.

Top: *Jasper, Texas,* ca. 1950, by Alonzo Jordan, photograph. © Texas African American Photography Archive, Dallas, Texas.
Bottom: *Unidentified Woman,* Fort Worth, Texas, ca. 1905, photograph. © Texas African American Photography Archive, Dallas, Texas.

TRAMMELL AND MARGARET CROW COLLECTION OF ASIAN ART

2010 Flora, Dallas 75201
214-979-6430
www.crowcollection.com

Fine arts museum

The museum exhibits Japanese, Chinese, Indian, and Southeastern Asian artifacts created from 3500 B.C.E. to the early twentieth century and changing exhibitions that often feature other private collections of Asian art.

Tue.–Sun. 10 a.m.–5 p.m. (Thu. till 9 p.m.)

Free

Gift shop

Seated Daoist diety, China, late Ming dynasty (1368–1644), seventeenth century, gilt bronze. Courtesy of the Crow Collection of Asian Art.

DETAILS

The Crow Collection includes roughly 600 objects selected from the personal collection of Trammell and Margaret Crow by Clarence Shangraw, curator of the Asian Art Museum in San Francisco and director emeritus of the Tsui Museum of Art in Hong Kong. Roughly half of these can be shown at one time. The collection includes precious jade ornaments from China, delicate Japanese scrolls, and a rare 28-foot-by-12-foot sandstone façade of an eighteenth-century Indian residence. New works of exceptional quality are purchased from time to time, although there is no attempt to fill gaps in a collection meant simply to reflect one couple's eye for beauty. The family's involvement continues through Trammell S. Crow, their son, who serves as president of the Crow Family Foundation, which exists solely to support the museum. Temporary exhibitions, many of which explore the point of view of other collectors of Asian art, are also presented in the galleries.

The senior Crows' interest in Asian art was sparked by the successful real estate developer's involvement with the Canton Trade Fair (as a result of having built the Dallas Trade Mart) and the couple's trips to China, begin-

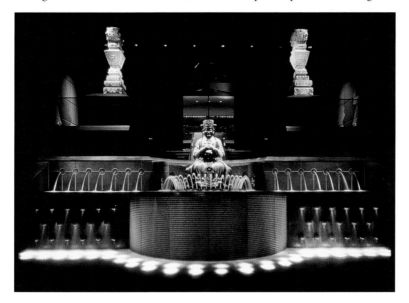

ning in 1976. Over time, mostly through private dealers and auction houses, they acquired more than 7,000 objects. They especially loved jade, purchasing more than 1,200 pieces in all. For years they displayed their treasures at home and in the lobbies and office areas at the Trammell Crow Center and other office buildings, marts, and hotels that belonged to Crow's company, before deciding to create the museum as a legacy for their children and grandchildren.

The museum site was once a special-events pavilion, a multipurpose space tied to the Trammell Crow Office Tower downtown. (The museum retains a long-term lease, but the Crows no longer own the building.) The space was redesigned by local architect Bill Booziotis to create an environment that encourages contemplation and relaxation and reflects the transcendent beauty of the objects on display. Music appropriate to the collection is played sporadically throughout the day.

Each culture is accorded a separate gallery, and subtle architectural changes—the Japanese galleries have wooden floors, in the Chinese gallery the floors are stone, and in the India, Nepal, Tibet, and Southeast Asia galleries they are slate—serve as clues to the transition from one geographic area to the next. The jade collection is highlighted with a lovely "moon gate" and benches where visitors may sit and enjoy the exquisite beauty of the objects or their own quiet thoughts, despite the pavilion's multiple plate-glass windows with urban vistas. The dark casework and intimacy of each space within the 1,200-square-foot facility reinforces the remove that visitors feel from the city's hustle and bustle.

HELPFUL HINTS

Parking is often available at meters on the street, or you can use the Dallas Museum of Art's parking garage and also visit the DMA and the Nasher Sculpture Center. The entrance to the collection is marked by a lovely fountain and a 2,000-pound sculpture of Confucius. Inside, don't forget the Lotus Shop, tucked behind the museum's entry foyer and also filled with Asian treasures.

Top: Figure of a dog, China, Song dynasty (eleventh through thirteenth centuries), white nephrite with brown inclusions. Courtesy of the Crow Collection of Asian Art.
Bottom: Large Namban chest, Japan, Momoyama period (1568–1615), seventeenth century, lacquer on wood base, gold *maki-e,* mother-of-pearl inlay. Courtesy of the Crow Collection of Asian Art.

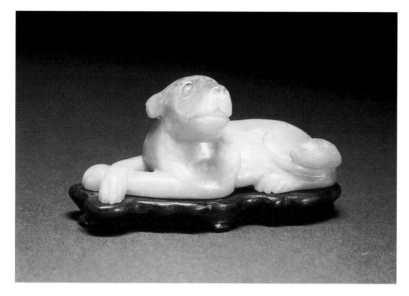

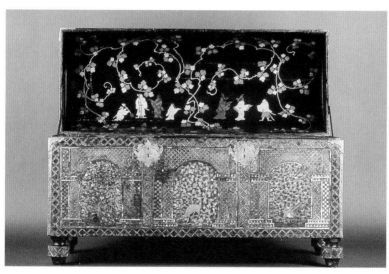

*"If you're interested in art,
you look at the world around you
and see things differently,
with clearer eyes and greater sensitivity."*

—RAYMOND NASHER, COLLECTOR[6]

CENTER FOR THE VISUAL ARTS

400 E. Hickory, Denton 76201
940-382-2787
www.dentonarts.com

Municipal arts center

The Center for the Visual Arts in Denton presents historical, contemporary, and community-based art exhibitions.

Tue.–Sun. 1 p.m.–5 p.m.

Free

DETAILS

Annual exhibitions at Denton's community arts space include "On My Own Time," a sampling of area amateur and professional (albeit part-time) artists, and "Materials: Hard and Soft," a national contemporary crafts exhibition that attracts impressively high-quality entries from across the country. The center's Meadows Gallery hosts as many as six shows a year, and the East Gallery is likely to have eight to ten. These have included area art league exhibitions, juried high school shows, and others exploring themes as diverse as Mexican folk art, the Talmud, African roots, and Lone Star regionalism. An exhibition committee advises the Greater Denton Arts Council staff, which also works closely with North Texas State University and Texas Woman's University in selecting and realizing programs and exhibitions.

Begun in 1985 as a project of the GDAC, the center is located in an old warehouse where engines were once repaired. The building was renovated in stages, from west to east, with the roomy Meadows Gallery completed in the first phase. The smaller East Gallery came later. Festival Hall, located between the two galleries, was once employed as a theater and now is a large multipurpose area used for performances, as a community meeting place, and occasionally for the display of art. Festival Hall and Meadows Gallery represent a playful conversion from warehouse to art hall. Both have sealed-concrete floors and brightly painted exposed pipes and air-conditioning ducts. The smaller, L-shaped East Gallery is somewhat more muted and formal.

HELPFUL HINTS

Easy to find on the corner of Hickory and Bell Streets, the center is marked by a sprinkling of outdoor sculptures—most of them on loan to the institution—and an ample parking lot. Also in Denton are the University of North Texas Art Gallery and Texas Woman's University Galleries.

*"We will have a museum district
second only to the Smithsonian—
not bad for a city of half a million people
on the plains."*

—MAYOR KENNETH BARR, FORT WORTH[7]

UNIVERSITY OF NORTH TEXAS ART GALLERY

Art Building
12001 W. Mulberry, Denton 76203
940-565-4316
www.art.unt.edu/gallery

University gallery

The UNT Gallery presents an extensive range of exhibitions representing regional, national, and international trends in contemporary art.

Mon.–Tue. noon–8 p.m., Wed.–Sat. noon–5 p.m.

Free

DETAILS

The gallery in the University of North Texas Art Building (completed in 1975) was programmed by faculty members until 1989 when Diana Block, the first (and so far only) full-time gallery director, was hired. Since that time, it has presented works by such established artists as Whitfield Lovell, Tracey Moffatt, and Luis González Palma from outside of Texas, as well as regional art stars, selections from private collections, and traveling exhibitions. Early in 2003 Wenda Gu, an artist who was born and reared in China, created two multimedia installations for the gallery and participated in a symposium. The exhibition was organized by the UNT Art Gallery in collaboration with the Kansas City Art Institute and the Institute of Contemporary Art at Maine College of Art in Portland. The gallery presents about eight exhibitions a year.

Located near a three-story atrium in the UNT Art Building, the gallery is a simple, flexible, 2,500-square-foot space that underwent a face-lift in 2002. MFA exhibitions are held in the smaller Cora Stafford Gallery in Oak Street Hall at Oak and Ponder Streets. Selections from the university's fashion collection, which has its own director, are also occasionally exhibited in the gallery.

HELPFUL HINTS

The UNT Art Building is located at Mulberry and Welch, and parking is available in a garage at the corner of Welch and Prairie Streets or at parking meters. Visitors who want to park closer to the building can call 940-565-3020 in advance for a visitor's permit to use the student lot.

The Center for the Visual Arts and Texas Woman's University's East and West Fine Arts Galleries in Denton are also worth a visit.

AMON CARTER MUSEUM

3501 Camp Bowie Blvd., Fort Worth 76107
817-738-1933
www.cartermuseum.org

Fine arts museum

Built to house Amon Carter's original gift of paintings and sculptures by Frederic Remington and Charles M. Russell, the museum now collects and exhibits a broad range of American art, including masterworks by artists working from the nineteenth through the mid-twentieth centuries and photographic objects spanning the history of the medium.

Tue.–Sat. 10 a.m.–5 p.m. (Thu. till 8 p.m.), Sun. noon–5 p.m.

Free

Museum shop

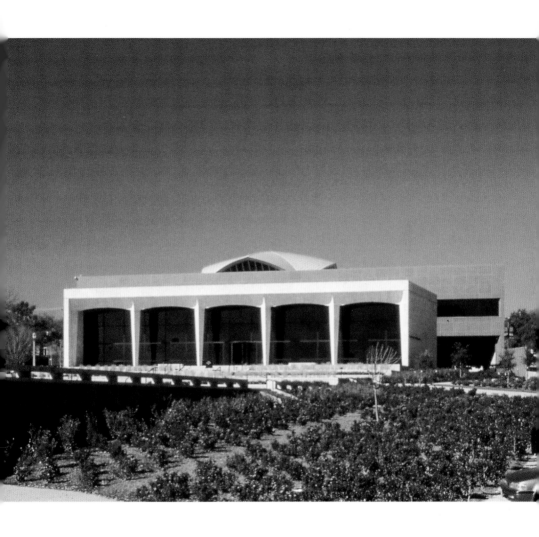

Amon Carter Museum (exterior)

DETAILS

The museum was initially built to honor Amon Carter (1879–1955), president and publisher of the *Fort Worth Star-Telegram,* and to house his collection of Western art. In part because of his friendship with American humorist Will Rogers (who had been a personal friend of Charles M. Russell), and also because of his own Western roots, Carter acquired 400 paintings and sculptures by Frederic Remington and Charles M. Russell. These include the only complete set of Russell's bronzes and Remington's masterpiece *A Dash for the Timber* (1889).

Today the collection encompasses nearly 250,000 works, although the Remingtons and Russells still hold a prominent position on the museum's ground floor. Some 230,000 of these artworks are photographic objects, among them the archives of photographers Nell Dorr, Laura Gilpin, Eliot Porter, Clara Sipprell, and Karl Struss. Also represented are major works by Thomas Eakins. *Swimming,* better known as *The Swimming Hole,* his 1885 masterwork, was purchased from the Modern Art Museum of Fort Worth in 1990. William Merritt Chase, Stuart Davis, Charles Demuth, Marsden Hartley, Winslow Homer, and Georgia O'Keeffe are also represented. In addition to selections from the permanent collection, four special exhibitions are presented each year. In 2003 these included the first in-depth look

at Eliot Porter's legacy, assembled from the collection, and exhibits featuring the works of Karl Bodmer, Winslow Homer (images devoted to fly-fishing), and Edward Weston, organized entirely or in part by other institutions. The museum also has a 38,000-volume library (accessible by appointment) and the active Teacher Resource Center, which aids regional educators. In the 160-seat auditorium, visitors can select and view short video presentations describing the museum's building and collections.

The museum is located on a site in the city's Cultural District purchased for that purpose by the Amon G. Carter Foundation during Carter's lifetime. After he died in 1955, his daughter, Ruth Carter Stevenson, met New York architect Philip Johnson through the de Menils of Houston and hired him to design the building. The prominent New York architect had had previous experience with art museums, particularly through his association with the Museum of Modern Art in New York City. Johnson's charge was to create a memorial to Amon Carter and to establish a place where the public could visit Carter's beloved collection. The site, the highest point in the area, allowed Johnson to orient the building toward a spectacular view of downtown Fort Worth, from the terrace and also from inside, through the two-story window wall that faces east. Johnson, who was known for his spare, international-style office buildings, delivered instead a surprising edifice inspired by the Renaissance-style loggia. Columns clad in fossilized Texas shellstone support a two-story portico, and a simplified rendition of the original façade serves as the museum's logo. Visitors approach by climbing dramatic exterior stairs to an open court, ascending to the museum as if it were a temple. The art was initially displayed in tiny galleries beyond the entry hall with its shellstone, teak-paneled walls, and granite floors.

The museum opened in 1961. Several months later, Mitchell Wilder, the museum's first director, determined that the building wasn't adequate to support plans for an expanded collection and exhibition policy. The museum built an addition in 1964, another in 1977, and in 1996 Johnson made adjustments in the original façade to help mitigate the effects of the sun so that art could be more safely presented in the sun-bathed entry. But in 1998 the decision was made to tear down all but the original (1961) portion of the museum and begin again.

A Dash for the Timber by Frederic S. Remington, 1889, oil on canvas.
Courtesy of Amon Carter Museum.

Philip Johnson, already in his nineties, and his partner, Alan Ritchie, were tapped to design the new $39 million expansion, which was completed in 2001, in time for the museum's fortieth anniversary. The addition is clad in brown granite and beautifully joined to the original building. More than 28,000 square feet of gallery space quadruples the amount of art that can be displayed at any one time. Whether visitors select the original entry or a new portal facing Lancaster Avenue, images by Remington and Russell are there to greet them. Upstairs galleries are devoted to the display of temporary exhibitions, photography, works on paper, and selections from the permanent collection of painting and sculpture. During the most recent campaign and building process, a new museum slogan emerged—"An American Masterpiece Filled with American Masterpieces." The building's evolution, which spans much of Johnson's architectural career, serves as a compact retrospective of his work.

HELPFUL HINTS

While the original entrance overlooking the city is best for a dramatic arrival, the Lancaster Street entrance is the one to choose for wheelchair access or group tours. It leads directly to the ample museum shop and the auditorium.

The atrium (Johnson refers to it as the "great hall") is bathed in natural light and is meant to function as the orienting feature of the building, but ask for a gallery map anyway. Because of the mazelike arrangement of the upstairs galleries, it is easy for visitors to lose their way.

"The total experience of a visit to the museum should be one of warmth, mellowness and even elegance. . . . The spaces, forms and textures should maintain a harmonious simplicity and human proportion between visitor, the building and the art objects observed."

—RICHARD FARGO BROWN,
FIRST DIRECTOR OF THE KIMBELL[8]

KIMBELL ART MUSEUM

3333 Camp Bowie Blvd., Fort Worth 76107
817-332-8451
www.kimbellart.org

Fine arts museum

At the Kimbell the high quality of the collection and temporary exhibitions of non-Western and Western art through 1950 is echoed in the museum building, a masterwork of mid-twentieth-century architecture.

Tue.–Thu. and Sat. 10 a.m.–5 p.m., Fri. noon–8 p.m., Sun. noon–5 p.m.

Barrier-free access to the museum is available at the Arch Adams Street entrance (opposite the Modern Art Museum of Fort Worth). A limited number of wheelchairs are available upon request.

Free (special charges for special exhibitions)

Kimbell Buffet open for lunch Tue.–Thu. and Sat. 11:30 a.m.–2 p.m., Fri. and Sun. noon–2 p.m. Beverages and desserts served Tue.–Sun. 2 p.m.–4 p.m. Dinner served Fri. 5:30 p.m.–7:30 p.m. (open seating, no reservations)

Museum shop

Kimbell Art Museum (exterior—north portico, reflecting pool and waterfall), Louis I. Kahn, architect (1901–1974), completed 1973. Photo by Michael Bodycomb, 1987. Copyright © 2003 by Kimbell Art Museum.

DETAILS

The Kimbell Art Museum's holdings include European, Asian, pre-Columbian, African, and Oceanic art from antiquity through the mid-twentieth century. Among these are acknowledged masterpieces by Duccio, El Greco, Fra Angelico, Mantegna, Rembrandt, and many others. For those interested in a reliable overview of the collection, most works are accessible on the museum's Web site if not in the galleries. A tantalizing array of temporary exhibitions such as "Modigliani and the Artists of Montparnasse," "The Quest for Immortality: Treasure of Ancient Egypt," and others are presented to complement the Kimbell's works, but sadly these often seem to necessitate that the museum's own treasures be hidden from view or installed in compromised locations. The small, elegant facility was designed originally to feature only the founders' collection of art. The building, an internationally acknowledged icon designed by Louis Kahn, was originally conceived as a means of sharing the Kimbell collection with the public.

The first painting Kay Kimbell and his wife, Velma, bought was one they saw at a public-library exhibition arranged by the Fort Worth Art Association, the precursor to the Modern Art Museum of Fort Worth. Kimbell, who made his fortune in the grain business, retailing, real estate,

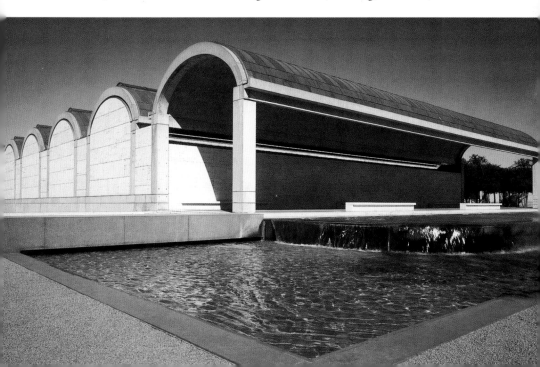

and petroleum, purchased the work of late-eighteenth-century British painter Sir William Beechey through Bertram Newhouse, a New York art dealer who subsequently became the curator of their collection and helped with other purchases. For the most part they collected eighteenth- and nineteenth-century British and French portraiture. When Kay Kimbell died in 1964, the couple owned 360 works of art, including ivories, jades, and about 200 paintings. The decision to create a museum had been made long before his death, with the establishment of the Kimbell Foundation in 1931.

In November 1964 the city of Fort Worth contributed a site (nine and a half acres east of and downhill from the Amon Carter Museum) for the building that would house the Kimbell Collection. The next year foundation trustees hired Richard F. Brown as director and charged him with the responsibility of expanding and refining the collection to include only works of definitive excellence, regardless of medium, period, or school of origin. The quality of individual objects was to take precedence over creating a sense of historical completeness. The director also selected and worked with Louis Kahn to create an excellent building in which to exhibit the collection.

Under Brown's leadership, the third art museum to be established in Fort Worth's Cultural District made every effort to be a good neighbor. Philip Johnson, the Amon Carter's architect, was consulted before the height of the building was determined so as not to restrict the Amon Carter's view of downtown Fort Worth. Brown also initiated an agreement among the three art museums that they would avoid overlapping their respective areas of interest.

Finally, at a cost of $6.5 million, the Kimbell Art Museum opened on October 4, 1972. The details of the building—120,000 square feet capped with a series of cycloid vaults, post-tensioned concrete, and walls sheathed in Italian travertine marble—have been discussed and praised ever since. Louis Kahn (1901–1974), one of America's most revered architects, produced a building that is known worldwide for its elegance and restraint, for the way it blends into its parklike setting and converses with the art. Narrow slits open to the sky at the end of each vault, allowing natural light into the galleries. According to the architect, "The museum has as many moods as there are moments in time, and never as long as the museum remains as a building will there be a single day like the other."

But some people, including the current director, have speculated that the museum may have been built too soon. The trend in art museums, beginning in the mid-seventies after its completion, has been to present blockbuster exhibitions comprising borrowed works of art from throughout the world. But

when the Kimbell presents traveling exhibitions—for instance, the 2002 exhibit "Mondrian, 1892–1914: The Path to Abstraction" from the Gemeentemuseum in The Hague—most of the permanent collection must be hidden away. Visitors who arrive looking for favorite works by Caravaggio or Cézanne or Matisse may be disappointed, and yet the museum's status as an architectural icon makes it difficult, perhaps impossible, to enlarge. Perhaps a bit of acreage diagonally across the street (and across from the MAMFW) now owned and underused by the museum will one day provide a solution.

HELPFUL HINTS

Light Is the Theme, a book republished by the Kimbell in 2002 for its thirtieth anniversary, is a lovely testament to the architecture and the architect. For visitors who want a small memento of the visit, this is one to consider.

The Cardsharps (I Bari) by Caravaggio (Italian, 1571–1610), ca. 1594, oil on canvas, 37⅛" x 51⅝". Photo by Michael Bodycomb. Copyright © 2003 by Kimbell Art Museum.

MODERN ART MUSEUM OF FORT WORTH

3200 Darnell, Fort Worth 76107
817-738-9215
www.themodern.org

Fine arts museum

The Modern Art Museum of Fort Worth exhibits selections from its collection of approximately 2,600 Modern and contemporary objects in all media and presents changing exhibitions that also address international developments in post–World War II art.

Tue.–Thu. and Sat. 10 a.m.–5 p.m. (except September 9–November 18 Tue. 10 a.m.–8 p.m.), Fri. 10 a.m.–8 p.m., Sun. 11 a.m.–5 p.m.

Adults $6, students with ID and seniors 60+ $4, children 12 and under free. Members free; Wednesdays and first Sunday of the month everyone free.

Café Modern open Tue.–Sat. 11:30 a.m.–2 p.m., Sun. noon–2:30 p.m.

Museum shop

DETAILS

The museum's collection includes works large and small by such artists as Milton Avery, Morris Louis, Robert Motherwell (one of the world's largest collections of his work), and Jackson Pollock. Andy Warhol's *Twenty-five Colored Marilyns,* one of his best-known works, is joined by a substantial number of other Pop Art pieces. A newly commissioned 67-foot-high steel spiral by Richard Serra greets visitors outside the front door. According to curator Michael Auping's introduction in a recent museum publication, the museum has begun collecting a number of artists' work in depth, including Philip Guston (the focus of the retrospective exhibition in the spring of 2003 organized by the MAMFW), Anselm Kiefer, Agnes Martin, Susan Rothenberg, and Sean Scully. A catalog produced in December 2002, *Modern Art Museum of Fort Worth 110,* marks the museum's 110th anniversary and the opening of its new galleries and features 110 of the artists whose work appeared in the inaugural exhibit in the museum's new home. Ironically, the MAMFW, housed in one of the most heralded new museum buildings in Texas and beyond, is, in fact, the state's oldest visual arts institution.

It was chartered in April 1892, when a group of determined women led by Mrs. Charles Scheuber began rallying support for the arts in Fort Worth. This was at a time in the life of the city when electricity had been available for only seven years, and the police force had been around for only five. The Fort Worth Public Library and Art Gallery Association moved to Fort Worth's new Carnegie Public Library in 1901 and three years later purchased *Approaching Storm* (1875), by George Inness, the first in a long history of thoughtful acquisitions. The organization became known as the Fort Worth Museum of Art and later by other names, enough to warrant an entire page of the museum's Web site tracing the evolution of the institution's name. In 1946 citizens approved a $500,000 bond issue for the museum's first real home, to be constructed at Montgomery and West Lancaster on a city-owned site. A professional director was hired in 1951, and the museum opened to the public in 1954. (It was joined in Fort Worth's Cultural District by the Amon Carter Museum seven years later and by the Kimbell Art Museum in 1972.)

In the sixties, O'Neil Ford and Associates designed an addition for the original Herbert Bayer building, doubling the interior spaces and modifying the façade and entry court.

Thirty years later, the board, under the leadership of Anne Marion Tandy, decided that the museum deserved an even bigger building, one that would garner more attention from Fort Worth audiences and from those outside the area. Six international architects were invited to submit proposals for the new museum, to be constructed on a nearly eleven-acre plot of land purchased by the Burnett Foundation and across the street from the Kimbell, a twentieth-century architectural icon. The challenge was to acknowledge Louis Kahn's masterpiece but not to be overshadowed by it. The proposals were unveiled in 1997 and exhibited in the museum galleries. Tadao Ando was the board's unanimous choice. A native of Osaka, Ando has been awarded numerous international prizes for architecture, including the Pritzker Prize. But perhaps more important, he is an avowed fan of Kahn's work. Ando's building, with its Kahn-inspired vocabulary of materials and aesthetic reserve, nods respectfully to its smaller neighbor while at the same time setting a new standard for museum design. From certain vantage points the concrete-and-glass edifice appears to float above a man-made pond. The 153,000-square-foot building is second only to the New York Museum of Modern Art in the amount of gallery space (53,000 square feet) dedicated to Modern and contemporary works of art. Courtyard sculpture gardens and interior galleries are housed in three forty-foot-high rectangular pavilions. Some gallery spaces have twenty-foot ceilings and others have forty-foot ceilings; some are intimate and others expansive. Together they provide curators with a great deal of flexibility and visitors with an architectural environment as stimulating as the collections and the exhibition program.

HELPFUL HINTS

Café Modern offers indoor and outdoor dining overlooking the reflecting pond. The MAMFW is large, and the Cultural District is filled with other aesthetic possibilities as well. It will take several days to see it all, and several visits a year to keep up with changing exhibitions.

Modern Art Museum of Fort Worth (exterior—night view), Tadao Ando, architect. Photo by David Woo.

Andy Warhol: Self-Portrait, 1986, synthetic polymer paint and silkscreen ink on canvas, 108" x 108". Collection of the Modern Art Museum of Fort Worth, Museum Purchase, The Friends of Art Endowment Fund. © 2004 Andy Warhol Foundation for the Visual Arts/Artists Rights Society (ARS), New York.

*"Asked about the audience for his art,
[Frederic] Remington replied in 1903,
'Boys—boys between twelve and seventy.'"*

—SID RICHARDSON COLLECTION BROCHURE[9]

SID RICHARDSON COLLECTION OF WESTERN ART

309 Main, Fort Worth 76102
817-332-6554 or 888-332-6554
www.sidrmuseum.org

Fine arts museum

The Sid Richardson Collection, a project of the Sid Richardson Foundation, was created to make available to the public the late oilman's collection of Western art, primarily paintings by Frederic Remington and Charles M. Russell, and to create educational programs to enhance the viewer's experience.

Tue.–Fri., 10 a.m.–5 p.m. (Thu. and Fri. till 8 p.m.), Sat. 11 a.m.–8 p.m., Sun. 1 p.m.–5 p.m.

Free

Museum shop

DETAILS

Sid Richardson built his collection of Western art in the forties and fifties with the help of Bertram Newhouse, president of a New York City gallery, but it is first and foremost a reflection of the collector's love of ranching, horses, and all things Western. These pictures reminded him not only of his roots in Athens, Texas, where he was born in 1891, but also of the ranches and horses he later bought in Texas and Oklahoma after striking it rich in the oil business. "I get a kick out of seein' 'em around me," he said of the works. By the time he died in 1959, art filled the walls of his office, his Fort Worth Club suite, and his home on San José Island.

Richardson, who never married, left more than one hundred paintings and sculptures, including more than fifty works by Frederic Remington and Charles M. Russell, to the Sid Richardson Foundation, which he had established in 1947 to benefit the people of Texas, particularly in the areas of education, health, human services, and the arts and humanities. As foundation trustees, Richardson's nephew Perry Bass and Bass's sons envisioned creating a small museum devoted to sharing the collection with the public. The collection now complements their efforts to revitalize downtown Fort Worth. In 1982 nearly sixty of Richardson's works were installed in a small, two-room, street-level gallery in Sundance Square, a newly rehabilitated area of downtown Fort Worth filled with turn-of-the-century buildings and restored façades fronting new interiors. The museum's modest storefront entrance is a quick walk from the new Bass Performance Hall, numerous eateries, easy parking, office buildings, and hotels. It is a prime location for attracting walk-in visitors as well as accommodating tourists who have come specifically to see the art.

According to the museum's first and only director, Jan Brenneman, many of the visitors to the museum come to Fort Worth specifically to see "Charlie" Russell's work. From her small office in the gallery, she is easily drawn into conversation about both Russell and Remington. She watches as replicas of their work and other related materials nearly fly out of the small museum shop, which claims the highest revenue per square foot in the downtown area.

The Scout by Charles M. Russell, 1907, pencil, watercolor, and gouache on paper. Courtesy Sid Richardson Collection of Western Art, Fort Worth, Texas.

The artistic strengths of the small collection are the late works or "nocturnes" by Remington and the early Russells. Two of the nocturnes were loaned to the National Gallery in Washington, D.C., for an exhibition of Remington's work. The strength of the facility lies in its intimate nature, clear focus, and accessibility to walk-in traffic. Its weakness is its static quality. Fewer than half a dozen works have been added to the collection since Richardson's death, and almost no changes have been made in the installation of the work or the space itself. As a rule, the Richardson Collection does not exchange work with other museums (the National Gallery was an exception). But changes are afoot: The gallery has made plans to close for as long as a year for renovations.

HELPFUL HINTS

Because of the uncertain start date for renovations, call for information before heading out to visit the collection. The museum shop will continue on-line even while the museum is closed. Russell and Remington fans can also find the artists' works on display at the Amon Carter Museum in the Cultural Arts District.

IRVING ARTS CENTER

3333 N. MacArthur Blvd., Suite 300, Irving 75602
972-252-7558 or Metro 972-256-4270
www.ci.irving.tx.us

Municipal arts center

The Irving Arts Center presents a varied program of art exhibitions in multiple interior galleries and an outdoor sculpture park. These include the work of local students and arts groups as well as established artists from throughout the United States.

Mon.–Fri. 9 a.m.–5 p.m. (Thu. till 8 p.m.), Sat. 10 a.m.–5 p.m., Sun. 1 p.m.–5 p.m.

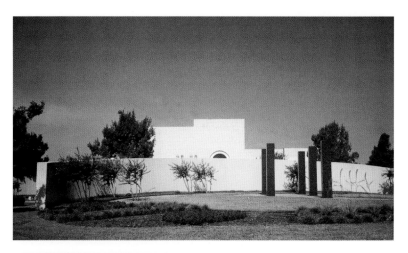

Top: Irving Arts Center (exterior)
Bottom: *Fountain Columns* by Jesús Bautista Moroles, 1998, Dakota mahogany granite, each 10' x 20" x 20"

DETAILS

The IAC offers an incredibly ambitious schedule of changing exhibitions—more than thirty a year. These have ranged from artwork by local students to a collaborative sculptural dialogue between Austin artists Jill Bedgood and Beverly Penn, and solo exhibitions by Mel Chin and Celia Alvarez Muñoz. Group shows have included the annual African American History Month Exhibition presented by the Irving Black Arts Council and an annual exhibition of flowers and paintings by the Association of Oriental Art. The center commissioned Jesús Bautista Moroles of Rockport to create five ten-foot granite columns with water cascading softly over them, and limestone benches by another Texas sculptor, Michael Manjarris, are also featured.

The 64,000-square-foot arts center includes two theaters with lobbies that serve as exhibition spaces, as well as the 4,500-square-foot Main Gallery, the much smaller New Talent Gallery, and a two-acre sculpture garden. The center was built by the city on land donated by the Carpenter family (developers of Las Colinas) and opened in 1990.

HELPFUL HINTS

The sheer volume of work shown at the Irving Arts Center almost always guarantees something for everyone's taste. Visitors to the area should also plan to visit the Haggerty Gallery at the University of Dallas.

*"I do not believe that architecture
should speak too much. . . .
It should remain silent and let nature
in the guise of sunlight and wind speak."*

—TADAO ANDO, ARCHITECT[10]

UNIVERSITY OF DALLAS HAGGERTY GALLERY

Art History Building, Irving 75062
972-721-5087
www.udallas.edu (university site)

University gallery

The Haggerty Gallery exhibits challenging work by emerging and established contemporary artists of the region.

Mon.–Fri. 7 a.m.–5 p.m., Sat.–Sun. noon–5 p.m. Closed summers.

Free

Persons with disabilities who need special assistance are advised to call 972-721-5000 three days before their visit and ask for the ADA coordinator.

DETAILS

With a modest budget and a staff of one, the Haggerty Gallery presents six challenging exhibitions a year by established regional artists. (These do not include faculty and student shows, which take place in the Upper Gallery in the painting and printmaking building.) Site-specific installations and idea-based pairings of statewide artists predominate. A 2002 Haggerty Gallery exhibition titled "Slide" featured works using digital imaging by Dallas artists Scott Barber, Brian Fridge, Jin-ya Huang, Ted Kincaid, and John Pomara. The gallery's first 2003 exhibit, "Upwards," included works by seven artists from throughout the state who combine an interest in industrial materials with attention to the painted surface. The biennial University of Dallas National Print Invitational, which is spearheaded by art faculty member Juergen Strunk, is also presented in the Haggerty Gallery.

The gallery is located in the Haggerty Arts Village, a cluster of buildings on the edge of the sprawling University of Dallas campus that are devoted to the study of art and art history. The notion of creating the arts complex originated with O'Neil Ford forty years ago and with donors Patrick E. Haggerty (now deceased) and his wife, Beatrice. Ford, who also has since died, designed the first building in 1960. The architectural firm Landry and Landry made additions in 1965 and 1975, but it was fully realized only recently, revived by university president Father Monsignor Milam Joseph. Gary Cunningham, of Cunningham Architects, designed the new copper-clad multiuse building that houses the Haggerty Gallery, and also individual studio buildings for sculpture, ceramics, painting, and so on. They are all situated in a bucolic, tree-shrouded area at the edge of campus with bridges and paths linking one to another.

The new space measures forty-two feet by forty-three feet, with high ceilings and track lighting, movable interior walls, and concrete floors. It is a fine space for presenting contemporary art objects and installations but somewhat less easily accessible than when it was located in the student center and known as the Haggar Gallery.

HELPFUL HINTS

The sprawling University of Dallas campus is located at 1845 E. Northgate Drive, Irving 75062. The Art History Building, distinctively clad in copper, stands at the corner of Gorman Drive and Haggar Circle. There are a number of parking lots within walking distance of the gallery. The university's Web site will help direct visitors, but even without it, the Arts Village buildings are easy to distinguish from the rest. Let your instincts guide you.

BIBLICAL ARTS CENTER

7500 Park Lane, Dallas 75225
214-691-4661
www.biblicalarts.org

The Biblical Arts Center building was literally built around a monumental mural titled *Miracle at Pentecost* by artist Torger Thompson. Visitors must pay to see the painting and the accompanying sound and light show, which presents the biblical narrative that inspired it. Access is free to other galleries presenting selections from the collection, changing exhibitions, and life-size dioramas.

ALSO OF INTEREST

CITY OF DALLAS CULTURAL CENTERS

THE BATH HOUSE
512 E. Lawther Dr., Dallas 75218
214-670-8749
www.bathhousecultural.com

THE ICE HOUSE
1000 W. Page, Dallas 75208
214-670-7524
www.dallasculture.org/icehouse

SOUTH DALLAS CULTURAL CENTER
3400 S. Fitzhugh, Dallas 75210
214-939-2787
www.dallasculture.org/sdcc

The City of Dallas Office of Cultural Affairs operates a number of neighborhood cultural centers where programming includes art exhibitions and other community-based activities.

WILLIAM AND ELIZABETH HAYDEN MUSEUM OF AMERICAN ART

930 Cardinal Lane, Paris 75460
903-785-1925

PLAZA GALLERY

8 West Plaza, Paris 75460
903-737-9699

Paris is well north of the Dallas/Fort Worth Metroplex, but for those who might be traveling in the area, the Hayden Museum features the private collections of Dr. and Mrs. William Hayden. Open by appointment, the museum building and restored hundred-year-old Victorian house together exhibit art, antiques, period furniture, and memorabilia. The Plaza Gallery, another Hayden project, is dedicated to the exhibition and sale of work by Lamar County artists.

EAST TEXAS

EAST TEXAS IS KNOWN FOR ITS PICTURESQUE PINEY Woods, not for its picture galleries. There are, admittedly, no art museums in this part of the state that enjoy national prominence (although Texas A&M University's Forsyth Center Galleries have a distinguished collection of English cameo glass). But the smaller museums in this region do play a critical role in galvanizing local communities, educating children, renewing urban landscapes, and providing a link with the cultural experiences available in Dallas, Houston, San Antonio, New York City, and beyond. They are museums that nurture and inform local audiences and also create cultural tourists who travel outside the region seeking to see and learn more.

Some of the galleries listed in this section were created by universities to expose students to original works of art by established artists and to display their collections. The rest developed primarily through the efforts of energetic women, some of them members of the Junior League or its precursor organizations, who were determined to create cultural oases in their respective communities.

Initial interest in the visual arts commenced in 1952 when the Tyler Service League's "Picture Ladies" began showing prints of famous artworks to children in local schools. They also created an art center in a building purchased for that purpose and finally, in 1971, established the Tyler Museum of Art on the Tyler Junior College campus. (The museum is not affiliated with the college.)

In nearby Longview in the late 1950s, Junior League members interested in the arts consulted with Dallas Museum of Fine Arts director Jerry Bywaters. He suggested that they invite art museum directors and curators from around the state to jury annual exhibitions in the local library. The league followed his

recommendation, awarded prizes, and bought one work from each show. Their choices now form the basis of the collections at the Longview Museum of Fine Arts, chartered in 1970. The museum moved to its current home, a renovated retail space, in 1998.

In Lufkin, a group of women saved a burned-out Episcopal church across from the civic center from being razed and turned into a parking lot. They transformed it instead into the Lufkin History and Art Museum, which opened in 1976 as a bicentennial gift to the city. It was renamed the Museum of East Texas in the mid-eighties, and a substantial addition to the building opened to the public in 1990.

And finally, the Leo Michelson Collection came to Marshall in the mid-eighties as the result of an introduction made by native daughter and former resident Wendy Reves. She advised her friend Janine Michelson, of Paris and New York, to give her late husband's Post-Impressionist paintings—nearly 1,000 in all—to Marshall. These objects came with the stipulation that the town create a space to exhibit them. The resulting museum was initially known as the Michelson-Reves Museum.

The two other destinations listed in this chapter, College Station and Nacogdoches, have university galleries that serve not only students and faculty but also the larger community. Since 1992 Texas A&M University has maintained three distinct galleries in the Memorial Student Center on campus: the Forsyth Center Galleries, the J. Wayne Stark Galleries, and the MSC Visual Arts Gallery. Stephen F. Austin University in Nacogdoches offers the Griffith Gallery in the Griffith Fine Arts Building and a second, larger and more accessible space, the Art Center, in a historic downtown building. In fact, almost every college or university

with an art department (there are others in the region) maintains an exhibition gallery to present student and faculty work. Texas A&M deserves attention here for its collections and Stephen F. Austin for its efforts to reach beyond the campus audience to promote community interest in and access to exhibitions and programs.

(While Beaumont and Orange are also undeniably part of East Texas, they are listed in Chapter 3, "Upper Gulf Coast.")

*"In the art world,
all names are written in pencil."*

—FRANCESCO BONAMI, CURATOR,
MUSEUM OF CONTEMPORARY ART, CHICAGO[1]

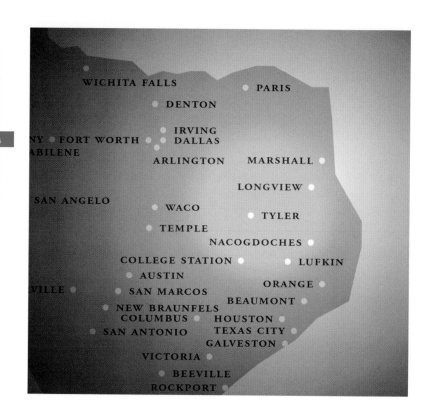

COLLEGE STATION
MEMORIAL STUDENT CENTER GALLERIES
 AT TEXAS A&M UNIVERSITY

LONGVIEW
LONGVIEW MUSEUM OF FINE ARTS

LUFKIN
MUSEUM OF EAST TEXAS

MARSHALL
MICHELSON MUSEUM OF ART

NACOGDOCHES
STEPHEN F. AUSTIN UNIVERSITY GALLERIES

TYLER
TYLER MUSEUM OF ART

MEMORIAL STUDENT CENTER GALLERIES

Memorial Student Center
Texas A&M University, College Station (on Joe Routt Blvd. opposite Kyle Field)

University galleries

Three art galleries are located within the Memorial Student Center at Texas A&M University. One features student work and exhibits selected by a student committee, while the other two present university collections and changing exhibits.

MSC Forsyth Center Galleries
979-845-9251 • http://forsyth.tamu.edu
Mon.–Fri. 9 a.m.–8 p.m., Sat.–Sun. noon–6 p.m. • Free

J. Wayne Stark Galleries
979-845-6081 • http://stark.tamu.edu
Tue.–Fri. 9 a.m.–8 p.m., Sat.–Sun. noon–6 p.m. • Free

MSC Visual Arts Gallery (second floor)
979-845-9251 • http://vac.tamu.edu
Mon.–Fri. 9 a.m.–8 p.m., Sat.–Sun. noon–6 p.m. • Free

Top: Flower-form vase (full view), Tiffany, ca. 1900, 13¹³⁄₁₆". Bill and Irma Runyon Art Collections, Texas A&M Foundation, MSC Forsyth Center Galleries, Texas A&M University, College Station.
Bottom: *Boats in Harbor* by Maurice Prendergast, ca. 1918, oil on canvas, 24" x 25" unframed. Bill and Irma Runyon Art Collections, Texas A&M Foundation, MSC Forsyth Center Galleries, Texas A&M University, College Station.

DETAILS

The MSC Visual Arts Gallery is the oldest of the three Memorial Student Center Galleries, having been organized fifty years ago by the center's founding director, J. Wayne Stark, to encourage the integration of the visual arts into the everyday lives of students. One exhibit a year is devoted to student work, and the rest involve emerging and established artists selected by the thirty-member Visual Arts Committee. The VAC offers students practical experience in selecting and caring for art and brings an interesting array of contemporary exhibits to the center. (The other galleries avoid one-person exhibitions by living artists.) Artists featured during the past several years have included John Cunningham, Dmitri Koustov, Jane Miller, and Bill Wright.

In 1986 the MSC Forsyth Center Galleries were created in the former alumni center to house the Bill and Irma Runyon Art Collections—1,200 pieces of Tiffany, Steuben, and Mt. Washington glass and an especially fine selection of English cameo glass. The collection also includes 66 paintings, with representative works by Mary Cassatt, Childe Hassam, and Robert Henri and Taos school artists. A separate collection of French glass is on long-term loan to the university, and a number of cut-glass works are also on display. Changing exhibitions are presented, and occasionally the gallery hosts recitals, receptions, and concerts that make use of the 1922 Mason and Hamlin nine-foot concert grand piano, a permanent fixture in the space.

The J. Wayne Stark Galleries, the largest and newest of the three, opened in 1992 as part of an expansion of the student center. The Stark hosts twelve to fourteen shows per year, changing every six to eight weeks. The offerings may include traditional fine arts as well as exhibits that focus on architecture, history, or anthropology. Exhibitions in 2003 included ultrarealistic sculptures by Milwaukee artist Marc Sijan, contemporary Native American works from the Heard Museum, and the A&M College of Architecture's Biennial Exhibit. Excerpts from the university's collection, primarily American figurative works by regional artists, are also shown in the Stark Galleries from time to time, including work by John Biggers, Thomas Hill, Julian Onderdonk, and E. M. Schiwetz. With several discrete, high-ceilinged galleries, the Stark can present multiple exhibitions simultaneously. The facility is sited so that students can enter directly from an outside courtyard or through an ample student lounge inside the center.

Mother in a Large Hat Holding Her Nude Baby, Seen in Back View by Mary Cassatt, ca. 1909, oil on canvas, 31⅜" x 25" unframed. Bill and Irma Runyon Art Collections, Texas A&M Foundation, MSC Forsyth Center Galleries, Texas A&M University, College Station.

It may be tempting to feel sorry for the MSC Galleries, sharing space with snack bars and a university bookstore, bereft of the solemnity that a freestanding art museum can offer. Then again, the thousands of students and visitors who swirl past gallery doors and window walls seven days a week may well boost attendance at Texas A&M University's art spaces to outpace that of other university galleries.

HELPFUL HINTS

Visitors will also find a collection of contemporary art in the center's hallways, much of it donated by the Class of '85 and located on the second floor near the MSC Gallery. Nearly every year, class representatives select one Texas-born or Texas-based artist's work (Malou Flato, Bill Wiman, and others) to add to the collection. "A Self-Guided Sculpture Walking Tour" brochure is available. While you're here, visit the Cushing Memorial Library to see its collection of German genre paintings and Western illustrators.

Parking, at $1 an hour, is available in a garage on Joe Routt Boulevard, a short walk from the student center.

LONGVIEW MUSEUM OF FINE ARTS

215 E. Tyler, Longview
903-753-8103
www.lmfa.org

Fine arts museum

The Longview Museum exhibits selections from its permanent collection—most of them regional works selected from an annual juried show—and also presents changing exhibitions.

Tue.–Fri. 10 a.m.–4 p.m., Sat. noon–4 p.m.

Free

Mezzanine offices are not wheelchair accessible.

H ANNUAL INVITATIONAL
WINNERS' EXHIBIT
GREGORY GIOIOSA
TEPHEN DALY • FUTURE AKINS
SEPT. 11 – OCT. 31

Longview Museum of Fine Arts (interior)

DETAILS

A decade before the museum was chartered in 1970, the Junior League of Longview hosted annual juried exhibitions, offering purchase prizes and buying works of art. Today these works, on permanent loan to the museum, form the basis of the collection of roughly three hundred works. Paintings, drawings, prints, photography, and sculptures by contemporary artists working in the Southwest predominate, including Kelly Fearing, Michael Frary, Karl and Charles Umlauf, and Bill Wiman. Many of the artists and jurors, such as Joan Davidow, Jim Harithas, and Marti Mayo, are influential names in the Texas arts scene. Three of the artists whose work appears in the annual juried show are invited back to the museum to present individual exhibitions the following autumn.

The museum purchased, renovated, and moved into its current downtown quarters in January 1998. Local donors not only gave money, they rolled up their sleeves and spent time refurbishing the walls and floors, helping to turn the former Trend Furniture Company into a lively and accommodating space for the display of contemporary art, which is the museum's primary, although not exclusive, focus.

The Wrather (main) Gallery has wood floors, fourteen-foot ceilings painted black, and structural columns that organize (and occasionally restrict) vistas inside the large room. The Garland Proscenium, a raised platform in the center of the gallery, is used to showcase artworks and, occasionally, lecturers and performers. Visitors to the mezzanine offices climb a stairway with an Art Deco–style balustrade, while a ramp compensates for a slight shift in floor height between the main gallery and the Premier Galleries in what was once a second building. A third storefront has been acquired for classrooms.

The accomplishments of the Longview Museum of Fine Arts seem all the more impressive in light of its tiny staff (two paid employees) and relatively small annual budget. Ruth Bernhard and Michael Kenna, internationally renowned photographers, were featured in the January 1998 inaugural exhibit, and each is now represented in the permanent collection, an indication of how far volunteer effort and a good idea can carry a small museum.

HELPFUL HINTS

Street parking is usually available. A same-day visit to the Tyler Museum of Art and the Michelson Museum of Art in Marshall is easy to accomplish.

MUSEUM OF EAST TEXAS

503 N. Second, Lufkin 75901
936-639-4434

Fine arts museum

The Museum of East Texas presents changing exhibitions of contemporary regional art interspersed with historical exhibits and selections from its collections.

Tue.–Fri. 10 a.m.–5 p.m., Sat.–Sun. 1 p.m.–5 p.m.

Free

Museum shop

DETAILS

The Museum of East Texas collections include more than 100,000 photographic prints and negatives of local and regional history. There are also a large number of Charlotte Baker Montgomery prints and drawings documenting area life during the East Texas oil field days and many works by Janet Turner, a local master printmaker. The museum also owns the Latane Temple Collection of Latin American paintings and sculpture and Ben Shahn lithographs, which was given to the museum along with an endowment for exhibitions. In addition, there are period clothes and furniture, carefully cataloged and stored in boxes.

Changing exhibitions in the main galleries always include the presentation of art—most often artists from Texas—and, occasionally, exhibits related to the history of the community. Recent shows have been devoted to works by Vincent Falsetta, Corinne Jones, James Robert Pace, and Ronnie Wells. Exhibitions change every three to five months. During the summer, the best show in the main gallery is the hundreds of local children making art there as part of the museum's summer camp program.

From the beginning, the underlying purpose of the museum was to benefit children. St. Cyprian's Episcopal Church, built in 1906, suffered a fire and was sold to the city to be torn down to make way for additional parking for the civic center across the street. But a group of women from Lufkin's Service League (a precursor to the Junior League) had a different idea. They raised $20,000 to convert the old church into the Lufkin Historical and Creative Arts Center. The proposed parking lot instead became a place to benefit the area's children. The center opened January 19, 1976, a bicentennial gift to the community. It was renamed the Museum of East Texas about ten years later.

The original chapel was turned into a performance space, but the shape of the windows and the steeply pitched ceiling still hint at the structure's roots, even without religious iconography. Nearby, the Discover Room is reserved as a children's gallery combining art and historical exhibitions. The small Rotary Gallery, also in the original portion of the building, is used by the Angelina Photographic Association for photography exhibits.

In 1990 the museum completed an addition designed by Jerry Sutton, of Morgan Hill Sutton and Mitchell Architects in Lufkin. The award-winning design echoes the shape of the old church and its red-brick exterior, although limestone accents and a slate floor mark the new entry. Beyond

Museum of East Texas (exterior), Jerry S. Sutton, architect

the gracious foyer is a framed view of a memorial garden, a small outdoor space waiting for the appropriate piece of sculpture. In the new galleries, located to the left of the entry, are temporary walls—not quite ceiling height—that divide the space for multiple exhibits, permitting natural light to flow throughout. A huge window at the end of the galleries offers a touch of drama and provides a cheerful atmosphere during summer art camp, but limits the wall space for hanging art.

HELPFUL HINTS

If you have trouble finding your way through Lufkin, ask for directions to the civic center—it's the larger landmark. The museum is easy to spot across Second Street, and you can park in the civic center parking lot.

216 N. Bolivar, Marshall 75670
903-935-9480
www.michelsonmuseum.org

Fine arts museum

Originally created to display the work of Latvian-born artist Leo Michelson, the museum now exhibits the Michelson and other collections alongside changing exhibitions.

Tue.–Fri. noon–5 p.m., Sat.–Sun. 1 p.m.–4 p.m.

Free

MICHELSON MUSEUM OF ART

DETAILS

The Michelson Museum hosts approximately four changing exhibitions a year, which may include watercolor shows or one-person exhibitions by living artists. But visitors to the Michelson Museum are always greeted first by one of the numerous museum-owned self-portraits of Leo Michelson, the museum's namesake. More than half of the large front gallery is filled with an assortment of Michelson's drawings and paintings rendered in a fluid, Post-Impressionist manner and rotated on occasion to keep the experience fresh for repeat visitors. Portraits, landscapes, and still lifes predominate. The collection also includes personal items that belonged to the artist and inspired him. Even the artist's ashes, stored in an urn, are housed in the museum (but off limits to the public).

Leo Michelson (1887–1978) was a Latvian-born Jew who lived in Germany, then France, and finally escaped to America in 1940; most of his family was killed during World War II. Beginning in 1948, he and his wife, Janine, divided their time between New York and Paris, where he maintained studios. Their friends included Emery Reves, a wealthy publisher and art collector, and his Marshall-born wife, Wendy, best known in Texas for their gift of art and furnishings to the Dallas Museum of Art. When Leo Michelson died in 1978, Wendy Reves introduced Janine Michelson to her hometown (population 25,000), which offered to create a museum to house the artist's work. After she gave the collection to the town, Mrs. Michelson spent a great deal of time in Marshall, where she died in 1992.

The museum was initially known as the Reves-Michelson Museum. It was established in 1985 and moved in 1992 to its current location on the first floor of a lovely 1928 Romanesque-style building that is owned and still occupied in part by SBC. The museum paid for improvements to the first floor, creating the Dr. David Weisman Hirsch Discovery Room as a hands-on education space for small children, galleries, and administrative spaces.

Today the museum also owns the collection of Bernard Kronenberg, an art patron and ophthalmologist from New York. In 1999 his wife donated one hundred paintings, works on paper, and sculptures—all twentieth-

Left: *Self-portrait* by Leo Michelson, 1937, oil on wood.
Courtesy of the Michelson Museum of Art.
Right: *Redhead in a Crowd* by Leo Michelson, 1931, oil on plywood.
Courtesy of the Michelson Museum of Art.

century American works that complement the Michelson Collection and broaden the experience of museum visitors. Through a family connection in Marshall, the museum also received the Ramona and Jay Ward Collection of African Masks. Ward was the creator of the cartoon *Rocky and Bullwinkle.* Exhibited in the galleries at least once a year, the Ward Collection includes a number of significant pieces.

HELPFUL HINTS

A book titled *City of Life, City of Death: Memories of Riga,* by the artist's nephew Max Michelson, provides wonderful insight into the artist's early life and allows readers to wonder at the twist of fate that brought his legacy to Marshall, Texas. The vibrant Jewish community that once existed in Marshall, which would surely have embraced the artist with particular enthusiasm, had already disappeared by the time the museum was created.

*"Making art is how people
sort through chaos, through life."*

—TONY OURSLER, ARTIST[2]

**STEPHEN F. AUSTIN
UNIVERSITY GALLERIES**

Griffith Gallery
208 Griffith Fine Arts Building
Vista Drive, Stephen F. Austin University, Nacogdoches

The Art Center
329 E. Main, Nacogdoches
936-468-1131
www.art.sfasu.edu

University galleries

The Stephen F. Austin University Galleries exhibit work by established and mid-career artists, including university faculty and alumni.

Tue.–Sun. 12:30 p.m.–5 p.m. Griffith Gallery is also open in the evening when there are performances at Turner Auditorium in the Fine Arts Building.

Free

DETAILS

Griffith Gallery, a modest-sized box of a space in the Fine Arts Building (distinct from the Art Building, which has its own galleries for exhibiting student art), began offering graduate student and alumni shows, faculty exhibitions, regional photography and other exhibits in the mid-eighties. The centerpiece of the gallery's programming soon became the Texas National, an annual art competition and exhibition. For this show, a prominent artist is selected to jury work from slides and to give a lecture on campus before the opening reception. To date, jurors have included Faith Ringgold, Sandy Skoglund, Doug and Mike Starn, Donald Sultan, and Texas' own Art Guys. It is hard to imagine how the first juror, internationally acclaimed Leon Golub, must have responded when he arrived to find the tiny Griffith Gallery crammed full of the art he'd selected.

An opportunity for the gallery to expand presented itself when the city's 1888 Opera House building downtown was donated to the SFA Real Estate Foundation, a university-related nonprofit entity. The foundation leased the nearly 10,000-square-foot building (with roughly three times the gallery space as the Griffith Gallery) to the university, contingent on the gallery's ability to raise $4 million to renovate and create an operating endowment that would pay for a curator of education and an administrative assistant. Plans are in place to complete renovations in 2004 if the fund-raising is successful.

Programming has already begun at the Art Center, as the new downtown space has been named, with exhibitions that range from the Texas National competition to watercolor shows, high school art exhibits, and theme shows such as the "Art of Wood Joinery." Smaller exhibitions such as alumni shows continue to be presented at the Griffith Gallery on campus.

HELPFUL HINTS

Additional art department galleries reserved for student work are located in the Art Building on Wilson Drive.

TYLER MUSEUM OF ART

1300 S. Mahon, Tyler 75701
903-595-1001
www.tylermuseum.org

Fine arts museum

The Tyler Museum of Art presents a varied assortment of
temporary exhibitions and collects and exhibits work by
emerging and established regional artists.

Tue.–Sat. 10 a.m.–5 p.m., Sun. 1 p.m.–5 p.m.

Free (suggested donation adults $3.50, seniors and children
$1.50). Special exhibition fees on occasion.

Top: Tyler Museum of Art (exterior)
Bottom: *Swamp Ritual* by Clyde Connell, 1971, mixed media. Gift from
Atlantic Richfield Company, Dallas, Texas. Courtesy of Tyler Museum of Art.

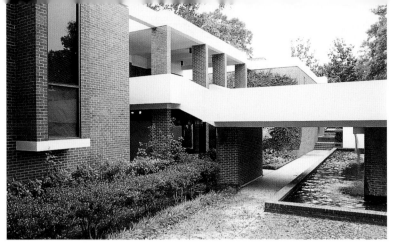

DETAILS

Artists such as Terry Allen, Clyde Connell, Vernon Fisher, Robert Kipniss, Celia Muñoz, James Surls, and Charles Umlauf are represented in the Tyler Museum's collection, which numbers approximately 500 objects, most of them works on paper. The museum's exhibition policy, on the other hand, has expanded to include everything from sixteenth- and seventeenth-century Japanese folding screens, eighteenth- and nineteenth-century British teapots from the Norwich Castle Museum in England, and nineteenth-century cloisonné to a silkscreen series by Jacob Lawrence and a solo exhibition of paintings by Austin-based Sydney Yeager. The museum has also exhibited work from contemporary artists Jun Kaneko (ceramic objects) and Dale Chihuly (glassworks).

There are two distinct 2,000-square-foot, high-ceilinged galleries on the first floor and a more intimate 1,000-square-foot gallery upstairs. Recent additions to the permanent collection and small hands-on exhibits for children spill out into the wide second-floor hallway, a quiet echo of the days when the Tyler Service League's so-called Picture Ladies took art prints to fifth- and sixth-grade classrooms around town and talked about the artists and their work. It was the league's Community Arts Committee whose work led to the formation of an art center in an old home and, finally, to raising funds to build the museum.

The current building was completed in 1971. Designed by the local firm E. Davis Wilcox and Associates and located on the Tyler Junior College campus, the impressive two-story modern brick edifice with tall trees all around has a fountain in front and a grand exterior staircase that is no longer used. The primary entrance has been sensibly shifted to the ground floor.

HELPFUL HINTS

Unlike many museums located on campuses, the Tyler Museum is easy to find and has a small nearby parking lot for visitors.

THIS CHAPTER IS ABOUT HOUSTON AND ART
destinations that are an easy day trip from the center of the
largest city in Texas. The area is filled with art museums,
art centers, university galleries, and an assortment of quirky
institutions that are unique in the state and perhaps in the
world. The Museum of Fine Arts, Houston recently celebrated
its centennial with the opening of yet another building, and Art
League Houston and the Contemporary Arts Museum have been
around for fifty years. Most of the others have grown up over
the past twenty to thirty years, part of the national trend toward
creating alternative spaces and multidisciplinary arts centers to
supplement or circumvent established institutions. Two very
promising new spaces, the Houston Center for Contemporary
Craft and the Station, have opened since preparation for this
guidebook began in 2000. And although there is no discussion
here of the city's vibrant commercial gallery scene or FotoFest,
one of the most prestigious biennial citywide photography
extravaganzas in the country, they too deserve a visit.

Even without the commercial galleries, however, it could
take several weeks to visit every art venue listed in this section,
several days just to observe all that the Museum of Fine Arts,
Houston has to offer. In addition to the encyclopedic collections
and changing exhibitions at the Caroline Wiess Law and Audrey
Jones Beck buildings, there are the Lillie and Hugh Roy Cullen
Sculpture Garden across the street and the Glassell School of
Art, which has its own tiny gallery. The Law and Beck buildings
anchor Houston's Museum District, which also includes the
Contemporary Arts Museum, where internationally recognized
artists regularly complement and challenge the MFAH perspective
on the arts. Another entire day should be set aside for a visit to

Bayou Bend and Rienzi, house museums associated with the MFAH, each with its own decorative art collection, paintings, and sculpture.

The Menil Collection and its satellites, including the Cy Twombly Gallery, the Byzantine Fresco Chapel Museum, and Richmond Hall, demand another day or more. In the same neighborhood visitors will find the Rothko Chapel, originally commissioned by John and Dominique de Menil, and the Houston Center for Photography. HCP leases its space from the Menil Foundation, which owns much of the surrounding Montrose neighborhood and uses a number of its little gray bungalows for offices.

The Artcar Museum in the Heights is a unique entity invented and run by James and Ann Harithas and wholly supported by their Ineri Foundation. This quirky little museum collects and exhibits art cars and also presents changing exhibitions of contemporary art. The Station, on the outskirts of Houston's Third Ward, is a recently opened annex to the ACM that presents similarly provocative exhibitions. Near the Station is Project Row Houses, an alternative space that combines community activism with the presentation of artists' projects in a series of renovated row houses.

Houston enjoys a number of alternative spaces and art centers developed through the efforts of area artists. Art League Houston, the oldest, maintains a gallery, studio, and classrooms on Montrose. Compared to other art league galleries around the state, it offers surprisingly adventuresome exhibitions. Lawndale and DiverseWorks, two cutting-edge alternative spaces, exhibit not only Houston artists but others from around the country. The Blaffer Gallery at the University of Houston, the Texas Southern

University Art Museum, and the Rice University Art Gallery all present their own unique perspectives on the arts.

The Galveston Arts Center, an hour's drive, more or less, from Houston's Hobby Airport, maintains an energetic exhibition program that draws on work by artists throughout the state and is famous for assembling at least one solo exhibition annually, which travels throughout Texas and occasionally beyond. Beaumont is home to the Art Museum of Southeast Texas, an attractive facility that also exhibits regional artists and maintains a collection of regional and folk art. The Dishman Art Gallery at Lamar University likewise shows regional works and also maintains a small decorative arts collection. The Art Studio, Inc., a rough-and-ready alternative space, provides emerging artists with a venue for exhibiting their work and audiences with an opportunity to observe careers evolving over time. The Beaumont Art League also maintains an exhibition space.

Perhaps the biggest surprise in the region is the Stark Museum of Art in Orange, Texas, situated along I-10 and closer to Louisiana than to Hobby Airport. Its substantial collections of Western art, Audubon prints, and Steuben glass presented in a Modernist marble-clad building could hold their own in downtown Houston as easily as in downtown Orange.

In Houston, the orange itself is celebrated in one of the oddest and most delightful folk art environments in this country. While it is mentioned here only briefly (in the Also of Interest section) the Orange Show is as likely to entertain and inform as any of the other galleries in the Gulf Coast region.

"I figure we're probably going to be building the audience one person at a time. You know, that's the way you do it. One person at a time."

—TERRI SULTAN, DIRECTOR,
BLAFFER GALLERY, UNIVERSITY OF HOUSTON[1]

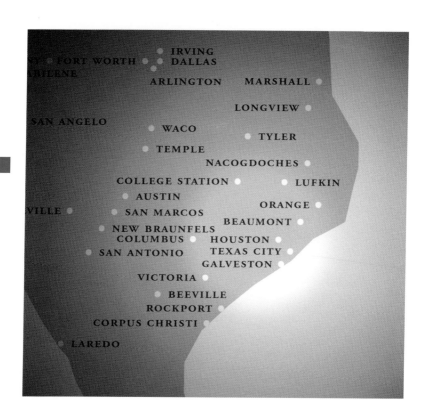

BEAUMONT
ART MUSEUM OF SOUTHEAST TEXAS
THE ART STUDIO, INC.
DISHMAN ART GALLERY

GALVESTON
GALVESTON ARTS CENTER

HOUSTON
ARTCAR MUSEUM
ART LEAGUE HOUSTON
BAYOU BEND COLLECTION AND GARDENS
BLAFFER GALLERY

BYZANTINE FRESCO CHAPEL MUSEUM
CONTEMPORARY ARTS MUSEUM
CY TWOMBLY GALLERY
DIVERSEWORKS
HOUSTON CENTER FOR CONTEMPORARY CRAFT
HOUSTON CENTER FOR PHOTOGRAPHY
LAURA LEE BLANTON GALLERY,
 ALFRED C. GLASSELL SCHOOL OF ART
LAWNDALE ART CENTER
LILLIE AND HUGH ROY CULLEN SCULPTURE GARDEN
MENIL COLLECTION
MUSEUM OF FINE ARTS, HOUSTON
MUSEUM OF PRINTING HISTORY
PROJECT ROW HOUSES
RICE UNIVERSITY ART GALLERY
RICHMOND HALL
RIENZI
ROTHKO CHAPEL
THE STATION
TEXAS SOUTHERN UNIVERSITY MUSEUM

ORANGE
STARK MUSEUM OF ART

Also of Interest

BEAUMONT
BEAUMONT ART LEAGUE

COLUMBUS
LIVE OAK ART CENTER

HOUSTON
HOLOCAUST MUSEUM
JUNG CENTER
ORANGE SHOW

TEXAS CITY
COLLEGE OF THE MAINLAND FINE ARTS GALLERY

ART MUSEUM OF SOUTHEAST TEXAS

500 Main, Beaumont 77701
409-832-3432
www.amset.org

Fine arts museum

Changing exhibitions of work by regional artists are accompanied by selections from the collection, including, among other things, a significant number of objects by untrained folk artists such as X'meah ShaEla'ReEl of Beaumont and the late Felix "Fox" Harris.

Mon.–Fri. 9 a.m.–5 p.m., Sat. 10 a.m.–5 p.m.,
Sun. noon–5 p.m.

Free ($2 suggested donation)

Cafe Arts open Mon.–Fri. 11 a.m.–2 p.m.

Museum shop

Top: Art Museum of Southeast Texas (exterior)
Bottom: *Untitled* by Felix "Fox" Harris, date unknown, found objects and cut metal. Courtesy of Art Museum of Southeast Texas.

DETAILS

The Art Museum of Southeast Texas regularly exhibits works from its permanent collection and presents temporary exhibits featuring artists from throughout the state such as David Bates, Keith Carter, Mark Greenwalt, Mary McCleary, Julie Speed, and (former Texan) John Alexander. The collection also includes nineteenth- and twentieth-century American paintings, prints, sculptures, and decorative art. Its strength is its folk art collection, which includes 130 works by visionary sculptor Felix "Fox" Harris. Most were built and displayed by the artist outside his home and came to the museum in exchange for paying the cost of the artist's funeral. The museum also received more than 200 additional folk objects from the Warren and Sylvia Lowe Collection, and some 600 pieces are on long-term loan from a Dallas collector.

The museum moved to its current location in September 1987. Local architect Lynn Hardin designed the 23,000-square-foot postmodern showcase for art with a distinctive red-brick and white-stucco façade and a porte cochere for rainy day drop-offs. Sculpture is shown on the grounds. The building represented a significant departure from the museum's earlier homes, a historic residence donated by the J. Crooke Wilson family and a small building on the South Texas State Fairgrounds. The Fairground galleries are now occupied by the Beaumont Art League, which continues to present exhibitions there.

HELPFUL HINTS

If you travel to Beaumont looking for art, be sure to also visit the Dishman Art Gallery at Lamar University, the Art Studio, Inc., and perhaps the Beaumont Art League. For a real treat (and surprise) continue east on I-10 to Orange for the Stark Museum of Art.

720 Franklin, Beaumont 77701
409-838-5393
www.artstudio.org

Alternative space

The Art Studio exhibits work by area artists, including those who work in studios on the premises.

Mon.–Fri. 10 a.m.–6 p.m., Sat. by appointment
No exhibitions scheduled in July and August.

Wheelchair access available via a ramp along the back side of the building.

Free

Gift shop

THE ART STUDIO, INC.

DETAILS

The Art Studio, primarily the vision of artist/founder/director Greg Busceme, was established in 1983 to present shows that highlight the work of early- and mid-career artists working in the area. One-person exhibitions, featuring a variety of media, have included Stephen Briscoe (stained glass), Cecelia Johnson (paintings and assemblage), and Prince Thomas (photography). Artists who lease space in the Art Studio warehouse complex also have the opportunity to participate in the annual tenants' show, and members participate in the "holiday shop-o-rama extravaganza." Work by area junior high and senior high students is exhibited in January. While this is not a collecting institution, an assortment of ceramics and books, left to the Art Studio years ago, remains accessible to tenant artists and visitors. The public is invited to attend monthly musical performances and to take art classes taught in studios in the warehouse.

After ten years in its current location, this alternative space retains the determinedly rough and rugged atmosphere of a warehouse. There is no air-conditioning except in the office and kitchen, but that apparently does not concern artists who contribute works for display in the galleries or those who lease studio space upstairs. Visitors may take a different view about this, especially during the warmer months. Plans for expansion are under way.

HELPFUL HINTS

The Art Studio's gift shop sells paintings, handmade jewelry, and ceramics, as well as Studio Blend Coffee. The exhibitions are uneven but regularly include a number of artists whose work has made or one day will make its way into more-polished exhibition spaces. Those seeking a reliable diet of landscapes and portraits may want to check out the Beaumont Art League on the South Texas State Fairgrounds, which also exhibits paintings, works on paper, and sculpture by local artists.

DISHMAN ART GALLERY

Lamar University
E. Lavaca and Martin Luther King, Jr. Parkway, Beaumont 77710
409-880-8141

University gallery

A portion of the Dishman Gallery is reserved for changing exhibitions of student and faculty work and other temporary exhibits. The remainder holds the Eisenstadt Collection of seventeenth- through twentieth-century paintings, porcelains, furniture, and carpets.

Mon.–Fri. 8 a.m.–5 p.m.

Call ahead for tours of the Eisenstadt Collection.

Free

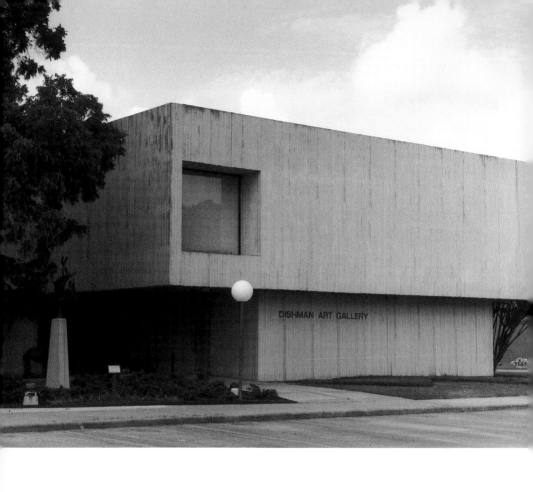

Dishman Art Gallery (exterior)

DETAILS

The Dishman Gallery presents exhibitions by students and faculty, a national juried competition, an exhibit of work by an art department artist-in-residence, a high school scholarship show, and other temporary exhibitions curated by the director, all using the original portion of the building, which was completed in the mid-eighties. At that time the museum's modest-sized collection included tribal art objects, original prints, illustrations, and work by a number of graduates of Lamar University, including John Alexander. Then, in 1992, Heinz and Ruth Eisenstadt, longtime supporters of the university's Friends of the Arts, donated their collection—147 paintings, 252 porcelains, 8 sculptures, a 17-piece German Biedermeier dining room suite (complete with display cabinets and carpets)—representing styles from the seventeenth century to the middle of the twentieth century. After other family members donated additional paintings and porcelains, a museum addition was built to house the collection. Its rooms, used primarily as a teaching tool, are kept locked unless public access is requested.

Local architect Marvin Gordy designed the original 6,000-square-foot building, which the gallery's first director, Lynne Lokensgard, describes as the "Whitney of the Southwest" because of its simple cast-concrete exterior and stained-concrete floors. The exhibition space in it offers high ceilings and natural light. A smaller mezzanine gallery is accessible by elevator or stairs. The addition created for the Eisenstadt Collection, a smaller two-story space, bridges the gallery and art buildings, so the two now abut, but there is no direct interior access from one to the other.

HELPFUL HINTS

The gallery, on the edge of campus, is soon visible after taking the first Lamar University exit from the southbound MLK Parkway. Parking is limited.

GALVESTON ARTS CENTER

2127 The Strand, Galveston 77550
409-763-2403

Art center

The Galveston Arts Center exhibits work in a variety of media, by emerging and established regional artists. Galveston may be an island, but the exhibitions at the GAC are closely tied to contemporary trends throughout Texas.

Winter hours (Labor Day–Memorial Day):
Tue.–Sat. 11 a.m.–5 p.m., Sun. noon–5 p.m.
Summer hours (Memorial Day–Labor Day):
Mon.–Sat. 10 a.m.–5 p.m., Sun. noon–5 p.m.

A small staircase from the street to the front door makes wheelchair access difficult. Inside there is an elevator to the second floor, but bathrooms are not accessible.

Free

Gift shop

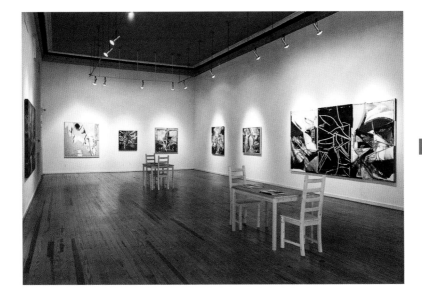

Galveston Arts Center (interior)

DETAILS

The Galveston Arts Center's three galleries together feature roughly two dozen exhibitions a year, including solo and group shows by regional artists at various stages in their careers. These have included painting, sculpture, and drawing shows as well as black-and-white and color photography and sound and video installations. Each of the roughly eight or nine opening receptions annually coincides with a citywide "Art Walk," when nearly a dozen commercial galleries and shops also open their doors for the evening. The center attracts Galvestonians, tourists, and visitors from Houston, as well as curators and other arts professionals. One (or sometimes two) exhibits organized by the GAC each year travel to other art centers and museums throughout the state. These are mid-career survey shows presenting ten to fifteen years of work by a solo artist and accompanied by a catalog assembled by Clint Willour, director of the GAC for more than a decade. Artists featured have included David Bates, Ray Carrington, Lance Letscher, Mary McCleary, Ann Stautberg, Jean Wetta, and Sydney Yeager. Equally accomplished artists participate in other exhibitions, including theme shows specific to Galveston Island, such as "For the Birds," planned to coincide with "birding" season in Galveston, and "Ship Shapes," celebrating the opening of the Seaport Museum. Even the gift shop, near the entry, presents unique handmade works by artists. The shop helps lure tourists into the large main gallery on the first floor and then upstairs into the two smaller spaces.

The Arts Center is located in a 130-year-old bank building purchased by the Junior League in 1970, in what has become a vibrant tourist area with shops, eateries, and ice cream parlors. Three directors preceded Willour, who came from Houston, where he was (and continues to be) a longtime presence on the art scene. While Houston artists are often found on the schedule, the GAC routinely exhibits work by artists from throughout the state.

HELPFUL HINTS

A visit to the Galveston Arts Center, only an hour's drive from Houston's Hobby Airport, is an easy day trip from Houston, and for contemporary art fans, it's one well worth making.

"As the peak of New York's Chrysler Building resembles nothing so much as a stylized cog or hubcap, the roof of Houston's Art Car Museum evokes a Byzantine temple and its silvery carport provides an agora for people to meet beneath the Texas sky and the star of solidarity."

—TEX KERSCHEN, CURATOR, ARTCAR MUSEUM[2]

ARTCAR MUSEUM

140 Heights Blvd., Houston 77007
713-861-5526
www.artcarmuseum.com

Fine arts museum

The Artcar Museum maintains a relaxed and somewhat offbeat attitude toward the fine arts by regularly exhibiting art cars, vehicles that have been modified through the addition of paint and glued-on baubles, beads, water buffalo heads, and the like, as well as art employing somewhat less idiosyncratic media.

Wed.–Sun. 11 a.m.–6 p.m.

Free

Museum shop

Top: Artcar Museum (exterior). Photo courtesy of the Artcar Museum.
Bottom: *Rex Rabbit* by Larry Fuente, Artcar Parade 2000. Photo by Suzanne Paul.

DETAILS

This is not your average art museum. That message is immediately delivered to visitors by the museum's chrome-plated George-Jetson-meets-Mad-Max exterior that thrusts skyward in an otherwise low-profile neighborhood. Art cars are parked in front of the building as if lined up for service, while inside they are presented as objets d'art in the museum's main gallery. In the large back gallery and smaller exhibition cubicles, more-traditional art forms—photography, works on paper, and so on—are exhibited. All works in the galleries, including the cars, are professionally presented and confidently crafted by emerging and mid-career artists, many from the Houston area. It is often art with a message, eager to provoke viewers in unlikely ways.

A long-planned exhibition titled "Secret Wars" opened less than two weeks after New York's twin towers were destroyed on September 11, 2001. During the opening an airport-style metal detector was installed at the front door and set off repeatedly by hundreds of attendees throughout the evening. Shortly thereafter, FBI agents descended on the museum, concerned about Houston artist Tim Glover's less than flattering portrait of the president, Houstonian Lyn Randolph's depiction of an urban skyline on fire, Stephanie Swartz's hazy painting of Osama Bin Laden, and who knows what else. The exhibition catalog, completed long after the opening, provided ACM founder James Harithas and exhibition curator Tex Kerschen an opportunity to respond. "When the government goes to war abroad, the violence at home is intensified," wrote Harithas, who had developed the concept for the show long before 9/11. "Under these conditions, artists become heroes," wrote Kerschen.

These might seem like serious ideas for a museum that grew out of Houston's Artcar Parade. On the other hand, as Harithas wrote in his 1997 "Art Car Manifesto," "All art cars are subversive." Championed by the Orange Show Foundation, the annual parade escalated from a gathering of forty art cars in 1987 to roughly three hundred participants a decade later. Many artists, in fact, traveled great distances to join. Houston artist and art car lover Ann Harithas rolled ahead of the pack with "Swamp Mutha" and "Mona Lupe," classics with Southern and Tex-Mex flair.

Eventually, Ms. Harithas and her husband, James, a former director of Houston's Contemporary Art Museum, turned the attentions of their Ineri Foundation to making these rolling wonders available year-round. Car exhibits rotate from time to time, albeit less frequently than the other art

exhibits. In 2002, the Station, an ACM annex, opened at 1501 Alabama, featuring artists who employ more-traditional supports for their work. The Ineri Foundation is considering establishing other satellite spaces over time.

HELPFUL HINTS

Heights Boulevard is the extension of Waugh Drive—this is critical information if you're not familiar with Houston. Visitors in ordinary cars park on the street.

ART LEAGUE HOUSTON

1953 Montrose Blvd., Houston 77006
713-523-9530
www.artleaguehouston.org

Alternative space

With few exceptions, Art League Houston exhibits work by emerging and established local artists, including students and faculty affiliated with the league's studio art classes.

Tue.–Fri. 9 a.m.–5 p.m., Sat. 11 a.m.–5 p.m.

Free

DETAILS

Unlike most Art League exhibition galleries in the state, which seem to prefer traditional media and figurative images, Art League Houston embraces a more experimental and contemporary point of view. Its six exhibitions a year include the annual (since 1983) solo exhibition for Texas Artist of the Year, an honor conferred by the league on an outstanding established talent. The 2003 recipient was Houston's Virgil Grotfeldt, and previous honorees have included John Biggers, Dorothy Hood, and Luis Jiménez. The Open Show, a juried group exhibition, and the League's Student and Faculty Exhibit also occur annually. The remaining slots are filled by artists (primarily from Houston) who submit proposals that are reviewed by artist board members.

The organization, which began in 1948 when a group of artists banded together to exhibit their work, acquired five lots at the present location between 1969 and 1977. Two of the original buildings remain and are used as classrooms; the current gallery and sculpture court were completed in 1991.

HELPFUL HINTS

Art League Houston is easy to find, and parking is available in a small lot on the property.

BAYOU BEND COLLECTION AND GARDENS

1 Wescott, Houston 77007
713-639-7750
www.mfah.org/bayoubend

Museum of Fine Arts annex—house museum

Bayou Bend, the former home of Ima Hogg, daughter of former Texas governor Jim Hogg, contains her collection of American seventeenth- to mid-nineteenth-century decorative and fine arts. The collection's strength is furniture from urban homes of the early colonial period through the Civil War. Another draw for visitors is Bayou Bend's beautiful fourteen-acre garden setting.

• Guided ninety-minute tours of the entire house begin every fifteen minutes Tue.–Fri. 10 a.m.–11:30 a.m. and 1 p.m.–2:45 p.m., Sat. 10 a.m.–11:15 a.m. Reservations suggested.

• "Best of Bayou Bend" one-hour tours on specialized topics are offered Tue. and Thu. at noon. Reservations required.

Adults $10, seniors over 65 and college students with ID $8.50, children 10 and older (must be accompanied by an adult) $5, minimum age admitted is 10 years

• Self-guided home tours Sat. and Sun. 1 p.m.–5 p.m. (in August only, Tue.–Sat. 10 a.m.–5 p.m.) (last admission 4 p.m.)

Adults $10, seniors over 65 and college students with ID $8.50, children 10–18 $5, children 9 and under $1.50

- Self-guided tours of gardens available Tue.–Sat. 10 a.m.–5 p.m., Sun. 1 p.m.–5 p.m. (last admission 4:30 p.m.)

Adults $3, children 10 and under free

- Family Day, third Sun. Sept.–May 1 p.m.–5 p.m.

Admission free

Primary collections, on the first floor of the house, are wheelchair accessible, but the second floor is not.

Gift shop

DETAILS

Room after room at Bayou Bend is filled with exquisite period furniture grouped according to age and origin and testifying to the discerning eye of collector Ima Hogg. Hogg also amassed a substantial collection of paintings and sculpture over the years by artists such as John Singleton Copley, Edward Hicks, Charles Willson Peale, Gilbert Stuart, and Thomas Sully. She also collected Southwest Native American art and contemporary European works on paper, which are not displayed at Bayou Bend, as well as silver and English ceramics, which are. Excerpts from the collection are also shown at the MFAH's Audrey Jones Beck Building on Bissonnet.

Visitors enter the grounds from the parking lot, crossing over the bayou via a suspension bridge that wiggles just a bit. A small building, once a garage, serves as a gift shop. Bayou Bend's administrative offices used to be located there, but after they were flooded twice, the director of the collection moved back to the MFAH offices downtown, and the curator moved into the upper floor of the house itself. The modified Palladio-style house, finished in 1928, was designed for Hogg and her brothers William and Michael, by John Staub, acclaimed Houston architect. Jim Hogg, Texas' first native-born governor, who served from 1891 to 1895, had three sons

and daughter Ima, who was named after the heroine in a poem written by her paternal uncle. Miss Ima (1882–1975) was a beautiful woman whose intellectual curiosity and philanthropic nature were renowned.

The collection had its origin in her memory of a colonial American chair she'd once seen in passing. That recollection lingered until 1920, when she bought another chair she thought was similar to the first. By the late 1930s, she was collecting seriously, long before it became fashionable to do so, with the idea that she would one day give the objects she acquired to a museum for the benefit of the people of Texas. But in 1954 she was persuaded by fellow collector Henry du Pont that she should instead turn her home into a museum with a garden setting. She gave the house to the Museum of Fine Arts in 1957, but continued to live there for nearly a decade while it was being converted into a public museum.

Hers was a particularly generous gift in that she allowed items she herself had purchased to be moved or removed and others to be added, giving great flexibility to the curator and director. When the museum was ready in 1966, Miss Ima moved into an apartment and Bayou Bend opened to the public. She remained as spry as ever well into old age, dying in her sleep at the age of ninety-three, after a day of shopping at Harrods in London. Her gift to the museum included a small endowment, which has since been augmented.

Personal mementos are for the most part absent from Bayou Bend except for those in one room upstairs. There, visitors will find, among other things, the chair that first caught Miss Ima's eye and the infinitely more beautiful one that was her first purchase.

HELPFUL HINTS

Special seasonal hours are in effect in December, March, and August. Call for information before dropping by. It is interesting to note that the pink sandstone exterior walkways at Bayou Bend came from downtown Houston, which gave them up in favor of modern cement sidewalks. Fresh flowers inside the home are provided regularly by the Garden Club of Houston, which helps maintain and support the gardens.

Top: Bayou Bend Collection and Gardens, dining room, The Museum of Fine Arts, Houston. Photo by Rick Gardner.
Bottom: *Portrait of a Boy* by John Singleton Copley, ca. 1758–1760, oil on canvas. Bayou Bend Collection and Gardens, The Museum of Fine Arts, Houston, gift of Miss Ima Hogg.

"We're always looking for a dialogue,
not a monologue.
We are not about telling people
what they're supposed to think.
What we try to do is provide points of view,
points of entry."

—TERRI SULTAN, DIRECTOR,
BLAFFER GALLERY, UNIVERSITY OF HOUSTON[3]

BLAFFER GALLERY

Art Museum of the University of Houston
120 Fine Arts Building, Houston 77204
713-743-9530

www.blaffergallery.org

University art museum

The Blaffer Gallery presents challenging work by a
national roster of emerging and established artists working
in a variety of media.

Tue.–Fri. 10 a.m.–5 p.m., Sat.–Sun. 1 p.m.–5 p.m. Closed
university holidays.

Free

Museum shop (online only)

DETAILS

The eight to ten exhibitions presented annually at the Blaffer Gallery attempt to challenge and engage audiences on campus and throughout the community and to stimulate dialogue. In other words, the gallery aims for the cutting edge of contemporary practice, providing insight into the artist's process through lectures and publications. In addition to a student show in the fall and an MFA thesis exhibit in the spring, the gallery presents solo shows by artists such as Nancy Burson, Michael Byron, and Donald Lipski and group exhibitions such as "Here & There/Aqui y Alla: Six Artists from San Juan." Area artists are included in the Houston Art Exhibition every four years and occasionally appear in solo exhibitions, but otherwise the Blaffer concedes local and regional shows to other contemporary spaces in town. While this non-collecting university museum does not purchase art, the gallery's "Special Projects" series encourages artists to create new and often experimental work for the galleries. Houston-based Tierney Malone inaugurated the first such project by painting directly on the gallery walls.

It's likely that Malone's work was not what the original donor had in mind. The Sarah Campbell Blaffer Gallery was founded in 1973 and named for the benefactor, who gave the university a collection of major artworks dating from the fifteenth century. Today, the interest derived from income produced by the sale of those works provides a portion of the gallery's program budget. The rest is raised from outside sources.

HELPFUL HINTS

Use campus entrance #16 near the intersection of Cullen and Elgin and search for metered visitor parking spaces in the lot near the Fine Arts Building. The gallery's front door faces an internal courtyard rather than the street, which makes it somewhat difficult to locate.

While you're in the area, you might also consider visiting the Texas Southern University Art Museum, the Station, and Project Row Houses.

Top: Blaffer Gallery (interior), "Seeing and Believing: The Art of Nancy Burson," June 22–September 8, 2002. Photo by Rick Gardner.
Bottom: Blaffer Gallery (interior), "My Favorite Things and Other Rent Party Songs: New and Classic Works" by Tierney Malone, October 27–December 21, 2001. Photo by Rick Gardner.

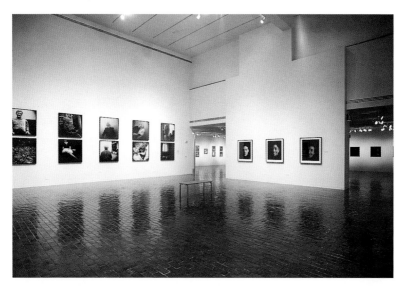

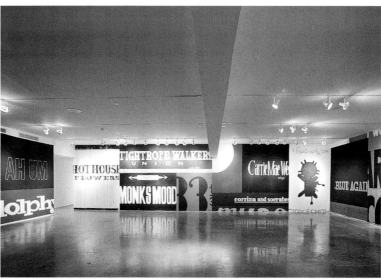

BYZANTINE FRESCO CHAPEL MUSEUM

4011 Yupon, Houston 77006
713-521-3990
www.menil.org/byzantine.html

Menil Collection annex

This chapel/museum was built to contain two rescued and restored thirteenth-century frescoes in a manner respectful of their value both as art and as sacred objects.

Fri.–Sun. 11 a.m.–6 p.m.

Free

DETAILS

The serene and even surreal environment of the Byzantine Chapel, created to house two thirteenth-century frescoes, belies the violence in their recent past, when they were cut apart and smuggled out of Cyprus. It refers instead, albeit in a contemporary setting, to their origins seven hundred years ago as a painted dome and apse in the small stone chapel of Saint Themonianos in the town of Lysi. Now the paintings hang suspended in a "translucent cage, illumined from practically invisible sources," according to *Houston Chronicle* writer Patricia Johnson. Sandblasted glass panels shaped like pointed Gothic arches and framed in black steel shape the inner sanctum of the chapel, where religious services are occasionally conducted. These occur, as they have for centuries, under the watchful eye of Christ Pantokrator and the Virgin Mary, skillfully rendered by an anonymous thirteenth-century artist. Sunlight subtly washes the face of the outer walls of the room. Architect François de Menil created a small sacred alternative universe in an understated building on an otherwise ordinary block in the Montrose area of Houston.

But it was the architect's mother, Dominique de Menil, who saved the frescoes and restored them in preparation for this sacred yet artful setting. In 1983, after the murals were cut from the walls of the Lysi chapel and smuggled out of Cyprus, she was contacted and shown photographs of the frescoes, which were by then in thirty-eight separate pieces. Dominique de Menil and her advisors traveled to Europe on a mission to determine the authenticity of the photos and to ransom the art. Money was paid and the pieces were shipped to London for restoration. Meanwhile, a deal was negotiated with the Cypriot minister of culture and the archbishop of the Church of Cyprus that allowed the church to retain ownership of the frescoes. In exchange, the Menil Foundation paid for the restoration and was afforded the opportunity to house them in Houston for twenty-five years. After that time, their disposition will be subject to renewal.

At first, the Menil curator argued that the frescoes should be displayed with other Byzantine objects in the collection, but Dominique de Menil wished not only to exhibit the frescoes but also to restore their sacred function. The Byzantine Fresco Foundation was created to raise funds to build the chapel, a modern reliquary of sorts, which opened to great acclaim in February 1997.

HELPFUL HINTS

This magical place includes the inner chapel where the frescoes are displayed and also a sacristy for the use of clergy, a small back room where visitors may sit and meditate, a reflecting pool in the front, and a second water feature accessible through a door opposite the main entry.

Pantocrator with Deesis, Lysi, Cyprus, thirteenth century fresco (dome of church), Byzantine. Courtesy Byzantine Fresco Chapel. Photo by Paul Hester.

CONTEMPORARY ARTS MUSEUM

5216 Montrose Blvd., Houston 77006
713-284-8250
www.camh.org

Fine arts museum

The Contemporary Arts Museum, or CAM, as it is best known,
is a non-collecting institution that exhibits the art of our time
by regional, national, and international artists.

Tue.–Sat. 10 a.m.–5 p.m. (Thu. till 9 p.m.), Sun. noon–5 p.m.

Free

Coffee available in the downstairs reading room

Museum shop

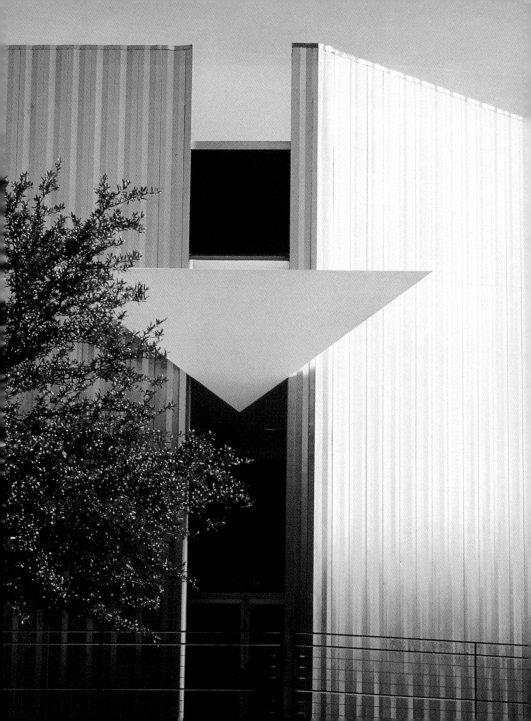

DETAILS

According to *Finders/Keepers,* a catalog detailing the history of the organiza-tion, the Contemporary Arts Association was formed in 1948 "to bring the most recent and revolutionary developments in art to the attention of the city's citizens." After more than five decades, the art museum founded by the association has survived a host of enduring and short-lived "revolution-ary developments," two moves, several floods, and the occasional internal feud to become a professionally run, internationally recognized showcase for art being made today. The CAM regularly brings examples of contemporary artistic practice from around the world to Houston. Exhibitions in 2003 alone included the art of Spanish sculptor Juan Muñoz, New York musician and visual artist Patti Smith, Iran-born video artist Shirin Neshat, and an exhibition titled "Splat Boom Pow! The Influence of Comics in Contempo-rary Art, 1970–2000," originated by the museum staff. With the exception of a few well-intentioned early gifts, which were eventually returned to the donors, this is a museum that has never had a collection.

The entire exhibition history of the CAM is available on the museum Web site. It has evolved over time as various directors have come and gone and as individual arts patrons have become involved with the museum and then turned their energies to alternative institutions. When the first professional director, Jermayne MacAgy, was hired in the mid-fifties, the CAM integrated fine and applied arts Bauhaus style in the galleries. Dur-ing Sebastian J. "Lefty" Adler's term as director, beginning in 1966, the museum made the push to expand physically in order to accommodate the art world's growing inclination toward large-scale work. Gunnar Birkerts, a Latvian-born, German-educated architect, collaborating with the Houston firm of Charles Tapley Associates, was selected to design the current build-ing. According to *Finders/Keepers,* the architect was instructed to provide a "10,000-square-foot uninterrupted warehouse-type space in which every-thing (or nothing) could be accommodated." The resulting metal shed shaped like a giant parallelogram on a concrete pedestal signals its cutting-edge agenda by its very form. The building opened to the public in 1972 and was updated by Houston's William F. Stern and Associates in 1997.

Contemporary Arts Museum (exterior). Courtesy Contemporary Arts Museum, Houston. Photo by Paul Hester.

Adler resigned in 1972 after "Exhibition 10," still remembered in Houston as the "roach show" because of one installation that featured live bugs in the gallery. James Harithas, who arrived in 1974, exhibited a greater number of Texas artists, including Terry Allen, Luis Jiménez, and James Surls. They were shown along with national figures, including John Chamberlain, most of whose CAM exhibit work is now permanently ensconced at the Chinati Foundation in Marfa. Linda Cathcart, director from 1979 to 1987, maintained an interest in regional artists while reaching for an even higher profile, exhibiting nationally recognized artists such as Nancy Graves, Robert Morris, Robert Rauschenberg, and James Rosenquist. Suzanne Delehanty, who followed Cathcart, increased the representation of international artists. Marti Mayo, the current director, continues to balance regional, national, and international exhibitions and to collaborate with other arts groups in Houston while keeping CAM programming in line with the museum's original mission.

HELPFUL HINTS

Spotting the CAM's profile across the street from the Museum of Fine Arts is easy. Finding the front door got easier in 1997 with the addition of a triangular canopy that projects out from the building and marks the entry. But parking in the neighborhood is another matter. The MFAH garage, several blocks away, is convenient to both institutions if you plan to spend an entire day in the area.

On Thursday, Saturday, and Sunday, the FAQ (frequently asked questions) Team of well-trained artists and art historians is stationed in the galleries, ready to offer information and respond to questions. Even the gallery guards are usually prepared to discuss the art or to direct visitors to the small museum shop downstairs, which is filled with interesting and affordable treasures.

CY TWOMBLY GALLERY

1501 Branard, Houston 77006
713-525-9400
www.menil.org/twombly.html

Fine arts museum

The Cy Twombly Gallery, an exhibition annex of the Menil Collection, was developed in collaboration with the Dia Center for the Arts and artist Cy Twombly to house his paintings, sculptures, and drawings.

Wed.–Sun. 11 a.m.–7 p.m.

Free

Gift shop—see Menil Collection

Left: Cy Twombly Gallery (exterior view--detail of roof). Courtesy of The Menil Collection, Houston. Photo by Hickey-Robertson, Houston.
Right: *Thermopylae* by Cy Twombly, 1991, bronze with patina, edition 3/3. Cy Twombly Gallery, The Menil Collection, Houston. Gift of the artist. Photo by Hickey-Robertson, Houston.

DETAILS

More than thirty of Cy Twombly's paintings, sculptures, and works on paper dating from 1953 to 1994 are permanently installed in the Cy Twombly Gallery. Among these are a number of masterworks such as *The Age of Alexander, Triumph of Galatea,* and the monumental *Untitled (Say Goodbye Catullus, to the Shores of Asia Minor),* completed in 1994.

The gallery, a collaboration between the Menil Foundation and the Dia Foundation, opened in February 1995, across the street from the Menil Collection. It houses only Twombly's works, a number of which were given by the artist himself.

Dominique and John de Menil did not collect Twombly's art, preferring contemporaries Jasper Johns and Robert Rauschenberg. The impetus for this one-artist pavilion came, rather, from their daughter, Philippa, who with her husband, Heiner Friedrich, had been instrumental in founding the Dia Foundation. The creation of a discrete showcase for one artist's work was, however, certainly not unfamiliar to the de Menils. The Rothko Chapel and Richmond Hall, projects that Mr. and Mrs. de Menil initiated, are each devoted to one artist's work.

The Twombly Gallery was designed by Renzo Piano, architect for the Menil Collection building. Once again his ability to manage and manipulate Houston's intense sunlight and simple yet elegant sensibility and style is evident.

HELPFUL HINTS

The Twombly Gallery is conveniently located across Branard Street from the Menil Collection. For those who know the artist's work, the installation offers a surprisingly fresh context for his familiar calligraphic squiggles and also includes less familiar works.

DIVERSEWORKS

1117 East Freeway (I-10 at N. Main), Houston 77002
713-223-8346
www.diverseworks.org

Multidisciplinary alternative space

DiverseWorks exhibits new and experimental works by national
and international artists in the Main Gallery and provides
opportunities for emerging artists in the smaller Projects Space.
It also presents performing and literary arts projects.

Wed.–Sat. noon–6 p.m.

Free

DiverseWorks (interior)

DETAILS

Visitors enter directly into the DiverseWorks Projects Space, which is devoted primarily to exhibits of work by emerging artists. These ten to twelve solo and group exhibitions presented annually are curated by individual members of the Artist Board and offer an opportunity for visitors to see fresh work by young artists. They also offer artists on the board a chance to hone their curatorial skills.

The larger (3,000 square feet) Main Gallery is reserved for five exhibitions a year by national and international artists whose proposals are reviewed by the board's Visual Arts Committee. These have included Texas-born, New York–based artist Paul Henry Ramirez and his installation *Elevatious Transcendsualistic,* William Pope.L presenting an exhibition titled "eracism," about the politics of body and race, and the first-ever collaboration among three provocative Chinese artists living in the United States. New York–based artists Zhang Huan and Zhang Jian-jun and Houston's Weihong used the entire site for an installation and performance examining technological advancement, globalization, and the state of human society's rapid change.

If all this sounds somewhat confusing, please note that a trip to the gallery may be equally mystifying for novices to contemporary, experimental, cross-disciplinary, site-specific art. While the DiverseWorks board and curator reliably assemble a nationally recognized program that provides seasoned visual and performing arts audiences with a global perspective, newcomers to new art are left to their own devices. Signage is minimal and no effort is made to provide a staff member or volunteer to greet first-time visitors or to answer questions. This is a place that is primarily by, for, and about artists, arts professionals, collectors, and those who know them well.

DiverseWorks, which marked its twentieth anniversary in the spring of 2003, began like many of the other alternative spaces that grew up across the country during the seventies and eighties. A group of Houston artists decided to convert individual studios to a space where they could show their own work and invite other artists to experiment and exhibit. After a fire, the organization moved to its current location, an old cotton warehouse built in the twenties. With its concrete floor and high, arched ceiling (in the Main Gallery), this is the ultimate new-art flexi-space. Offices are tucked along a corridor behind the galleries, and the space also houses a theater with its

own small foyer to support an equally energetic and cutting-edge performing arts program.

HELPFUL HINTS

Neophytes to the contemporary art scene should not avoid DiverseWorks, but rather should consider bringing along a more experienced companion or doing a bit of research after the fact.

"Museum activity is scholarly activity.
And the curators of your institutions are your scholars.
And the schedule follows the interests of the curators."

164

—MARTI MAYO, DIRECTOR,
CONTEMPORARY ART MUSEUM, HOUSTON[4]

4848 Main, Houston 77002
713-529-4848
www.crafthouston.org

Art center

The Houston Center for Contemporary Craft presents the work
of regional and nationally prominent artists working with clay,
fiber, glass, metal, and wood.

Tue.–Sat. 10 a.m.–5 p.m., Sun. noon–5 p.m.

Gift shop

Free

**HOUSTON CENTER FOR
CONTEMPORARY CRAFT**

DETAILS

The Houston Center for Contemporary Craft made its debut in September 2001 a few months after Tropical Storm Alice devastated the city, less than two weeks after the World Trade Center towers fell in New York, and just prior to the collapse of Enron. Nonetheless, the opening of the first exhibition, "Defining Craft 1: Collecting for the New Millennium," presenting objects derived from the collection of the American Craft Museum in New York, went off without a hitch. Wendell Castle, Robert Arneson, and Faith Ringgold, names well known to those interested in craft media, were among the artists represented. Castle, a nationally venerated furniture maker, attended the opening.

Works in the first-anniversary show "CraftHouston 2002: A Texas Juried Exhibition" were selected by Kenneth R. Trapp of the Smithsonian's Renwick Gallery in Washington, D.C. Exhibits featuring works by individual artists such as William Morris are also included in the course of the four or five shows the HCCC hosts each year. In its short life dedicated to exhibiting museum-quality crafts, the center has already set a high standard and appears to be committed to meeting and even exceeding its goals. Almost immediately it attracted more than two thousand members, kudos from the press, and a steady stream of visitors, even midweek.

The gift shop, known as the Asher Gallery, not only plays an integral role in educating the public about contemporary crafts but helps support artists as well. The shop represents local, regional, and national jewelers, ceramicists, fiber artists, and woodworkers, and sells their work on consignment. It does not sell "how-to" craft books, but instead offers artful tomes featuring contemporary artists working in craft media. Visitors who want to understand even more about the artists' processes are also encouraged to step inside HCCC studios, where they can watch and talk with artists-in-residence at work. Each artist is granted a stipend and studio for three months at a time. Nearby halls are used to exhibit even more original works that are for sale.

The building (formerly a medical supply house), with its sleek metal exterior, soaring eighteen-foot gallery ceilings, and crisp 3,000 square feet of exhibition space, reflects the serious intent and professionalism of its

Top: Houston Center for Contemporary Craft (exterior)
Bottom: Houston Center for Contemporary Craft (interior)

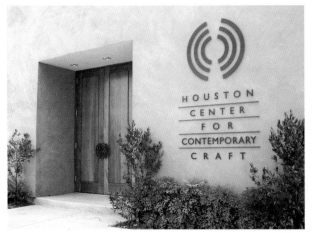

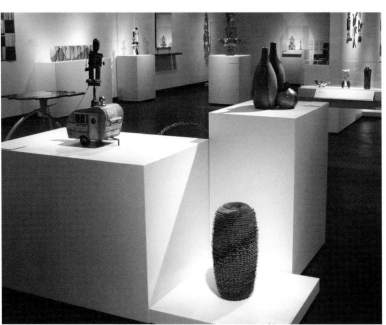

founders. Board president Sara Morgan and her husband, Bill, desired initially to create studio space for artists. Executive director Ann Lancaster, who has a background in both fiber arts and arts administration, worked with the couple, and together they shaped the facility's goals. Integral to their planning was recognition of the overwhelming success of the city's annual International Quilt Festival, which after thirty years remains one of Houston's largest yearly conventions. Eventually, a foundation set up by the Morgans purchased the building and helped fund the start-up. The HCCC, of course, is still a work in progress. It will take time to fully understand and respond to the needs of its audience, expand its search for regional artists, collaborate with other museums and art centers in Houston, and secure its funding base. Even so, the HCCC is already a welcome addition to Houston's Museum District.

HELPFUL HINTS

There is a small parking lot for HCCC visitors on Travis, behind the museum building. Lawndale Art Center, at 4912 Main, is located close enough for visitors to park once and visit both spaces.

"Walking through the [Cullen Sculpture] Garden, I think there is a kind of conversation going on, a very quiet conversation between walls and spaces, people and sculptures."

—ISAMU NOGUCHI, ARTIST[5]

HOUSTON

170

HOUSTON CENTER FOR PHOTOGRAPHY

1441 W. Alabama, Houston 77006
713-529-4755
www.Hcponline.org

Art center

The Houston Center for Photography exhibits work by early- and mid-career photographers from regional, national, and international art communities.

Wed.–Fri. 11 a.m.–6 p.m., Sat.–Sun. noon–5 p.m.
Closed during August.

Free

DETAILS

For more than twenty years the Houston Center for Photography has been exploring and promoting photographic media. Exhibitions have included art and documentary photography, photographic installations, film, and video. Between fourteen and seventeen individual exhibitions are presented annually, up to three at a time, depending on the size of each show. These include the Juried Membership Exhibition, the HCP Fellowship Exhibition, and the Annual Print Auction. Exhibitions also feature works by individual photographers and theme-based group shows.

The organization began in 1981 with a nudge from Anne W. Tucker, curator of photography at the Museum of Fine Arts, Houston. It became a nonprofit the following year, one that nurtures the photographic medium itself by providing a forum for experimentation and discussion, three annual fellowships to photographers, and exhibition opportunities. HCP benefits, in turn, from the support of artists such as Suzanne Bloom, Peter Brown, Keith Carter, Ed Hill, George Krause, and Prince Thomas, who serve on the board or as ex officio advisors and donate work to the print auction. It also enjoys the participation of colleagues from nearby institutions, including Tucker and Clint Willour, director and curator of the Galveston Arts Center.

HELPFUL HINTS

The HCP is located near the Menil Collection in a space leased from the Menil Foundation. Parking is usually available in front of the building. Be sure to look for the current issue of *SPOT,* a self-described "journal of independent opinions" published twice yearly by HCP. The articles are interesting and, of course, the photographs are terrific.

LAURA LEE BLANTON GALLERY

Alfred C. Glassell School of Art
5101 Montrose Blvd., Houston 77006
713-639-7500
www.mfah.org

Museum of Fine Arts, Houston school

The Laura Lee Blanton Gallery exhibits works by local and Texas mid-career artists, those who have participated in the school's Core Artist-in-Residence Program, and students in the Studio School for Adults.

Mon.–Fri. 9 a.m.–10 p.m., Sat.–Sun. 9 a.m.–5 p.m.

Free

DETAILS

The Alfred C. Glassell School of Art opened its current facility in 1979. The building is located directly across the street from the MFAH's Caroline Wiess Law Building, behind the Cullen Sculpture Garden. The gallery, which consists of a small discrete space and another area that also serves as the passageway between the building's front and back doors, was named in memory of the late Laura Lee Blanton, longtime chair of the school. The gallery hosts four exhibitions a year. Two feature solo shows by mid-career, local, or regional artists, such as Helen Altman and Annette Lawrence. Artists are encouraged to create experimental work that in turn helps encourage and motivate the school's students. Occasionally, artists living outside the area, such as Luca Buvoli and Rubén Ortiz Torres, are invited to exhibit work.

In mid-March, Core Program artists are featured in the galleries. To date, participants in this one-to-two-year artist-in-residence program include some of the hottest young artists working in Texas today—Michael Ray Charles, Trenton Doyle Hancock, and Annette Lawrence, to name a few.

And finally, from mid-May through July the gallery focuses on work by students from the Adult School.

HELPFUL HINTS

Visitors can park in the Glassell School parking lot, which is accessible from Montrose, or they can approach the building on foot through the Cullen Sculpture Garden. Plans in the works for a new gallery will have the added benefit of allowing the current space to be used for student exhibitions. The nearby Junior School also has a gallery that features work by students ages four to eighteen.

LAWNDALE ART CENTER

4912 Main, Houston 77002
713-528-5858
www.lawndaleartcenter.org

Alternative space

Lawndale exhibits contemporary works in all media by artists of the region and beyond, but places a particular focus on those living and working in Houston.

Mon.–Fri. 10 a.m.–5 p.m., Sat. noon–5 p.m.

Free

Mezzanine is not wheelchair accessible.

Lawndale Art Center (exterior)

DETAILS

Lawndale Art Center was originally located on Hillman and Lawndale (thus the name) in the East End near the University of Houston. It was founded in 1979 by members of the university's art faculty as an alternative space to exhibit student work and that of other local talent. Noted Texas artist James Surls was its first director. Today local artists are still the primary focus of exhibitions and programming, although exceptions occur. The January 2003 Main Gallery exhibition illustrates the ties that do and don't bind Lawndale artists to Houston. The three curator/artists met at Rice University as art and architecture students. For Lawndale they collaborated on a hyperactive/interactive installation that combined their various areas of interest and

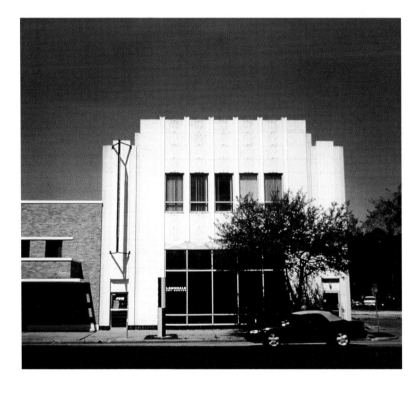

expertise: art, design, pop culture, and mass media. Of the three, only one—Brian Heiss—remains in Houston. Darshan Amrit and Peter Weir Clarke both reside out of the state.

Exhibitions change approximately every six weeks, with individual exhibits programmed in each of the four galleries. On the other hand, two exhibitions—the annual "Big Show," a juried exhibition featuring artists from a hundred-mile radius, and the "Dia de los Muertos/Day of the Dead" show—expand into all the galleries.

Lawndale moved to its current location in the early nineties and purchased the space in 1993. Performance, which had been a component of programming in the original larger space, was all but discontinued. The Main Street building was designed in 1930 by local architect Joseph Finger, who also designed the Houston City Hall. A graphic rendition of the attractive Art Deco façade is featured on the center's Web site. The building was originally created as a design studio but later was home to the Weldon Cafeteria and to Joe and Louie's Nite Club. It has been recently joined in its corner of Houston's Museum District by the Houston Center for Contemporary Craft. Eight studios on the third floor are rented to artists at below-market rates.

A unique annual event at Lawndale is the 20th-Century Modern Market, a weekend-long exhibition and sale by independent vendors of original twentieth-century design items. The "Hair Ball," the organization's once-famous annual fund-raising gala, was abandoned after 2001, but a move is afoot to revive the tradition for Lawndale's upcoming twenty-fifth anniversary.

HELPFUL HINTS

Combine a visit to Lawndale with a trip to the nearby Houston Center for Contemporary Craft and then consider other Museum District destinations. A small brochure produced by the Houston Museum District Association (available at most member institutions) will augment this guide in proposing potential destinations in the area.

LILLIE AND HUGH ROY CULLEN SCULPTURE GARDEN

Montrose Blvd. at Bissonnet, Houston 77005
713-639-7300
www.mfah.org

Museum of Fine Arts annex—sculpture garden

The Lillie and Hugh Roy Cullen Sculpture Garden was designed
by internationally renowned sculptor Isamu Noguchi in 1986
to provide an outdoor setting for a number of nineteenth- and
twentieth-century sculptures owned by the museum.

Daily 9 a.m.–10 p.m.

Free

See MFAH for restaurant and museum shop information.

DETAILS

Isamu Noguchi's undulating lawn enclosed by curved cast-concrete walls on the corner of Montrose and Bissonnet is itself a sculpture, one that also serves to contain other important late-nineteenth- and twentieth-century works belonging to the museum. These include sculptures by Louise Bourgeois, Alberto Giacometti, Joseph Havel, Aristide Maillol, Henri Matisse, Auguste Rodin, Joel Shapiro, and David Smith, among others. The walls tend to block both noise and visual clutter, creating a series of outdoor rooms with contemporary character where visitors can wander and contemplate art. Dozens of native Texas trees, including magnolias, pines, sycamores, and water oaks, mitigate the sun, although midsummer days in Houston are uncomfortable at best. Signage is present but unobtrusive, sufficient for those who want to learn the artists' names, as well as for visitors who are there to remember the curve of a bronze tendril or the way its shadow changes as the sun moves across the sky.

In 1976, Alice Pratt Brown, a Museum of Fine Arts trustee, suggested commissioning Noguchi, an important American sculptor, to create this one-acre urban oasis across from the museum's Caroline Wiess Law Building and in front of the Glassell School of Art. The garden was opened to the public in 1986, named after Houston philanthropists Lillie and Hugh Roy Cullen, and funded in large part by the Cullen Foundation.

HELPFUL HINTS

You can park in the museum parking garage on Bissonnet or try to find space in the lot next door that the museum shares with a parochial school. There is limited parking behind the Glassell School and on the street. While you're there, be sure to also visit the Glassell School's small gallery.

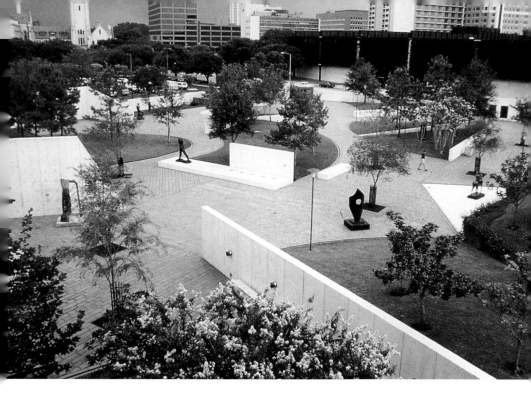

The Lillie and Hugh Roy Cullen Sculpture Garden. Photo by T. R. DuBrock.

MENIL COLLECTION

1515 Sul Ross, Houston 77006
713-525-9400
www.menil.org

Fine arts museum

In separate but neighboring facilities, the Menil Collection presents art purchased by John and Dominique de Menil and the Menil Foundation, as well as temporary exhibitions reflecting the founders' interests in art, architecture, cultural studies, religion, and philosophy. Richmond Hall, the Byzantine Fresco Chapel Museum, and the Cy Twombly Gallery—all Menil projects—are listed separately in this guide.

Wed.–Sun. 11 a.m.–7 p.m.

Free

Museum bookstore
1520 Sul Ross, Houston 77006
713-521-9148

Top: The Menil Collection (exterior—north façade), Piano and Fitzgerald, architects. Photo by Hickey-Robertson, Houston.
Middle: The Menil Collection, Houston (interior—view of Oceanic gallery and garden atrium), Piano and Fitzgerald, architects. Photo by Hickey-Robertson, Houston.
Bottom: The Menil Collection, Houston (exterior view—north promenade, facing east; at right: Michael Heizer sculpture *Charmstone,* 1991). Photo by Hickey-Robertson, Houston.

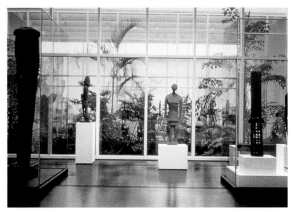

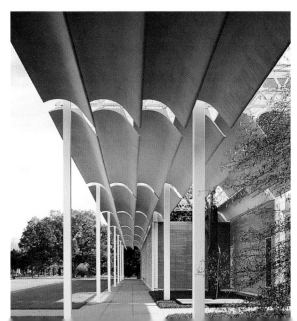

DETAILS

The Menil Collection encompasses more than 15,000 objects: antiquities, Byzantine and medieval works, tribal art, and twentieth-century painting and sculpture with a particular strength in works by Surrealists such as Max Ernst and René Magritte. Exhibits are rotated from time to time to allow visitors greater access to the breadth and depth of the collection and to accommodate traveling shows. Recent special exhibitions have included "H. C. Westermann," organized by the Museum of Contemporary Art in Chicago. "Donald Judd, Early Work 1955–1968" was assembled in conjunction with the Kunsthalle Bielefeld in Germany, and an exhibit of Jasper Johns's drawings was organized by the Menil Collection but included works from the artist's private collection. Younger working artists whose sensibilities are in tune with the museum's collections have also been featured in the galleries. The preceding information alone, however, sheds insufficient light on the richness of the legacy left by John and Dominique de Menil. A 1986 cover story in the *New York Times* magazine proclaimed the family "The Medici of Modern Art." Together the de Menils, who emigrated to Houston from France after World War II, built an extensive and very personal collection of art and commissioned exquisite architectural spaces so that these works might be shared with the public.

One of their early guides was Father Marie-Alain Couturier, the French Dominican priest who was instrumental in commissioning artists and designers such as Le Corbusier, Matisse, and Rouault to create works for French chapels in Vence, Ronchamp, Assy, and Audincourt. The couple also befriended Philip Johnson, founder in 1932 of the department of architecture at the Museum of Modern Art in New York, and hired him to design their home, a one-level Modernist masterpiece in River Oaks. They also retained Johnson to design a master plan and buildings for the University of St. Thomas campus.

The de Menils involved themselves in many community efforts, particularly in the arts. John de Menil served as chairman of the Contemporary Arts Association (later known as the Contemporary Arts Museum) in 1950, and both were subsequently involved with the University of St. Thomas art and art history department, Rice University, and the Museum of Fine Arts. They also focused their considerable energy and resources on the creation of a very personal project, the Rothko Chapel. Following its completion in 1971, the couple began planning for construction of a museum to house their personal art collection on land they had purchased in the Montrose area. But when John de Menil died in 1973 and the architect the couple had selected for the commission, Louis I. Kahn of Kimbell Art Museum fame, died the following

Top: *Golconde (Golconda)* by Rene Magritte, 1953, oil on canvas, 31½" x 39½". The Menil Collection, Houston. © 2004 C. Herscovici, Brussels/Artists Rights Society (ARS), New York. Bottom left: Dance mask, Alaska—Tlingit, wood, paint, shell, metal. The Menil Collection, Houston. Photo by Hickey-Robertson, Houston. Bottom right: Mask (ram), Nigeria—Ibibio, wood, paint, fiber. The Menil Collection, Houston.

year, Dominique de Menil set the idea aside. She took it up again in 1981 after meeting Italian architect Renzo Piano, who proved to be the perfect new partner for the enterprise. The museum opened in 1984.

This unpretentious building, a kind of elegant large-scale bungalow of painted gray cypress, sprawls comfortably on a city block in what is primarily a residential neighborhood. Even donors' names are subtly scrawled on a bronze plaque that lies on the ground outside the north entrance. The Menil barely calls any attention to itself, except, of course, for the difference in scale between the two-story museum and the modest gray cottages that line nearby blocks. These are owned and used by the foundation as offices or leased to artists and associates for finite periods of time. One of the little bungalows holds the museum's bookstore.

The Menil's interior spaces suggest a well-thought-out home with a gracious double-sided entry foyer (accessible from either Sul Ross or Branard). Generous hallways to the right and left lead to large galleries and smaller spaces, each perfectly proportioned to accommodate the works within. A sun-filled courtyard near the permanent collection of tribal arts and the mysterious, small dark rooms that hold Surrealist works seem particularly appropriate. The foyer usually holds just a few large paintings and occasionally a sculpture. Labels throughout the museum provide a minimum of information, encouraging visitors to think for themselves. Pictures are hung lower than in most museums to make them maximally accessible. Even the guards are particularly hospitable, taking care to respond to visitors' questions. Throughout the museum an overhead system of fixed roof panels allows visitors to remain aware of changing sunlight without straining to see the art. In short, Piano created a building that is both modest and grand, as welcoming as Dominique de Menil herself is reputed to have been.

HELPFUL HINTS

Park on the street or in the museum lot that is accessed from West Alabama between Mulberry and Mandell. The Menil Collection is directly across Branard Street from the Cy Twombly Gallery and across Sul Ross from the bookstore, which has a fine assortment of books, periodicals, and small objets d'art. It is little more than a block from the Rothko Chapel and the Houston Center for Photography. Weather permitting, Richmond Hall and the Byzantine Fresco Chapel are also accessible on foot.

"Art is what lifts us above daily life. It makes us more open, more human, more refined, and even more intelligent."

—DOMINIQUE DE MENIL[6]

MUSEUM OF FINE ARTS, HOUSTON

Caroline Wiess Law Building
1001 Bissonnet, Houston 77005
Audrey Jones Beck Building
5601 Main
Houston, 77005
713-639-7300, 713-639-7379 for information in Spanish,
TDD/TTY for the hearing impaired 713-639-7390
www.mfah.org

Fine arts museum

The Museum of Fine Arts, Houston, the country's sixth-largest
encyclopedic art museum and the biggest in Texas, is well
known, among other things, for its collections of twentieth-
century photography, Modern and contemporary art,
decorative arts, and European paintings. Museum collections
and changing exhibitions are housed in the Law and Beck
Buildings described here, in the Lillie and Hugh Roy Cullen
Sculpture Garden and the Glassell School in Houston's Museum
District, as well as in the house museums Bayou Bend and
Rienzi, located at other sites.

Tue.–Sat. 10 a.m.–7 p.m. (Thu. and Fri. till 9 p.m.),
Sun. 12:15 p.m.–7 p.m.

Wheelchairs available on a first-come, first-served basis

Adults $7, students with ID $3.50, children 6–18 and seniors over 65 $2.50, children 5 and under free

Free to all on Thu., free on Sat. and Sun. for children 18 and under with a Houston Public Library Power Card or any other library card

Café Express in the Audrey Jones Beck Building can be entered from Binz Street or through the museum. Tue.–Wed. and Sun. 11 a.m.–7 p.m., Thu.–Sat. 11 a.m.–9 p.m.

Museum shops in both the Law Building and the Beck Building

DETAILS

The Museum of Fine Arts, Houston is by far Texas' biggest art museum. Its operating budget is roughly double that of any other art museum in the state, and its physical plant includes nearly 160,000 square feet of galleries in the Caroline Wiess Law and Audrey Jones Beck Buildings as well as two house museums, a sculpture garden, and a museum school. The museum's endowment is roughly $360 million, and it holds more than 45,000 objects from cultures around the world in its collection. Among the highlights are twentieth-century paintings, including numerous works by Jasper Johns, Franz Kline, and Jackson Pollock, and a significant collection of African American works. Other crowd-pleasers include the Glassell Collection of African Gold, the John A. and Audrey Jones Beck Collection of Impressionist and Post-Impressionist Art, Baroque and Renaissance art from the Sarah Campbell Blaffer Foundation, and the Hogg Brothers Collection of Remington paintings and sculpture. Longtime director Peter Marzio describes the museum's photography collection as one of the four or five greatest in America and also speaks with pride about the museum's nationally recognized education and outreach program. It is one of the largest in the country, harking back to the institution's origins as the Houston Public School Art League, founded in 1900 to encourage art and culture in the city's schools.

Temporary exhibitions both complement and build on the museum's collections. The MFAH Web site is the best source for exhibition updates. In 2002 and 2003, the museum declared a "Season of Impressionism" and presented masterworks from the Phillips Collection in Washington, D.C.,

including Renoir's classic *Luncheon of the Boating Party,* French paintings from the State Pushkin Museum in Moscow, and "French Impressionism: Masterpieces from Copenhagen's Ordrupgaard Collection." At the same time, visitors got to see Alfred Stieglitz and Jacob Lawrence retrospectives, "Afghanistan: A Timeless History," and "Leonardo da Vinci and the Splendor of Poland." In other words, there is always something for everyone at the MFAH.

First-time visitors would be wise to ask for a gallery map before proceeding beyond the reception area.

The Caroline Wiess Law Building holds the museum's prized Glassell Collection of African Gold, other collections of African, Asian, Oceanic, and pre-Columbian art, and international art of the twentieth and twenty-first centuries. The original portion of the Law Building was designed by William Ward Watkin in the neo-Classical style and completed in 1924. Thirty years later the MFAH commissioned renowned Bauhaus architect Ludwig Mies van der Rohe to design an addition, Cullinan Hall, that was completed in 1958. Another Mies van der Rohe addition, the Brown Pavilion, which curves along Bissonnet, was completed in 1974. A small gift shop and the Hirsch Library, a lovely spot for resting and for reading periodicals, are located on the first floor. The lower level affords access to the MFAH's famous tunnel.

James Turrell, an American sculptor, was commissioned to create a light installation that makes the underground passageway between the Law and Audrey Jones Beck Buildings one of the most dynamic works in the MFAH collection. *The Light Inside,* a 150-foot pathway, changes color according to a predetermined cycle that demands at least a slow stroll from one building to the next, if not an outright pause to absorb the magic.

The Audrey Jones Beck Building was designed by Spanish architect José Rafael Moneo, winner of the Pritzker Prize in 1996, and opened to great fanfare in 2000. On the ground floor are Café Express, a gallery for temporary exhibitions, and escalators to the first floor. Two monumental bronze reliefs titled *Curtain* by sculptor Joseph Havel flank the Main Street entrance to the building. A huge gift shop and orientation area are also located on the first floor, along with permanent and temporary exhibition galleries. The Beck Building exhibits European art from antiquity to 1920; the Beck, Blaffer Foundation, and Hogg collections; and prints, drawings, and photography,

Top: Audrey Jones Beck Building, The Museum of Fine Arts, Houston, Rafael Moneo, architect. Photo © 1999 Aker/Zvonkovic.
Bottom: *Water Lilies (Nymphéas)* by Claude Monet, 1907, oil on canvas. The Museum of Fine Arts, Houston, gift of Mrs. Harry C. Hanszen.

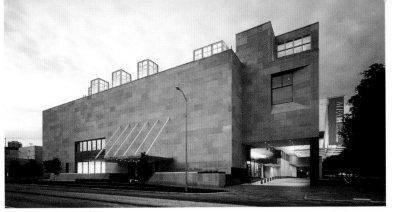

as well as American painting and decorative works from the nineteenth and twentieth centuries. Stretching from the first to the second floor is a monumental donor wall. The 1997–2000 capital campaign raised $130 million.

But, according to Peter Marzio, the museum is still not big enough to routinely exhibit some of the best works in the collection. The director is already discussing the next project, a building to house contemporary works, in particular the African American and burgeoning Latin American collections.

HELPFUL HINTS

For the opening of the Beck Building, the MFAH published a complete visitor guide that can be purchased in the museum shop. The museum also offers a random-access audio tour of the permanent collection titled "Museum Masterpieces: The Do-It-Yourself Audio Guide."

Park in the museum garage at 5600 Fannin (entrance on Binz) and stop at the visitors center, where brochures are available to help you plot a course through the museum. Weather permitting, be sure to cross Bissonnet to see the Sculpture Garden and the Glassell School Gallery, as well as the exhibitions in the Law and Beck Buildings.

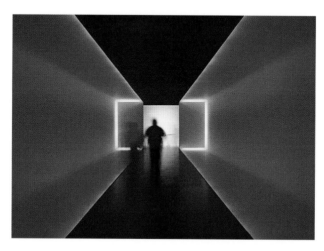

The Light Inside by James Turrell, 1999, neon light, projected light, gypsum board, plaster, glass, and oak. The Museum of Fine Arts, Houston. Museum commission with funds provided by Isabel B. and Wallace S. Wilson.

"Here [in Texas] we have one museum in a bus station, one in an old army base, one in a brewery, and a Mies van der Rohe in one city and Kahn in another. That's where the dynamism is. That's the genius of Texas museums. It's what excites me about them."

—PETER MARZIO, DIRECTOR, MUSEUM OF FINE ARTS, HOUSTON[7]

MUSEUM OF PRINTING HISTORY

1324 W. Clay, Houston 77019
713-522-4652
www.printingmuseum.org

Printing museum with art collection

The Museum of Printing History galleries frequently offer selections from the museum's collection of original prints. The museum also hosts temporary art exhibitions that further its exploration of the history of printing and its influence on society.

Tue.–Sat. 10 a.m.–5 p.m., Sun. 12:30 p.m.–5 p.m.

Adults $5, seniors and students $2, members free, Thu. all visitors free
Guided group tours by reservation, $2 for students, $4 for adults

Museum shop

DETAILS

Opened to the public in 1982, the Museum of Printing History has a collection that includes engravings and etchings from the sixteenth through the eighteenth centuries and antiquarian maps, manuscripts, and books. Its primary interests, however, revolve around the old printing presses and other equipment contributed by representatives of the commercial printing companies that were its founders. Period rooms created within the building help visitors understand how books are bound, how type was set, and how original prints were and are made. A nineteenth-century stone lithography press in the Hearn Printmaking Workshop has allowed the museum to publish prints for artists, including the late John Biggers, and to offer classes. Eventually, an "Undiscovered Printmakers Series" was established to exhibit work by one emerging printmaker each year in the galleries.

Additional art exhibits have included "Prints and Drawings of the Weimar Republic," organized by the Institute for Foreign Cultural Relations in Stuttgart, and photography exhibits and works on paper by Colombian artist Ana Uribe, who also offered workshops on creating linocuts and artist books. But if the artful presentation of miniature books, antiquarian prints, or exhibits relating even more specifically to commercial printing might disappoint, call ahead or consult the museum's Web site before stopping by.

HELPFUL HINTS

With an old printing press situated outside near the entrance, the museum is easy to spot from the street. To see art exhibits, turn to your left upon entering the building and wind your way through the halls; to go first to the museum shop, turn right. Spaces within the core of the building are currently leased to a for-profit business, but these don't interfere with the museum experience that encircles them.

PROJECT ROW HOUSES

2500 Holman (between Live Oak and Dowling), Houston 77004
713-526-7662
www.projectrowhouses.org

Alternative space

In seven small renovated houses in Houston's Third Ward, Project Row Houses presents temporary installations by artists selected from across the country. These works are based at least in part on interaction between the artists and members of Houston's Third Ward community.

Wed.–Fri. noon–6 p.m., Sat. and Sun. noon–5 p.m.

Free

Project Row Houses (exterior). Photo by Stephen L. Clark.

DETAILS

Project Row Houses is a unique program that combines art and cultural education with neighborhood revitalization, historic preservation, and community service. The idea resulted from discussions among a number of the city's African American artists who wanted to establish a positive presence in the black community. They organized volunteer muscle and money to renovate a small site in Houston's Third Ward and twenty-two shotgun houses located in that block-and-a-half area. Seven were set aside for a visual arts program.

Here is how it works: PRH selects curators for two "rounds," or cycles, of exhibitions each year, and the curator in turn selects artists to work in each of the row houses reserved for that purpose. Each artist is required to conduct workshops within the community that may directly, or indirectly, affect the installation. A broad range of ideas and aesthetics has been represented over time. Some artists hang art on the walls of the tiny house assigned to them, and others use the space itself as a platform for their art.

Efforts to renovate the site began in 1992, and to date PRH has invited the broader community to opening receptions for each new round of installations and implemented a series of literary and performing events. It has also developed summer and after-school programs for neighborhood youth (including a children's garden) and established a program for housing and services, promoting self-sufficiency for young single mothers and their children.

What does all this have to do with art? The answer might be found in a 2000 installation by East Coast artists Homer Jackson and Lloyd Lawrence, titled *Heroes,* that included a sign asking, "In an increasingly dangerous world, if a wish could save a life, would you make a wish?" The artists/founders of PRH wanted to find creative solutions to the economic and social problems that plague impoverished neighborhoods. They theorized that the power of artists to transform everyday objects into art could somehow reinforce the power of a caring community to transform the lives of its people. And then they made their wish come true.

HELPFUL HINTS

In the mailbox on the front porch of each house visitors will find information about the art within and the artist responsible for that installation. An Arts and Music Festival presented in October includes the exhibition and sale of fine art by artists and artisans, live music, food, and activities for children and families.

RICE UNIVERSITY ART GALLERY

Sewall Hall, Rice University Campus, 6100 Main,
Houston 77005
713-348-6069
www.ricegallery.org

University art gallery

In order to provide a unique experience for university and community audiences, Rice Gallery commissions site-specific installations by artists of national and international reputation living outside Texas.

Tue.–Sat. 11 a.m.–5 p.m. (Thu. till 7 p.m.), Sun. noon–5 p.m. Closed university holidays.

Free

DETAILS

The Rice University Art Gallery distinguishes itself from other university galleries and similarly sized nonprofit art spaces in the Gulf Coast region by presenting a steady diet of site-specific installations commissioned for the gallery. Gallery director Kim Davenport has shaped the program since she arrived in the mid-nineties and has involved a number of internationally recognized artists, architects, and designers, including Shigeru Ban, Stephen Hendee, Liga Pang, and Karim Rashid. Ban, a Japanese architect, made use of the outdoor plaza in front of Sewell Hall to create an installation called *Bamboo Roof.* The expansive, open-weave canopy of bamboo boards spanning the plaza was constructed in collaboration with Rice architecture students. Inside the Rice Gallery, visitors saw documentation of the construction of *Bamboo Roof.* Ban's first and only other project realized in the United States was a paper arch installed in the Sculpture Garden at the Museum of Modern Art in New York. For his installation called *Pleasurescape,* Rashid painted all the walls with multiple layers of orange fluorescent paint. In a sense, the gallery became the artist's canvas, and then, when the exhibition ended, it was returned to its pristine state, ready for the next transformation.

The Rice Gallery, nearly a cube (40 feet by 44 feet) with high ceilings and limestone floor, is located just inside Sewall Hall. It has three solid walls and a glass wall to the foyer. The gallery mounts four exhibitions a year plus the "Summer Window" series, meant to be viewed through the window wall while the gallery is closed for the summer. Catalogs are available for each exhibition, and the Web site offers an exhibition history and details about the current show. But there is no substitute for being there.

HELPFUL HINTS

Use campus entrance #2 off of Main. Park nearby for a small fee (credit card only) in the Founder's Court Visitor Lot directly in front of Sewall Hall. The building has large arched windows. Check the Web site or call first to avoid arriving between exhibits or on a university holiday.

Bamboo Roof by Shigeru Ban, 2003, site-specific installation at the Rice University Art Gallery, Houston, Texas. Photo by Heidi Sherman. Courtesy of Rice University.

RICHMOND HALL

1416 Richmond Ave., Houston 77006
713-525-9400
www.menil.org/flavin.html

Menil Collection annex

Richmond Hall is the site of a major installation by Minimalist
Dan Flavin, the last artwork commissioned by arts patron
Dominique de Menil before her death.

Wed.–Sun. 11 a.m.–7 p.m.

Free

DETAILS

A green fluorescent frieze hugs the Richmond Hall roofline, a signal that Dan Flavin, the artist best known for his light installations, has left his mark on Houston. Visitors pass first through an entry area with a diagonal arrangement of white lights and then into the 125-foot-by-50-foot interior, empty but for the aura of mystery created by the artist. The installation employs Flavin's signature light tubes—commercially produced four-foot pink, yellow, green, blue, and filtered ultraviolet fluorescent lights. They are lined vertically along the walls and appear to morph from one color to another depending on where the viewer is standing at a particular moment. But perceived as a whole, the work mysteriously envelops visitors in an ethereal white light. An unobtrusive skylight provides a bit of outside illumination without disrupting the otherwise introverted experience.

Discussions between Dominique de Menil and artist Dan Flavin continued for years during the 1980s before Houston's most famous arts patron commissioned the artist to light the otherwise bland building with its storefront exterior. (It originally served as a grocery in the 1930s and later as home to various bars.) Richmond Hall, named for the street on which it is located, is near the Menil Collection and the University of St. Thomas, where much of the land is owned by the Menil Foundation. It was used for temporary installations before 1998 when the Minimalist sculptor's "penultimate work," according to the Menil Web site, was finally installed. By then both Flavin and Dominique de Menil had died, leaving others to celebrate the completion of the installation, the last work commissioned by the longtime patron of the arts. Two other Flavin installations were realized after the artist's death: one in a 1930s church in Milan, Italy, in 1997 and the other in a series of barrack buildings at Chinati in Marfa in 2000.

HELPFUL HINTS

Richmond Hall is easy to find, and parking spaces are plentiful. Some visitors may not respond to this artist's work, but for those who bring an open mind and some understanding of Minimalism, Richmond Hall is a destination not to be missed.

RIENZI

1406 Kirby Dr., Houston 77019
713-639-7800
www.mfah.org

Museum of Fine Arts annex—house museum

At Rienzi, former home of Harris Masterson III and his wife, Carroll Sterling Masterson, the public can now view the couple's collection of European paintings, sculpture, and decorative arts.

Reservations required

Mon. and Thu.–Sat. 10 a.m.–4 p.m.
One-hour tours every 30 minutes.

Adults $6; MFAH members, seniors 65 and over, college students with ID, and children 12–18 accompanied by an adult $4; group tour 11–20 people for one hour $100, 21–40 people for two hours $200. Guided tours are for children ages 12 and above only.

Sunday Open House—self-guided tours of the house and garden, 1 p.m.–5 p.m. Individuals $5, groups of 2–4 $10, groups of 5–6 $15, groups of 7–8 $20

Families, including all children accompanied by adults, are welcome. No MFA member discounts on Sun.

Rienzi is closed for the month of August.

Rienzi (library), The Museum of Fine Arts, Houston. Photo by Hester + Hardaway.

DETAILS

Visitors to Rienzi can sense the presence of the home's gracious owners, Harris and Carroll Masterson, as they wander through each room. Not only does the house offer insight into period European works of art and furniture, it also provides a window into their social milieu. The philanthropic couple constantly opened their home to family and community events. Carroll tended to support social causes, and Harris took greater interest in the arts. Together they donated the house and its contents to the Museum of Fine Arts and took a life estate in the property. After his wife died in 1994, Harris Masterson continued to be a lively presence in the house, adding to and caring for the collection until his own death in 1997.

The collection includes everything from eighteenth-century English ceramics, furniture, and portraiture to sculptural objects by jewelers such as Jean Schlumberger and David Webb. Of particular note is the exceptional selection of Worcester porcelain. There are also objects outside of those eighteenth-century parameters, such as portraits by Jan Boleslav Czedekoski of the Mastersons (a twentieth-century couple), which hang in the dining room; a lovely Guido Reni portrait, *Saint Joseph and the Christ Child* (1638–1640), displayed over the fireplace mantel in the library; and an imposing early-nineteenth-century white marble sculpture of the Roman goddess Venus, modeled after an Antonio Canova sculpture. According to Katherine Howe, curator of the collection, the architecture of the original house is also in line to become part of the collection in another fifty years.

Rienzi was named after Harris Masterson's grandfather Rienzi Johnson and built in 1952. The one-story residence was designed by noted Houston architect John F. Staub, who also designed Bayou Bend, another MFAH satellite space. Because the architect would not deviate from his intent to create a symmetrical Palladio-style façade (ignoring Harris Masterson's own sketch for a formal picture gallery extending to one side) the Mastersons turned to architect Hugo Neuhaus twenty years later to create the gallery and ballroom wing. Floor materials change with each room, suggesting that each one was perhaps conceived by the couple as an independent stage set. Equally dramatic is the manner in which the house is sited between two ravines that lead into Buffalo Bayou. Visitors are welcome to explore the lush gardens, designed by Ralph Ellis Gunn, although some exterior areas may not be wheelchair accessible.

HELPFUL HINTS

The 4.4-acre museum is located in Houston's Homewood addition, which is surrounded by but is not part of River Oaks. If possible, select a beautiful day to visit so you can take advantage of the sweet-smelling garden as well as the house tour. The Houston Garden Club assists in maintaining the grounds.

Worcester vase, front and back views, by Jefferyes Hammett O'Neale, manufactured by Worcester Porcelain Manufactory, ca. 1768–1770, soft paste porcelain. The Museum of Fine Arts, Houston, The Rienzi Collection, gift of Mr. and Mrs. Harris Masterson III, by exchange.

"It is not an acropolis we want there.
It is not Culture on a corner.
I think of the new museum building as a
stage environment to house the multimedia
in which artists of today are working."

—SEBASTIAN J. "LEFTY" ADLER, FORMER DIRECTOR,
CONTEMPORARY ARTS MUSEUM, HOUSTON[8]

ROTHKO CHAPEL

1409 Sul Ross at Yupon, Houston 77006
713-524-9839
www.rothkochapel.org

Chapel (nondenominational)

The Rothko Chapel is a modern meditative environment.
It was named for American Abstract Expressionist Mark
Rothko, whose paintings adorn the walls in the octagonal
chapel and set the mood.

Daily 10 a.m.–6 p.m.

Free

DETAILS

Past the entry foyer and inside the chapel proper, fourteen distinct panels by Abstract Expressionist Mark Rothko, nine of them combined as triptychs, adorn the walls. Seven of the panels are essentially black, and the other seven are plum-colored. But in the changeable natural light that filters down through a skylight, the colors seem to breathe and shift. The paintings eschew specific religious imagery; in fact, there are no distinct shapes or figures at all.

These somber and subtle artworks were commissioned by John and Dominique de Menil in the mid-sixties and helped serve as the inspiration around which the structure itself developed. When Rothko's rejection of architect Philip Johnson's initial plans for a soaring pyramidal roofline won the de Menils' support, Johnson stepped away from the project, leaving Houston architects Howard Barnstone and Eugene Aubry to complete the chapel.

Originally the paintings were commissioned for a Catholic chapel to be built by the de Menils and affiliated with the University of St. Thomas, which had received much attention and support from the couple over the years. But the university already had a chapel and was, in addition, growing wary of the de Menils' determinedly ecumenical and aesthetic preoccupations. In 1969 the chapel was instead donated to the ecumenical Institute of Religion and Human Development, which was affiliated with the Texas Medical Center. Soon that association also came to an end. In October 1972, with financial help from John and Dominique de Menil and a group of friends, the chapel incorporated as an independent entity with its own board and endowment.

The other artist represented on the site is Barnett Newman. His sculpture *Broken Obelisk* stands outside in a reflecting pool and was dedicated along with the chapel in 1971. The de Menils had proposed to purchase the sculpture in collaboration with the Houston Municipal Art Commission so that it could be placed near the Houston City Hall and dedicated to Dr. Martin Luther King, Jr., but the mayor and city council resolved not to accept it with the dedication to King. The de Menils then purchased the sculpture outright and, with the artist, selected the Rothko Chapel site as a

Rothko Chapel (exterior) and Barnett Newman's Cor-ten steel *Broken Obelisk*, dedicated to the memory of Martin Luther King, Jr. Photo by Hickey-Robertson, Houston.

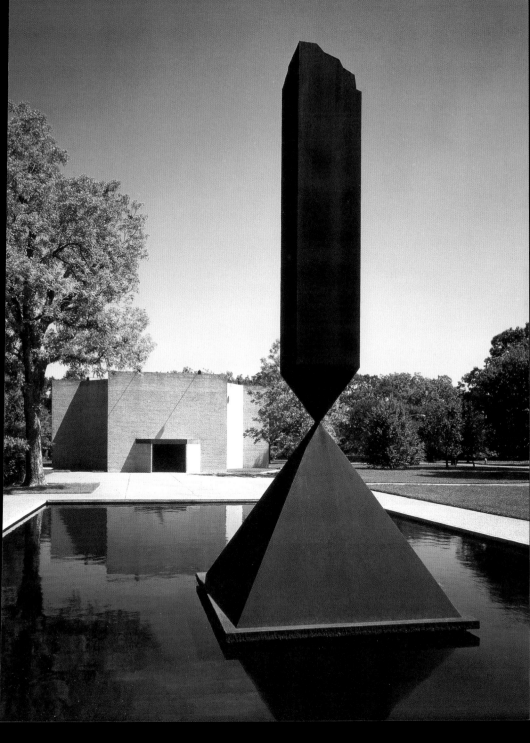

permanent location. It now seems to signal passersby that they should think seriously about stopping to look inside the mysterious low-slung building on a grassy, tree-covered corner of Houston that houses the chapel.

Over the years, many have done just that. The chapel has welcomed whirling dervishes, weddings, award ceremonies, memorial services, interfaith services, symposia, international colloquia, private contemplation, and much more. Holy books reflecting world faiths are available to all in the foyer, although for many, Rothko's paintings are sufficient inspiration for meditation and prayer.

HELPFUL HINTS

Combine a visit to the Rothko Chapel with your trip to the Menil Collection, the Cy Twombly Gallery, the Byzantine Fresco Chapel, and the Houston Center for Photography. Benches inside the chapel make it an ideal place for a physical as well as spiritual break in the day.

THE STATION

1502 Alabama, Houston 77004
713-529-6900
www.artcarmuseum.com

Artcar Museum annex

The Station presents local, national, and international work featuring artists and ideas that may not be represented elsewhere in Houston. Like the Artcar Museum, it reflects the independent spirit of its founders; you won't find art cars here, but you are likely to find politically charged themes explored through both traditional and nontraditional media.

Wed.–Sun. 11 a.m.–6 p.m.

Free

DETAILS

The Station opened in 2002 with an exhibition titled "Ajita." The word means "unconquerable" in Sanskrit, and the exhibition was about the indomitable spirit of painting and artists who explore the medium without regard to fashionable trends. It also included *Silver Bullet,* a provocative installation by Dennis Oppenheim incorporating giant handguns, and Lily Hatchett's rumpled music paper assemblages. In "Unearthed," the second exhibition, dirt was used as a painting medium by Jim Hatchett; turned upside down by Jo Ann Fleischhauer, who suspended a small forest of trees from the ceiling; and photographed by Fernando Castro to create his manipulated black-and-white images. The three Houston artists were joined by Irvin Tepper of New York, whose lifelong fascination with ceramic cups was conveyed through a variety of media. Expect to see crossover artists from the ACM and crossover ideas, if not exhibitions that are shared outright.

The 5,000-square-foot gallery is divided into a series of angled bays that have easily accommodated the theme-based exhibitions presented to date. With its pale pine floors and crisp white plasterboard walls, the Station's trendy upscale environment belies founder/director James Harithas's suspicion of (verging on antipathy toward) convention. The pale-yellow metal building is situated across from Houston Community College, on the fringes of the Third Ward and close to Project Row Houses, with which he feels a kinship.

The Station and the Artcar Museum are supported entirely by the Ineri Foundation, which was created by Harithas and his wife, Ann, as a platform for a number of social-action and artistic endeavors. Ineri is considering the creation of additional satellite spaces scattered throughout Houston. The same small staff that oversees the ACM runs the Station, although its exhibitions clearly reflect the director's vision. It remains to be seen how this private foundation, which does not have a board of directors, will evolve when its founders are gone.

HELPFUL HINTS

The Station projects a welcoming ambience; someone is routinely at the front desk to greet visitors and offer free catalogs or brochures. Consider combining a visit to the Station with a stop at Project Row Houses, followed by a jaunt to the Contemporary Art Museum (where James Harithas served as director in the 1970s), to compare and contrast the ways in which contemporary art and ideas can be presented.

Top: The Station (exterior). Photo by Michael Stravato.
Bottom: The Station (interior) during "Unearthed" exhibition, 2003. Photo by Michael Stravato.

TEXAS SOUTHERN UNIVERSITY MUSEUM

Fairchild Building
3100 Cleburne Ave., Houston 77004
713-313-7145

University museum

This new university museum balances exhibitions from its permanent collection—primarily works from graduates of Texas Southern University and faculty—with special exhibitions that highlight world cultures, particularly the African American experience.

Tue.–Fri. 10 a.m.–5 p.m., Sat.–Sun. noon–5 p.m.

Free

Lady in Black Coat by Earlie Hudnall, 1998, gelatin silver photograph

DETAILS

The idea for an art museum at Texas Southern University was born in 1949 when John Biggers founded the Fine Arts Department at the predominantly black institution. For fifty years, Biggers and fellow artist and faculty member Carroll Harris Simms gathered student, alumni, and faculty work in anticipation of the day when the museum would become a reality. That day came in April of 2000. The inaugural exhibition, "Pass It On: Fifty Years of Art from the Permanent Collection," featured excerpts from the collection. A major mural by Biggers, titled *The Web of Life,* remains on permanent display. Subsequent exhibitions have included "Our New Day Begun: African American Artists Entering the Millennium"; "Step into the Footmarks of My Ancestors: Recent Work by Leamon Green"; and "African American Art: 20th Century Masterworks, VIII" from the Michael Rosenfeld Gallery in New York City. One solo exhibition annually is devoted to a graduate of the TSU art department. Photographer Earlie Hudnall's work was exhibited in 2002 and Harvey Johnson's in 2003.

The museum's director/curator, Alvia Wardlaw, also serves as a curator for the Museum of Fine Arts, Houston, and this dual role is reflected in the museum's programming. Wardlaw curated "Lone Star Spirit: Texas Collects African-American Quilts" for the TSU Museum to coincide with "The Quilts of Gees Bend," which she organized for the MFAH, and TSU faculty and students are routinely encouraged to use the MFA as a laboratory for the study of art and art history. Artists presented at TSU are not exclusively Texan. Future exhibitions will include work by Nigerian photographers, Cuban printmakers, and perhaps Vietnamese folk artists, all with an eye to expanding the experiences of students and other visitors to the museum.

The museum galleries include 11,000 square feet of exhibition space divided by temporary walls. University Museum architects Rey de la Reza and Darrell Fitzgerald converted roughly one-fourth of the Fairchild Building, space that was formerly a gymnasium, into art galleries with windows and doors facing the campus.

HELPFUL HINTS

As with many university galleries, finding the museum and parking nearby can be difficult, but the young institution promises to make routine visits worth the effort.

"Museums, not city halls, palaces, state capitols, movie houses, and opera houses, are the buildings we look to today. They play a new symbolic part in the life of our cities."

—**PHILIP JOHNSON, ARCHITECT**[9]

STARK MUSEUM OF ART

712 Green Ave., Orange 77630
409-883-6661
www.starkmuseum.org

Fine arts museum

The Stark Museum was created by the Nelda C. and
H. J. Lutcher Stark Foundation to exhibit collections that
include Western art, decorative and craft objects, porcelain
birds, and Steuben glass.

Tue.–Sat. 10 a.m.–5 p.m.

Free

Museum shop

Top: Stark Museum of Art (exterior). Courtesy Stark Museum of Art, Orange, Texas.
Bottom: *Coming through the Rye* by Frederic S. Remington, bronze, 27¼" x 30⅞" x
17⅞". Courtesy Stark Museum of Art, Orange, Texas.

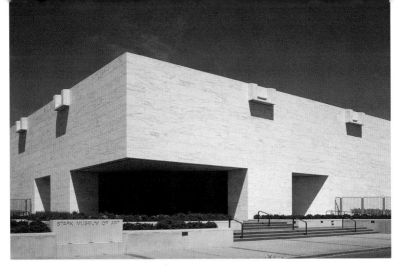

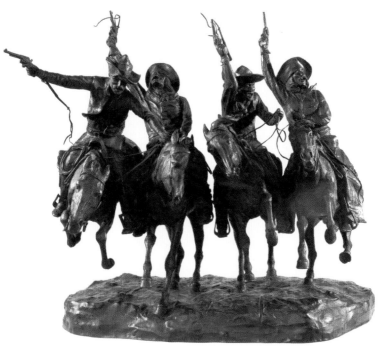

DETAILS

Lutcher Stark's collection includes some of the finest representations of nineteenth- and twentieth-century Western American paintings in the country. The nineteenth-century collection features early frontier artists such as Paul Kane, Albert Bierstadt, Thomas Moran, and John Mix Stanley; twentieth-century painters include Frederic Remington and Charles Russell. Engraved lithographs and aquatints by artist/naturalist John James Audubon (displayed individually and in the original bound volumes) and porcelains by Dorothy Doughty and Edward Marshall Boehm are also highlighted, as is a collection of Steuben glass. The Stark Museum owns the only complete set of *The United States in Crystal,* a series of bowls engraved with scenes representing the history of each of the fifty states. Changing exhibitions are created from time to time using works from the collection to explore individual artists, themes, or media. A substantial reference library adds another dimension to the facility.

Lutcher Stark's mother, Miriam Lutcher Stark, instilled in her only son a passion for collecting, while his father, William H. Stark, enjoyed a successful career in lumber, oil, rice, insurance, and banking. Evidence of their tastes can be found in the refurbished house, across the street from the museum, where they lived. Miriam Stark also gave more than 12,000 books to the University of Texas Library in Austin, where her son went to school. He began collecting art when he was an undergraduate. On trips with his family to New Mexico every summer, he bought Taos school painters and decorative and craft objects from the area.

In 1961, Stark and his third wife, Nelda, established the Nelda C. and H. J. Lutcher Stark Foundation to create, among other things, an art museum in Orange and to restore his parents' turn-of-the-century home. After he died in 1965, his wife assumed responsibility for those projects, which came to include construction of the Frances Ann Lutcher Theater for the Performing Arts, opposite the museum. A very private woman who grew up in Orange, Nelda Stark went about the business of creating this museum with a minimum of fanfare. It has only been since her death at the end of the twentieth century that the museum has begun to make a concerted effort to be recognized beyond the community of Orange.

The museum, designed by Austin architects Page Southerland Page, opened its doors to the public in the fall of 1978. This white Modernist building is a striking, albeit somewhat alien, presence in the town. Its

marble-paneled exterior, cast bronze doors, polished brick floors, and grass-cloth walls neither clash with nor try to emulate the museum's rugged frontier pictures. They show off these treasures well. Beautifully lit cases for the porcelain birds and for the Steuben glass provide extra drama. All exhibits and public spaces are on the first floor; the second level is reserved for staff offices, storage, and the library.

HELPFUL HINTS

Orange is situated along I-10, so far east that it's almost in Louisiana. The nineteenth-century Victorian Stark House across the street from the museum is also worth a visit. Call 409-883-0871 for additional information.

BEAUMONT ART LEAGUE

2675 Gulf, Beaumont 77703
409-833-4179

Free

Located on the corner of Plum and Gulf Streets on the South Texas State Fairgrounds, the Art League galleries primarily feature landscapes, still lifes, and portraits by local artists.

LIVE OAK ART CENTER

1014 Milam, Columbus 78934
979-732-8398

Free

This small, mostly volunteer-run facility in downtown Columbus hosts a surprising array of contemporary art exhibitions, featuring regional artists working in a variety of media. Exhibits change about every six weeks. The building itself dates back to the late nineteenth century and reportedly was a brothel at some point in its history.

HOLOCAUST MUSEUM

5401 Caroline, Houston 77004
713-942-8000
www.hmh.org

Free

Permanent exhibits at Houston's Holocaust Museum are augmented by temporary exhibitions of paintings, drawings, photography, and other media employed by artists to reflect on Holocaust-related themes.

JUNG CENTER

5200 Montrose Blvd., Houston 77006
713-524-8253
www.cgjunghouston.org

As an adjunct to its educational courses and outreach programs the Jung Center actively participates in Museum District activities by regularly hosting exhibits by emerging and established artists. These are free and open to the public during business and bookstore hours.

ALSO OF INTEREST

ORANGE SHOW

2401 Munger, Houston 77023
713-926-6368
www.orangeshow.org

The Orange Show in Houston's East End is the work of the
late Jefferson Davis McKissack, a postal worker who single-
handedly created an indoor/outdoor mazelike environment
dedicated to extolling the virtues of the orange, his favorite
fruit. This is a must-see destination for those who love folk or
visionary art.

COLLEGE OF THE MAINLAND
FINE ARTS GALLERY

1200 Amburn Rd., Texas City 77591
409-938-1211 or 888-258-8859, ext. 354

This college gallery located between Houston and Galveston
exhibits contemporary work by regional artists.

SOUTH TEXAS

SAN ANTONIO, THE NORTHERNMOST AND LARGEST
city in South Texas, serves as a multicultural role model for
the region. The city's arts institutions take their cue, on the
one hand, from the area's heavily Hispanic population and
proximity to Mexico while at the same time tracking national and
international museum trends. The meandering River Walk, old
Spanish missions, and Spanish-style mansions project an image
tied inextricably to Latin influences, yet exhibits presented in
major museums and nonprofit galleries are likely to offer a global
perspective.

The newly constructed Museo Americano in Market Square
and Centro Cultural Aztlán in southwest San Antonio devote
full time to exploring Chicano/Latino culture. The San Antonio
Museum of Art's Rockefeller Wing presents pre-Columbian
works, Spanish Colonial and Republic art, Latin Modern art,
and a fabulous folk art collection. But the city's other nonprofit
galleries tend to look elsewhere for inspiration. SAMA also
collects paintings, sculptures, and decorative arts from Asia and
America, and antiquities, including Greek vases and Graeco-
Roman sculptures. Visitors will find a Texas-based collection at
the Witte Museum, including figurative paintings, sculptures,
and works on paper, illustrative of area history. The Marion
Koogler McNay Art Museum focuses on the modern period of
American and European art, on its Tobin Collection of Theater
Arts, and, recently, on highlighting established regional artists.
ArtPace has tapped into the international art scene, inviting
area, national, and international artists to San Antonio to create
experimental projects. Similarly, Blue Star Art Space and the
Center for Spirituality and the Arts present exhibitions featuring
regional artists attuned to national and international trends. The

Southwest School of Art and Craft and various university galleries also exhibit contemporary works by area and national artists working in a variety of styles and media.

Cultural tourists who venture south of the city will find little to distract them from the flat truth of the land between San Antonio and Laredo along I-35. Vast ranches whose owners keep homes in San Antonio and Houston crouch in the distance. Beginning in Cotulla, roadside billboards are as likely to be written in Spanish as English, and conversations in convenience stores along the highway are bilingual as well. The Laredo Center for the Arts is located in a building that was once a *mercado*, or market, in a downtown square. Yet despite the building's origin and the city's shared border with Mexico, the center's gallery presents works by artists who are as likely to look north as south for their inspiration. McAllen's International Museum of Art and Science, on the other hand, responds directly to its position on the border with Mexico with a very special playscape and temporary exhibitions for children and adults that explore the science and history of the Rio Grande River and surrounding region. Their folk art collection and outreach programs further cement the museum's ties to Mexico, while other exhibits welcome artists from throughout the country.

In Corpus Christi, the South Texas Institute for the Arts, formerly known as the Art Museum of South Texas, takes an interest in Hispanic culture through the museum-run Antonio E. Garcia Arts Education Center, and its exhibitions are primarily, although not exclusively, tied to the region. In contrast, the museum's distinctive white building on the bay was designed by East Coast architect Philip Johnson. Soon an addition of a size similar to the original building, designed by Mexico City architect

Ricardo Legoretta, will reinforce the museum's commitment to Latino artists and influences as well as enhance its stature as a destination for architectural tours.

Up the coast, the Rockport Center for the Arts presents exhibitions in a vintage blue house on the bay. The lovely little sculpture garden and the exhibits, which change monthly, reflect the laid-back lifestyle in this small fishing town. Victoria and Beeville, on the other hand, boast small-town museums that are dedicated to importing big-city ideas. The Nave Museum and the Beeville Art Museum celebrate local artists and also present exhibitions featuring more-established Texas-based artists such as Melissa Miller and Julie Speed (the Nave), and selections from the Sarah Campbell Blaffer Collection of old masters (Beeville). While such opportunities are no substitute for an occasional field trip to San Antonio or even Corpus Christi, these and other small museums and art centers throughout the region provide a refreshing well around which their communities gather.

"Education is the whole reason we're here."

—BRENDA FLEMING PAWELEK,
FORMER DIRECTOR, BEEVILLE ART MUSEUM[1]

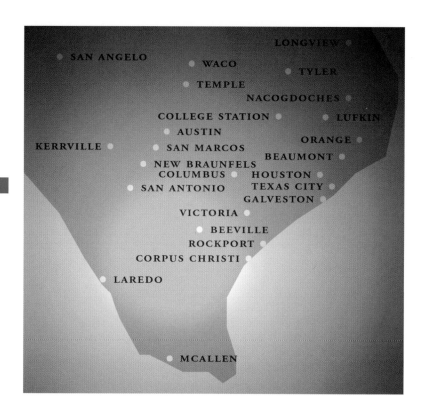

SAN ANGELO

LONGVIEW

WACO

TYLER

TEMPLE

NACOGDOCHES

COLLEGE STATION

LUFKIN

AUSTIN

ORANGE

KERRVILLE

SAN MARCOS

BEAUMONT

NEW BRAUNFELS

COLUMBUS

HOUSTON

SAN ANTONIO

TEXAS CITY

GALVESTON

VICTORIA

BEEVILLE

ROCKPORT

CORPUS CHRISTI

LAREDO

MCALLEN

BEEVILLE
BEEVILLE ART MUSEUM

CORPUS CHRISTI
SOUTH TEXAS INSTITUTE FOR THE ARTS

LAREDO
LAREDO CENTER FOR THE ARTS

MCALLEN
INTERNATIONAL MUSEUM OF ART AND SCIENCE

ROCKPORT
ROCKPORT CENTER FOR THE ARTS

SAN ANTONIO
ARTPACE
BLUE STAR ART SPACE
CENTER FOR SPIRITUALITY AND THE ARTS
MARION KOOGLER MCNAY ART MUSEUM
SAN ANTONIO MUSEUM OF ART
SOUTHWEST SCHOOL OF ART AND CRAFT
WITTE MUSEUM

VICTORIA
NAVE MUSEUM

Also of Interest

CORPUS CHRISTI
ART CENTER OF CORPUS CHRISTI
JOSEPH A. CAIN MEMORIAL ART GALLERY, DEL MAR COLLEGE
WEIL GALLERY AT
 TEXAS A&M UNIVERSITY–CORPUS CHRISTI

SAN ANTONIO
CENTRO CULTURAL AZTLÁN
INSTITUTE OF TEXAN CULTURES
INSTITUTO DE MEXICO
MUSEO AMERICANO
SAN ANTONIO ART LEAGUE MUSEUM
UNIVERSITY OF THE INCARNATE WORD SEMMES GALLERY
UNIVERSITY OF TEXAS AT SAN ANTONIO
 UTSA ART GALLERY
 SATELLITE SPACE
 DOWNTOWN GALLERY

BEEVILLE ART MUSEUM

Esther Barnhart House
401 E. Fannin, Beeville 78104
361-358-8615
www.Beeville.net/BeevilleArtMuseum

Art museum/sculpture park

The Beeville Art Museum, funded by the Joe Barnhart
Foundation of Houston, makes available to the community
a broad range of visual arts exhibitions, from contemporary
sculpture to old master paintings borrowed from the Sarah
Campbell Blaffer Foundation.

Mon.–Fri. 9 a.m.–5 p.m., Sat. 10 a.m.–2 p.m.

The new addition and first floor of the original house are
wheelchair accessible, but the second-floor offices are not.

Free

Beeville Art Museum (exterior)

DETAILS

Joe Barnhart moved to Beeville from Childress in 1936 and lived there for a number of years before graduating, going to medical school, and making his fortune in the world. But he never forgot how the small town had welcomed his family. Accordingly, he instructed his Houston-based foundation to repay that kindness. The foundation established a modern library downtown and, in 1982, purchased a lovely Victorian home built in 1910 and situated alone on a tree-shaded city block in a residential area. And then the foundation turned the house into an art museum.

The Beeville Art Guild, now the Beeville Art Association, created an "Artist-of-the Month" exhibit to spotlight local talent and also exhibited the Barnhart Foundation's dozen or more Western paintings and family-owned sculptures. In 1996, when central heating and air-conditioning were added and other repairs made to the structure, the way was cleared for more ambitious programming. Four years later, a director was hired to oversee spring and fall exhibitions and related educational programming. With access through the foundation to Houston's collections, galleries, and freelance curators, the quality and number of annual exhibitions increased. "Contemporary Outdoor Sculpture," held in Meditation Park (sometimes called Barnhart Park), included works by Virginia Fleck, Kathy Hall, Sharon Kopriva, Charmaine Locke, Jesse Lott, Michael Man-jarris, James Surls, and Anne Wallace. Other exhibitions have drawn upon the Torch Energy Collection in Houston, the Sarah Campbell Blaffer Collection of old masters, and the Rockefeller Collection of Folk Art at the San Antonio Museum of Art. In a town of roughly 14,000 people, with a poverty rate of 27 percent, such gestures make a powerful difference. Educational programs for children and adults accompany every exhibition, and a new addition has just been constructed to provide on-site classrooms and additional gallery space.

Visitors from outside Beeville will take pleasure in seeing the art, as well as the old house with its ground-level and second-floor wraparound porches and lovely dark wood floors and trim. The new addition is not too jarring a presence, and the adjoining sculpture park remains beautifully serene. Professionally designed invitations and catalogs promise a continued big-city commitment to quality in this small-town institution, all provided courtesy of the now deceased Joe Barnhart.

HELPFUL HINTS

Beeville is easy to find; signage for the museum will guide you the rest of the way. Street parking is available.

*"Texas is my favorite country.
In Texas there is more interest in
carrying out the American dream
than anywhere else in the United States—
and this leads to wonderful things
for architecture."*

—PHILIP JOHNSON, ARCHITECT[2]

SOUTH TEXAS INSTITUTE FOR THE ARTS

(Art Museum of South Texas)
1902 N. Shoreline Dr., Corpus Christi 78401
361-825-3500
www.stia.org

Fine arts museum

This South Texas museum collects primarily modern and contemporary works and presents changing exhibitions of work from the region.

Tue.–Sat. 10 a.m.–5 p.m., Sun. 1 p.m.–5 p.m.

Entry ramp available from lower parking area by the Shoreline Drive docks. Front entry offers only stairs. Access may change when new addition is completed.

Adults $3, seniors and students $2, children under 12 free

Museum shop

Top: South Texas Institute for the Arts (exterior)
Bottom: *Dancing and Gold* by Dorothy Hood, 1970s, oil on canvas, 90" x 70".
Courtesy of South Texas Institute for the Arts.

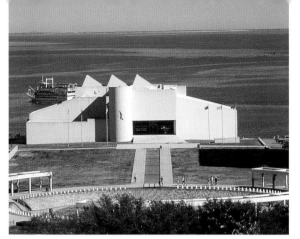

DETAILS

Of the 1,800 works in the museum's collection, approximately half are objects from the estate of noted Texas painter Dorothy Hood. An exhibition of Hood's work was presented in the spring of 2003 to introduce the artist and her art to museum audiences. The rest of the collection and temporary exhibitions also reflect the museum's commitment to art of the region. The museum also accepts gifts of high-quality works from outside the primary collection mission. Works on paper by Texans such as Terry Allen, Vernon Fisher, and Roy Fridge are joined by items from nationally recognized artists such as Richard Artschwager, Jenny Holzer, and Cindy Sherman. Sculptures in the collection include works by Jesús Moroles, Frederic Remington, and James Surls. As current director William Otton artfully states in the 1997 catalog, "Each director has brought his or her particular interest and direction to the collection."

Otton also brought about a major change in the organization of the museum by helping to establish an affiliation with Texas A&M University–Corpus Christi. The university provides an annual stipend for staff and other operating costs, which must be matched two to one by the community. In addition, the city contributes operating dollars, a portion of which are used for the museum-run Antonio E. Garcia Arts Education Center, a separate facility devoted to community outreach and exhibitions. The Garcia Center is located at 2021 Agnes (361-882-7837).

A catalog titled *Legacy: A History of the Art Museum of South Texas,* created to celebrate the twenty-fifth anniversary of the building, provides a detailed account of the history of the Art Museum of South Texas. According to it, the newly formed Corpus Christi Art Foundation petitioned the city in 1942 to turn the Centennial Memorial Museum, originally constructed to show science, history, and cultural exhibits, into a center for the arts. It was then renamed the Centennial Art Museum. Before long, a local arts council was formed, and with it came a long-range plan to create an Arts and Science Park at the entrance to the port.

Meanwhile, the Junior League took an interest in the museum and began to subsidize the salary of the director, Cathleen S. Gallander, who stayed for twenty years and oversaw the move from the original museum building to its handsome new home on the bay. With the move, a split occurred between local artists wanting to preserve the art center aspect of the insti-

tution and community supporters interested in creating a true museum. Today the Art League exhibits local artists' work in its own galleries at 100 Shoreline Drive.

Designed by Philip Johnson, the Art Museum of South Texas was opened in 1972. Edwin Singer and his wife, Patsy, who spearheaded the Corpus Christi project, had contacted Johnson on the recommendation of the de Menils in Houston. They gave him nearly free rein to design the $1.3 million building. The only visual context at the time was the beach and the bay, an architect's dream. As a result, the community received a tectonic wonder, white as the sand, sculptural in form, with water views framed so expertly that the museum's curator admits most people think the window is the best picture in the place. The lower floor houses a meeting room, educational facilities, some offices, and storage. The primary gallery on the main floor is a light-filled, high-ceilinged space. Smaller, more intimate galleries on the first and second floors provide flexibility.

As lovely as the museum was, however, Johnson had failed to provide room for storage. It didn't seem to matter at first—the building itself was the museum's first modern work—but soon donors (including Johnson himself) gave paintings to the museum and the collection grew. Before long, museum officials found themselves in the unenviable position of having to create storage space on the ground floor of the museum, below sea level. Today, it takes three hours to transfer those works to the upper-level galleries with every hurricane alert, a daunting responsibility in a coastal city with a museum on the waterfront. An addition, designed by Mexican architect Ricardo Legoretta, will provide an additional 4,500 square feet of exhibition galleries and safe storage space when completed. Construction begins in 2004.

HELPFUL HINTS

The exterior signage still reads "Art Museum of South Texas," and other materials as well reflect a slow transition from "museum" to "institute."

Visitors might also want to check out the Art Center of Corpus Christi, the Weil Gallery at Texas A&M University, the Joseph A. Cain Gallery at Del Mar College (all accessible by car), and the Asian Museum, which is within walking distance.

"The Art Museum of South Texas is the most exciting building I have ever done. . . . I wanted to create a space that in itself, without any pictures in it, without any reason for being, would be an exciting space. And second perhaps, I wanted to make a building that would have flexibility, such ease of installation that art of any and all periods . . . will be able to be placed and sympathetically understood."

—PHILIP JOHNSON, ARCHITECT[3]

500 San Agustin Ave., Laredo 78040
956-725-1715
www.laredoartcenter.org

Art center

The Laredo Center for the Arts programs its four exhibition galleries with a mixture of local and regional works, including the Texas Watercolor Society's annual exhibitions, an annual juried exhibition, the Art League's All Members Show, and a show featuring works by area schoolchildren.

Tue.–Fri. 9 a.m.–5 p.m., Sat. 10 a.m.–5 p.m., Sun. 1 p.m.–4 p.m.

Free

Laredo Center for the Arts (exterior)

DETAILS

The main entrance to the Laredo Center for the Arts on San Agustin Avenue is marked by a welcoming fountain and three sculptures by Mexican artist Mario Rendon Lozano that are owned by the center. It also holds a small collection of work belonging to the local Art League. Inside, visitors first enter the Goodman Gallery, a generous space with high ceilings. A second, even larger area, known as Exhibit Hall West, allows the center to host two distinct simultaneous exhibitions or to program the galleries together for the annual juried exhibition and Watercolor Society shows. Other exhibitions feature local and regional artists working in a variety of media and the Art League's annual membership exhibition. The small Community Gallery in between the two larger spaces doubles as a conference room and is reserved for children's art. Beyond Exhibit Hall West, a glass elevator moves visitors up to the mezzanine, a flexible space that can be rented for events.

The building was constructed in the 1880s as a *mercado,* or market, two blocks from San Agustin Plaza in the heart of Laredo. Over the years it housed municipal offices, the Laredo Police Department (including a jail), the municipal court, and the public library. The second floor also functioned as the city's first performing-arts space, for opera and theater. In fact, except for a brief interlude as a retail space and restaurant, it has always served as a center for civic and cultural functions. Today it is also home to the Laredo Philharmonic Orchestra, the Webb County Heritage Foundation, and the Laredo Art League.

HELPFUL HINTS

Parking is on the street and not always convenient, and temperatures are an uncomfortable 100+ degrees during the summer, but the center provides an important service to its primary (local) constituents and is worth a visit if you are in the area.

INTERNATIONAL MUSEUM OF ART AND SCIENCE

(formerly McAllen International Museum)

1900 Nolana, McAllen 78503
956-682-1564
www.imasonline.com

Art and science museum

The International Museum of Art and Science investigates the ways in which art and science intersect through exhibitions and programs aimed at both children and adults.

Tue. and Sat. 9 a.m.–5 p.m., Wed.–Fri. 9 a.m.–8 p.m., Sun. 1 p.m.–5 p.m.

Adults $3, children $2, Thu. 5 p.m.–8 p.m. free

Café (self-service)

Museum shop

DETAILS

The International Museum of Art and Science presents exhibits that explore both art and science and some that do both at the same time. The annual Wildlife Photo Contest, presented in partnership with the Valley Land Fund, provides an opportunity for visitors to learn more about the wild splendor of the Rio Grande Valley through the presentation of award-winning nature photographs. "Thin Skin: The Fickle Nature of Bubbles, Spheres, and Inflatable Structures," an exhibit organized by Independent Curators International of New York, featured humorous and seductive works of art involving malleable, inflatable materials. Exhibitions continue for six weeks to three months, and openings are staggered in the various galleries. The museum also presents solo exhibitions of select artists and excerpts from the museum's collection, which includes Latin American folk art, fine art, and a hands-on children's discovery room.

McAllen is situated in one of the fastest-growing areas in the country, and, accordingly, the museum serves more than 100,000 people annually, many of whom are children. It addresses the needs of twenty-eight surrounding school districts in an area roughly the size of Connecticut. Outreach to schools, including those in Mexico, has taken the form of exporting large traveling exhibits such as "Bubble Technology" and "Puppets around the World." Temporary exhibitions in the galleries, such as "Americanos: Latino Life in the United States," and RioScape, the museum's interactive science playground, address issues of place and the community's cultural heritage.

The museum opened in July 1976 at its current location as the city's bicentennial gift to its citizens. The 21,000-square-foot building served the city well for twenty-five years, but ultimately proved inadequate to accommodate its rapidly expanding audience. In 2001 an addition designed by Lake/Flato Architects of San Antonio added 20,000 square feet to the building. An outdoor playscape was underwritten by the Junior League. Five galleries in the original building have since been reconfigured, and a children's discovery pavilion, theater, and classrooms were added.

HELPFUL HINTS

The museum's emphasis, based on allocation of square feet, appears to be on science—and it clearly aims to attract children and families—but art fans will not be disappointed.

ROCKPORT CENTER FOR THE ARTS

902 Navigation Circle, Rockport 78382
361-729-5519
www.rockportartcenter.org

Art center

The Rockport Center for the Arts provides monthly changing exhibitions, including works by the center's artist members, local students, and visiting artists.

Tue.–Sat. 10 a.m.–4 p.m., Sun. 1 p.m.–4 p.m.

Free

Gift shop

DETAILS

Rockport's Center for the Arts has approximately nine hundred members, half of them working artists. No doubt it is the picture-postcard environment—gracefully bowed oak trees, water birds, and the glistening waterfront—that draws them to the locale. The main galleries are arranged around an enclosed service kitchen and have ten-foot ceilings and lots of track lighting to enhance the work. Monthly exhibitions feature watercolors and paintings that reflect the mood, if not always the specific landscape, of the coast, and they attract a substantial audience to opening receptions.

Beyond the galleries on either side are education rooms, including a pottery studio. Art classes are a critical component of the center's programming, which offers national and regional workshops and an annual summer art festival in July. Both kinds of events bring people from all over the country to Rockport. In fact, as far back as the nineteenth century, the port was a haven for artists who gathered in small groups to paint. The area reportedly has one of the highest concentrations of artists in the state, and a number of wealthy arts patrons maintain vacation homes nearby.

The Rockport Art Association incorporated in 1967 and in 1984 moved into a small nineteenth-century Victorian house, which donors moved to the current site and gave to the association. Over time a sculpture garden has been added with a small but growing collection of outdoor works, including *Rites of Spring* by Kent Ulberg and the granite *Lighthouse Fountain* and *Spirit Columns* by Jesús Moroles. The addition of the Garden Gallery increased exhibition space.

HELPFUL HINTS

To the right and left of a small entry foyer are the Pavilion Galleries, with members' artworks available for sale. The gift shop offers handcrafted items, postcards, and books.

Future plans include expanding the sculpture park, adding a café, and perhaps even initiating a midtown performing arts center. Until then, after leaving the galleries, it is enough to sit on a stone bench in the sunny sculpture garden and breathe in the salt air.

ARTPACE

445 N. Main, San Antonio 78205
210-212-4900
www.artpace.org

Art residency program

ArtPace, A Foundation for Contemporary Art, sponsors the
International Artist-in-Residence Program, bringing artists of
international renown to San Antonio to make and exhibit work
alongside national and regional artists.

Wed.–Sun. noon–5 p.m. (Thu. till 8 p.m.), and by appointment

Free

Personal Read by Mel Ziegler, 1999, ninety-four household lamps on a forty-foot flatbed trailer.
ArtPace exhibition 99.4.

DETAILS

At ArtPace, internationally recognized artists such as Vanessa Beecroft, Felix Gonzalez-Torres, Anthony Gormley, Annette Messager, and Tracey Moffatt have joined Texas-based artists such as Jesse Amado, Ken Little, Margo Sawyer, and Kathy Vargas to create new works and focus worldwide attention on San Antonio. A number of the artists have received recognition after their San Antonio experience, including two who won MacArthur fellowships, two who subsequently received Turner Prize nominations, and three who later appeared in the Whitney Biennial.

The Artist-in-Residence Program at ArtPace rotates three groups of three artists through studio/exhibition spaces annually. An outside curator is tapped to choose international, national, and South Central Texas artists to live and work on-site for two months. Guest curators have included Robert Storr (Museum of Modern Art, New York), Maaretta Jaukkuri (Kiasma Museum of Contemporary Art, Helsinki), and Okwui Enwezor (Art Institute of Chicago and curator of "Documenta 2002"). After a two-month residency, the artists' projects are presented to the public for viewing. During the artists' stay, ArtPace arranges potluck dinners, lectures, and other opportunities for the casual and formal exchange of ideas between artists and the community.

Additional exhibitions are held year-round by other artists in the Hudson [Show]Room, a large second-floor gallery space named to reflect the origins of the ArtPace edifice. Originally a Hudson dealership, the building was renovated by Lake/Flato Architects of San Antonio in 1995 and now stands as a somewhat quieter downtown complement to the boisterous Legoretta-designed public library a few blocks away. The architects initially carved out three large raw studio spaces where artists could create and then exhibit work during the course of their residency, several guest apartments, a small library, offices, a conference room, and a courtyard. In a second phase, additional offices and a rooftop patio were added.

The foundation itself also continues to evolve, moving slowly toward the traditional nonprofit model with a volunteer board to advise staff on policy. But while the organizational structure may one day be traditional, ArtPace intends to remain part of an international vanguard with regard to its programs, thereby facilitating the investigation of new ideas and art forms.

HELPFUL HINTS

For Art World insiders, ArtPace offers a welcome taste of New York, Venice, or Kassel, but if you're used to the traditional presentation of art as object, resident artists' installations and video projects may jolt your sensibilities. This is a good thing. Their mission is to promote and provoke dialogue. Be sure to look for the always informative exhibition brochures and call first or check the Web site to learn whether the ArtPace project spaces, as well as the gallery, are open to the public.

"*To be moved by art is to be lifted out of one's usual circumstances and taken out of oneself, the better to look back upon the place one has departed and the limited identity one has left behind. With or without metaphysics, and for however brief a moment it lasts, this state may fairly be called transcendence.*"

—ROBERT STORR, CURATOR[4]

116 Blue Star, Building C, San Antonio 78204
210-227-6960
www.bluestarartspace.org

Alternative space

Blue Star Art Space is a non-collecting visual arts space that exhibits work by emerging and established Texas artists and curators.

Wed.–Sun. noon–6 p.m.

BLUE STAR ART SPACE

DETAILS

Blue Star's warehouse-style space is divided into four galleries, allowing for maximum flexibility in programming. Exhibitions in the largest gallery change approximately every six weeks. Gallery Four, the smallest, is set aside to show the work of young area artists and curators, and exhibits here are rotated more frequently. The other two galleries are programmed individually, or in concert with the large gallery for special exhibitions. Exhibitions for 2003 included a survey of work by South Texas sculptors and a show of contemporary Mexican art arranged in collaboration with San Antonio's Instituto de Mexico in HemisFair Park. Even the organization's annual fund-raisers, such as the "Red Dot Sale," are usually a visual treat. No doubt this is due to the makeup of the board itself; at least half of its members are artists.

The origin of the Blue Star gallery dates back to the summer of 1986, when San Antonio Museum of Art curator Steve Bradley was dismissed from his position after planning a survey exhibition of work by twenty-seven local artists. When SAMA canceled the show, local artists, arts supporters, and property owners gathered together, and in only two months they located the space, raised money, produced a catalog, installed the work, and, after a hasty renovation, opened the first Blue Star exhibition to the public on June 27, 1986. Jeffrey Moore, who was then director of the Southwest Craft Center (now known as the Southwest School of Art and Craft), took a leading role in organizing the activity surrounding the exhibit. He also created a new support group for the arts called Contemporary Art for San Antonio (CASA) and convinced the City of San Antonio to proclaim July "Contemporary Art Month," a move that bolstered support for the exhibit from the city's other arts institutions.

Public response to the exhibition was overwhelming. Reportedly, two thousand people attended the opening, convincing the founders of the group that Blue Star Art Space should become a permanent fixture in San Antonio. For three years it functioned without paid employees; then Moore left the Craft Center and became director.

Contemporary Art Month continues every July, bringing together the growing San Antonio arts community. The Blue Star complex has been substantially upgraded since that first exhibition and now includes commercial galleries, eateries, performance spaces, residences, and businesses.

HELPFUL HINTS

The Blue Star complex is located just off South Alamo Street near Probandt. There is plenty of daytime parking in the lot. In addition to Blue Star Art Space, consider visiting the University of Texas at San Antonio Satellite Space and the commercial galleries that are in the Blue Star complex. On most first Fridays of the month, all are open from 6 p.m. to 9 p.m.

"Between Past and Future," June 27–August 18, 2002, exhibition at Blue Star Art Space. Curator: Maria Elena Botello Mogas.

SAN ANTONIO

CENTER FOR SPIRITUALITY AND THE ARTS

4707 Broadway, San Antonio 78209
210-829-5980
www.spiritualityandthearts.org

Multidisciplinary art center

The Center for Spirituality and the Arts, a ministry of the Sisters of Charity of the Incarnate Word, presents exhibitions that encompass a variety of art forms within a diverse religious, cultural, and historical context.

Mon.–Fri. 10 a.m.–5 p.m., Sat. 1 p.m.–4 p.m.

Free

Gift shop

DETAILS

The center's primary gallery, which is located upstairs (visitors can ask to use the lift if they can't negotiate the open wooden steps), is a long, narrow space with gray painted wood floor, a high-pitched ceiling, track lighting, and neutral-toned carpet-covered walls. The 1,200-square-foot former hayloft features emerging and established artists from the region such as Larry Graeber, Leticia Huerta, and Kent Rush in roughly six exhibitions a year. Shows encompass a wide variety of media and styles, not unlike those in secular-based contemporary spaces. Exhibitions may occasionally also include historical or ethnographic exhibitions.

Some might recall that in 1994 the archbishop prematurely closed an exhibition at the center that included angels engaged in what some believed was unbecoming behavior. The artist sued, and the incident received national press. But more noteworthy is that there has been only one such incident in the life of this unique art space. Perhaps spirituality and contemporary art are more compatible than the secular art press would have us believe.

In 1991 the Sisters of Charity of the Incarnate Word completed the restoration of a nineteenth-century dairy barn next to the campus of the University of the Incarnate Word to use as an exhibition space and for programs to complement their other activities. A board was formed to include community members and Incarnate Word sisters, and in the late nineties a director was hired. The old barn has adapted surprisingly well to its new mission, upstairs and down. The shelves on either side of the long, narrow first-floor gallery echo the feeding troughs that once were there. They serve as the gift shop, with an extensive assortment of crafts, art objects, and other items on display and available for purchase. Classes, lectures, and discussion groups occur in this area, with administrative offices beyond. Workshops are as likely to include tai chi chuan, hatha yoga, reflexology, and prayer as well as drawing, painting, and crafts, creating a sixties-style ambience.

HELPFUL HINTS

The center is located between the McNay and the Witte Museums on Broadway and next to the University of Incarnate Word. Visitors may also want to visit the Semms Gallery in the university's Fine Art Building.

"I think the most rewarding museums anywhere are those that are in°former residences, where the personality of the original owner and collector is reflected in every detail of the building."

—JOHN LEEPER, FORMER DIRECTOR,
MARION KOOGLER MCNAY MUSEUM[5]

6000 N. New Braunfels, San Antonio 78709
210-824-5368
www.McNayArt.org

Fine arts museum

In Marion Koogler McNay's gracious former home, the museum makes available to the public its extensive collection of nineteenth- and twentieth-century European and American art, the Tobin Collection of Theater Arts, and much more.

Tue.–Sat. 10 a.m.–5 p.m., Sun. noon–5 p.m.

Wheelchair accessible except for the Tobin Wing. Special arrangements can be made in advance or with the guard upon entering the museum for wheelchair access.

Free (with the exception of selected special events)

Museum shop

MARION KOOGLER MCNAY ART MUSEUM

DETAILS

Modern Art at the McNay, a lovely book celebrating the museum's twenty-fifth anniversary, begins with representative images of works in the collection by Francisco Goya, Eugène Delacroix, and Honoré Daumier, moves on to Mary Cassatt, Pierre-Auguste Renoir, and Claude Monet, and ends with Donald Judd, Joel Shapiro, and Leonardo Drew. Clearly the McNay is committed to exploring the Modern period, nineteenth- and twentieth-century art, as well as its contemporary legacy. The museum also owns the Oppenheimer Collection of medieval and Renaissance art and the Tobin Collection of Theater Arts, which includes thousands of rare books, stage designs, drawings, and prints. A number of works by sculptors such as George Rickey, Joel Shapiro, and others enjoy an idyllic outdoor setting. Temporary exhibitions have included solo shows for artists of the region, such as Jesse Amado, Dan Sutherland, and Kathy Vargas, as well as works culled from the museum's extensive holdings. Other exhibitions, organized by the museum or by institutions nationwide, are presented to complement the McNay's collection.

A video detailing the life of Marion Koogler McNay runs continuously in a small meeting room on the second floor of the museum, providing insight into what appears to have been a privileged but perhaps lonely life for one of San Antonio's great patrons of the arts. An only child, Jessie Marion Koogler was born in Ohio in 1883 and studied at the Art Institute of Chicago before becoming a public school art supervisor. In 1917 she married Don Denton McNay, who was ten years her junior. McNay, who had enlisted in the army before they met, died of the flu while stationed in Florida. His wife of ten months was at his side. She married three more times over the years, but it was McNay who provided the name that she took back after each divorce.

Her father provided the sixty acres of oil-rich land in Kansas that would later finance her passion for collecting art. And it was her marriage to Dr. Donald Atkinson in 1926 that brought her to San Antonio, where the couple built a Spanish Colonial Revival-style mansion on twenty-three verdant acres. Designed by San Antonio architects Atlee and Robert Ayres, the original house consisted of twenty-four rooms filled with pre-Depression-era tile from around the world. It was also embellished with wrought-iron window grilles, coffered and stenciled ceilings, and graceful archways and spectacular gardens. Today, a rough stucco exterior defines the original old home, while new construction bears a smoother surface.

When McNay died in 1950, she left her collection, decorative and house-

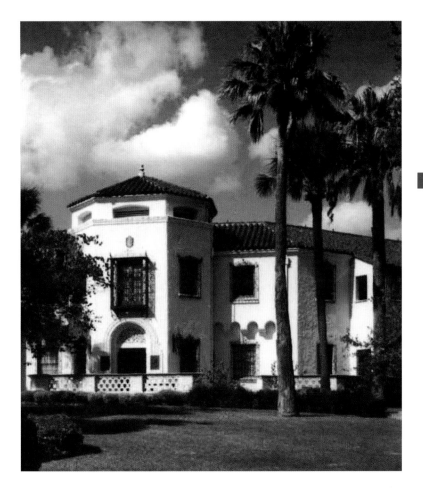

Marion Koogler McNay Art Museum (exterior)

hold objects, the house and surrounding acreage, and most of her fortune to create a museum "for the advancement and enjoyment of modern art." Most of the endowment was restricted to supporting the operation of the museum, as she assumed that the several hundred objects in the collection were sufficient for the museum's purposes. A seven-person board was charged with smoothing the transition from private collection to public museum. They hired John Leeper as the first director in 1953 and chose Ayres and Ayres to modify the home. When the museum opened to the public in 1954, it was the first privately endowed art museum in Texas.

The Leeper years saw the transformation of the small private collection into a much more complex entity. Today the museum collection includes approximately 14,000 objects, including almost 10,000 in the Tobin Theater Arts Collection, 450 paintings and sculptures, and more than 3,000 prints and drawings. The library has more than 30,000 volumes for public reference, as well as periodicals. Through a series of successful capital campaigns, the building has been expanded a number of times to include the Brown Pavilion, the Marcia and Otto Koehler Fountain and adjoining Esplanade, the Lang Galleries, the Jack and Adele Frost Wing, the Lawson Print Gallery, the Tobin Wing, the Jane and Arthur Stieren Wing, and the Blanche and John Leeper Auditorium. Leeper, now deceased, spent thirty-seven years with the McNay, setting the course of the institution, before passing the torch to the current director in 1991. Most recently, architectural elements of the original house have been upgraded, along with museum systems. Now all that remains are plans to add another gallery for temporary exhibitions and to deal with buildings left behind by the now defunct San Antonio Art Institute.

During the war years, McNay invited the Witte Museum's art education program to take up residence in an old aviary on her property after the Witte's location was given over to the war effort. When she died, she left it to the new board to decide whether the art school would become part of the museum. The board voted to create the San Antonio Art Institute with a separate board to oversee art classes on the grounds. Beginning in the seventies, the Art Institute built three education buildings, the last one designed by Charles Moore. But after trying and failing to be accredited, the institute went bankrupt in the early 1990s, and the buildings became the property of the McNay, which tore down the Moore building in 2003 and uses the others.

HELPFUL HINTS

Parking is plentiful, the grounds are inviting, and a gallery map is available at the reception desk.

Dream Village by Marc Chagall, 1929, oil on canvas, 39½" x 29⅛". Bequest of Marion Koogler McNay, 1950.24. © 2004 Artists Rights Society (ARS), New York/ADAGP, Paris.

SAN ANTONIO MUSEUM OF ART

200 W. Jones Ave., San Antonio 78215
210-978-8100
www.samuseum.org

Fine arts museum

The San Antonio Museum of Art presents significant artistic achievements of the world's cultures from ancient times to the present drawn from its diverse collections and presented through changing exhibitions.

Tue. 10 a.m.–8 p.m., Wed.–Sat. 10 a.m.–5 p.m.,
Sun. noon–6 p.m., third Thu. till 8 p.m.

Adults $6, seniors $5, students $4, children 4–11 $1.75,
children 3 and under free

Museum shop

Top: San Antonio Museum of Art (exterior)
Bottom left: Water support vessel, Oaxaca, Mexico, painted earthenware, 27" x 14½". The Nelson A. Rockefeller Mexican Folk Art Collection.
Bottom right: *Nicolés of Tolentino Performing a Miracle* by Alonso Lopez de Herrera (Mexico), seventeenth century, oil on panel, 14½" x 11½"

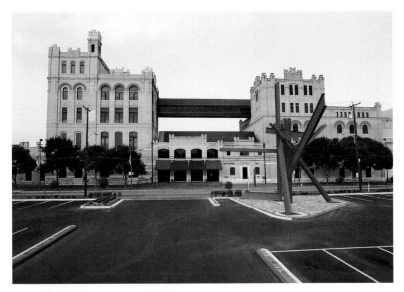

Santo Niño de Atocha (Mexico), oil on tin, 12¾" x 9¾".
The Nelson A. Rockefeller Mexican Folk Art Collection.

DETAILS

The San Antonio Museum of Art is South Texas' only major comprehensive art museum and, according to the current director, serves a population of more than one million people. Museum collections include American eighteenth- and nineteenth-century decorative arts and paintings with representative works by John Singleton Copley and Gilbert Stuart, among others, and Asian paintings, sculptures, and decorative arts. The 1986 Gilbert M. Denman, Jr., gift of classical antiquities reportedly includes one of the largest and most comprehensive collections of Greek vases and Graeco-Roman sculptures in the nation. And an $11 million wing was added in 1998 to house the Nelson A. Rockefeller Center for Latin American Art and collections, which spans four thousand years of Latin American history. These include pre-Columbian works, folk art, Spanish Colonial and Republican art, as well as Modern art. The folk art collection includes approximately 2,500 pieces from the collection of the late Nelson A. Rockefeller, donated by his daughter Ann Rockefeller Roberts in 1985. The museum also collects and exhibits post–World War II American painting and sculpture, including works by Helen Frankenthaler, Philip Guston, and Hans Hoffman, and it displays contemporary Texas art from time to time.

The San Antonio Museum of Art grew out of the San Antonio Museum Association, the organization formed to establish and support the city's Witte Museum in the mid-1920s (see the Witte Museum listing). In the early 1970s, the rapid growth of the association's fine art collections and the addition of art historian Jack McGregor as director helped shift the focus of the organization away from its initial attention to science and history of the region toward art.

In 1971 McGregor discovered the dilapidated 1884 Lone Star Brewing Company building and brought it to the attention of the board. The Anheuser-Busch Brewing Association of St. Louis had purchased the brewery in 1892 and expanded the facility over the next twenty years, adding the castlelike towers in 1904. The structure fell into disrepair after Prohibition despite attempts to find other uses for it. The board supported McGregor's vision to acquire the facility for use as an art museum to complement the Witte's science and history programs. Seven years of planning, fundraising, and renovation followed. The Lone Star Brewery was entered on the National Register of Historic Places in 1972 and soon was completely transformed by Boston's Cambridge Seven Architects, a newsworthy example of

adaptive reuse. On July 13, 1977, Mayor Lila Cockrell christened the new museum with the breaking of a bottle of beer. The doors opened to the public on March 1, 1981.

The brew house became the art museum, and the seven auxiliary buildings were restored to serve as offices, storage, and educational facilities. The museum's towers and the turrets of modified Romanesque design resembling medieval fortification were retained, with this change: each tower gained a glass elevator. Glass also encloses the "skywalks" that assist in organizing the space and orienting visitors, which is a substantial challenge. The old brewery yielded more than 100,000 square feet of museum space. Seventy thousand square feet were devoted to exhibitions, the lion's share of which are permanent installations of the collection. Gifts came to the museum almost immediately, necessitating the redesign of certain galleries and expansion of the original curatorial focus.

The adaptation of the old brewery allowed the Witte Museum to renovate its building and to reorganize exhibits. Subsequent financial strains in the late 1980s and conflicting priorities soon made it clear that the San Antonio Museum Association was trying to manage two very different entities. In June of 1994 the two museums were separated and the association dissolved. The Museum of Art now has a staff dedicated solely to exploring the world's artistic heritage, while the Witte uses its art collection as a tool in service to the exploration of the history and culture of the region. The original Texas collection was, after much negotiation, divided between the two entities.

HELPFUL HINTS

The Rockefeller Wing in particular provides a cohesive and satisfying museum experience, as does the Ewing Halsell Wing, where the Denman Collection is housed. Otherwise, the transition from one period to the next can be a bit bumpy. Leave plenty of time if you want to see all of the galleries and the museum shop too. Free parking is available in the lot across the street.

"More than places to store and show art, museums are monuments that express a city's identity and convey its prestige."

—ALAN LESSOFF, HISTORY PROFESSOR[6]

SOUTHWEST SCHOOL OF ART AND CRAFT

Russell Hill Rogers Gallery–Navarro Campus
1201 Navarro, San Antonio 78205
Ursuline Campus
300 Augusta, San Antonio 78205
210-271-3374
www.swschool.org

Art school and gallery

The Russell Hill Rogers Gallery on the Southwest School of Art and Craft Navarro campus exhibits the work of emerging and established artists who explore the boundaries between art and craft.

Mon.–Sat. 9 a.m.–5 p.m., Sun. 11 a.m.–4 p.m.

Free

Copper Kitchen Café, Ursuline campus, open Mon.–Fri. 11:30 a.m.–2 p.m.

Gift shop (Ursuline campus) open Mon.–Sat. 10 a.m.–5 p.m.

DETAILS

Over the years nationally recognized artists, including Rudy Autio, Michael Kenna, Mary Ellen Mark, Nance O'Banion, Betye Saar, and Toshiko Takaezu, have taught workshops and classes at the institute, formerly known as the Southwest Craft Center. The school was located in a historic Ursuline convent downtown and included a gallery space for exhibitions by students, faculty, and local, regional, and national artists of note. In 1998 local architects Lance, Larcade, and Bechtol created classrooms and exhibition spaces out of a former Sears Automotive building diagonally across the street from the old convent.

More than a tenth of the new 33,000-square-foot building is devoted to a polished exhibition space. The gallery, which has recently begun acquiring works by faculty and students, presents roughly six exhibitions a year showcasing ideas, skills, and materials that relate to contemporary issues and to the adult studio curriculum. These have included a printmaking invitational, featuring works created by nine artist-run presses in Texas, New York, Maryland, Minnesota, and Canada, and solo exhibitions of work by Barbara Cooper of Chicago and the late Robert Wilson of San Antonio. Printed educational materials and ancillary programming are a part of almost all exhibitions.

The Southwest Craft Center was incorporated back in 1965 by a group of artists interested in craft media and eager to share their enthusiasm and knowledge of contemporary craft with a larger audience. In 1968 the center opened its first gallery at La Villita to coincide with the citywide celebration of HemisFair. Two years later, the facility moved to the Ursuline campus.

The historic Ursuline Convent and Academy was established in 1851 and expanded over the next two decades. French architect and city planner François Giraud (his name was given to a nearby street) designed the dormitory and chapel buildings that were added over the next two decades. When, in the 1960s, the Ursuline sisters moved to a suburban site, the San Antonio Conservation Society purchased a portion of the property and had it listed in the National Register of Historic Places. A developer purchased the rest. In 1972 the Conservation Society offered its property to the Craft Center, which managed, over time, to purchase the rest of the site from the developer and to restore the remaining historic buildings.

Finally, in 1992, in order to satisfy increasing need for more space without endangering the historic site, the center purchased the site at Navarro

and Augusta, across the street from the downtown library and steps away from the Ursuline campus. While the dreamy, tree-covered five-acre historic site fronts the river and attracts weddings and private parties on the grounds, the green and metal building with bright accents on the one-acre Navarro campus provides a delightful urban homage to the Legoretta library.

HELPFUL HINTS

Parking is limited on the Navarro campus, so visitors may need to use the low-cost library parking garage or leave their cars at the Ursuline campus parking lot. The sales gallery and hallway gallery in the main building on the old site are also worth visiting, as is the visitors center museum, which houses historic artifacts.

Southwest School of Art and Craft 2000 exhibition, including (foreground, from left) *Ofrenda for a Maja* by Sandra Ortiz Taylor (1994, mixed media); *Los Mirones del Metro* by Ricardo Anguia (1999, assemblage); *Crooked-Nosed Man/Narizón* by Pamela Scheinman (1987, Xerox and acrylic paint on plaster bas-relief). Photo by Al Rendon.

WITTE MUSEUM

3801 Broadway, San Antonio 78209
210-357-1900
www.wittemuseum.org

Art collection within a history and science museum

The Witte, although best known for its science and history collections and exhibits, holds an extensive collection of Texas oil paintings, works on paper, folk art, and more. It displays these objects, along with borrowed works, as part of its mission to explore the history of the land and its the people.

Mon.–Sat. 10 a.m.–5 p.m. (Tue. till 9 p.m.), Sun. noon–5 p.m.

Adults 12–64 $5.95, seniors $4.95, children 4–11 $3.95, children 3 and younger free, members free

Museum shop

DETAILS

Art exhibitions at the Witte are primarily assembled in service to the historical mission of the museum; the curatorial bent is toward images that tell a story. In a second-floor gallery reserved for art, one is likely to find accomplished paintings and original prints of, for example, Texas missions or the depiction of ranch life. There are now 3,500 art objects in the collection, with such artists as Theodore Gentilz, Julian Onderdonk, Robert Onderdonk, and Porfirio Salinas represented.

The Witte Memorial Museum was opened in 1926 as a result of the efforts of a determined public school teacher, Ellen Schulz Quillin, who organized a successful effort to raise $5,000 to acquire an extensive natural history collection. Quillin was also instrumental in the formation of the San Antonio Museum Association to oversee the funds and to secure additional money for a proper museum building. A $65,000 bequest left to the city by wealthy businessman Alfred Witte and other donations made possible the construction of the museum in Breckenridge Park. Until 1960 Quillin served as director (at a salary of $1 a year) while she continued her teaching career. Ellen Onderdonk, daughter and sister of famed Texas painters Robert and Julian Onderdonk, was art curator from 1927 to 1958. Aided by a $10,000 endowment established by Witte for the purpose of collecting paintings, she concentrated on acquiring Texas art and organized exhibitions that encouraged donors to contribute additional works to the museum. She was succeeded as curator by Martha Utterback, who compiled a book on the association's collection, *Early Texas Art in the Witte Museum,* published in 1968. Three years later Utterback collaborated with Jerry Bywaters of Southern Methodist University in Dallas to assemble a show called "Texas Painting and Sculpture: The 20th Century," which traveled to Dallas, Fort Worth, Austin, and Lubbock.

Meanwhile, big changes were taking place in San Antonio's museum community. The San Antonio Art League, which had been instrumental in raising initial funds to build the Witte, moved out of its second-floor exhibition galleries in 1972 to a building in the King William District. The San Antonio Museum Association, which had won national attention for several exhibitions of Texas crafts, folk art, and decorative arts curated by Celia Steinfeldt, made plans to expand. Under the leadership of director Jack McGregor, the association purchased San Antonio's old Lone Star Brewery and adapted it for use as an art museum (see the San Antonio Museum of

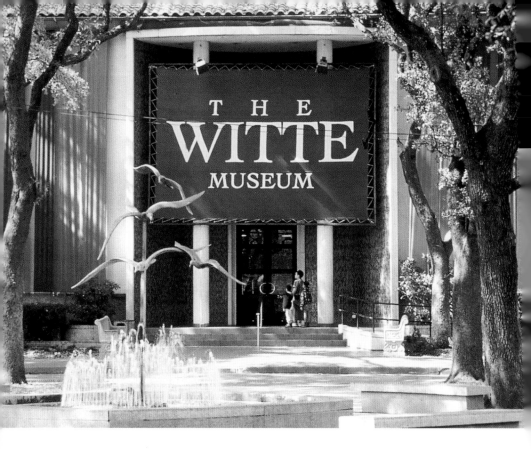

Witte Museum (exterior). Courtesy of the Witte Museum, San Antonio, Texas.

Art listing). Thus the association split its attention and resources between a history museum, the Witte, and a new fine arts museum housed in the brewery and christened the San Antonio Museum of Art.

A little over a decade later, the association dissolved as a result of financial strains in the late 1980s and conflicting priorities that arose as it tried to manage two very different institutions. After much negotiation, the Witte and the San Antonio Museum of Art divided the collection. For the most part, post-1945 art was shuttled to SAMA. But not all of the decisions seem logical. The Karl Umlauf statues that grace the exterior of the Witte Museum to this day belong to SAMA. The institutions actually share joint custody of one nineteenth-century painting, *San Jose Mission* by William Allen Walker. And a wonderful portfolio of works on paper by untrained artist Charles Dellschau was divided in half and its handmade cover discarded. But for the most part the Witte retained older historical works and continues to build its Texas artists files containing scrapbooks, sketchbooks, ephemera, and support materials. The Bybee Furniture Collection went to SAMA, but there are still examples of primitive Texas furniture at the Witte.

HELPFUL HINTS

If you're put off by the thought of dinosaurs, a science treehouse, or history exhibits, you might call first to see which objects of art the museum has on display. The museum shop, on the other hand, always delivers something for everyone.

NAVE MUSEUM

306 W. Commercial, Victoria 77901
361-575-8227
www.vrma.viptx.net/museum

Fine arts museum

The Nave is a fine arts museum serving Victoria and the surrounding region through presentation of changing exhibitions focused on work by emerging and established artists of the region.

Tue.–Sun. 1 p.m.–5 p.m.

Adults $2, children $1, members free

Museum shop

Nave Museum (exterior)

DETAILS

In the 1980s Victoria, a town of about 70,000 people, reported more millionaires per capita than any other city in the United States. That affluence has provided a number of regional hospitals, a cancer center, a two-year college and four-year university (University of Houston, Victoria), and a surprising little art museum for the community. Over the years, the Nave has exhibited work by internationally recognized abstract painter and American expatriot Joan Mitchell, as well as by Texas' own art stars, including Madeline and Nancy O'Connor of Victoria. During booming economic times, the sky was the limit, and shows were organized to compete with the best exhibits that Houston and Dallas museums had to offer. In recent years, the museum has refocused its attentions, presenting a more modest exhibition schedule, although with artists like Melissa Miller and Julie Speed it has clearly not sacrificed quality in favor of budgetary restraint.

The museum only occasionally displays its collection of thirty-five to forty paintings by well-regarded regional artist Royston Nave, landscapes and portraits that are most interesting for the story they represent. Emma McFaddin, daughter of a wealthy rancher, married James McCan, also an artist, in 1897. His murals graced the interior of their home, a wedding gift from the bride's father. The couple had one son. But Emma divorced McCan in 1916 and set local tongues wagging when she married Royston Nave the next year. When Nave died unexpectedly in 1931 at the age of forty-four, Emma commissioned the museum building, a classical structure designed by San Antonio architect Atlee B. Ayres, to display his paintings.

For many years the town library was also located in the Nave, but in 1976 the McCan family donated the building to the city as an art museum. There are two straightforward rectangular high-ceilinged galleries (the McFaddin and DeTar Galleries) and a small gift shop situated between them. The second gallery was a 1960s addition to the original structure. The Victoria Regional Museum Association operates the Nave, as well as the McNamara House, a social history museum in an 1890 Victorian home on the corner of Power and Liberty Streets. Administrative offices for both are located at McNamara House.

HELPFUL HINTS

The Nave programs four or five exhibitions a year and usually closes for a month during the summer. Check the Web site for the exhibition schedule if you're making a special trip to see the museum.

"Of course the nice thing would be if the trustee would simply give the director the funds and let him buy whatever he wants. But of course that is the fun of it and nobody wants to distribute pleasure lightly."

—JOHN LEEPER, FORMER DIRECTOR,
MARION KOOGLER MCNAY ART MUSEUM[7]

ART CENTER OF CORPUS CHRISTI

100 Shoreline Dr., Corpus Christi 78401
361-884-6406

This beachfront art center features changing exhibits by local artists, a gift shop, and Jezebelle's Restaurant.

JOSEPH A. CAIN
MEMORIAL ART GALLERY

Del Mar College, Fine Arts Center (East Campus off Ayers
Street), Corpus Christi 78404
512-886-1216
www.delmar.edu/art/events.html

The Cain Gallery presents contemporary exhibitions, including
an annual national drawing and small sculpture show, student
exhibitions, and the like. It also maintains and exhibits a
collection of works by emerging artists.

WEIL GALLERY AT TEXAS A&M UNIVERSITY–CORPUS CHRISTI

6300 Ocean Dr., Corpus Christi 78412
512-994-2314

The gallery presents contemporary exhibitions assembled to support students and faculty at Texas A&M University–Corpus Christi. The university is also affiliated with the South Texas Institute for the Arts.

CENTRO CULTURAL AZTLÁN

Las Palmas, 803 Castroville Rd., San Antonio
210-432-1896

Located on the southwest side of town, Centro Cultural Aztlán's Galería Expresión presents up to ten exhibits a year by emerging and mid-career artists in an effort to support and strengthen Chicano/Latino culture and identity. Youth programs, the annual lowrider festival, and projects involving literary arts and music also fall within the scope of the organization. Since the demise of the Guadalupe Center's visual arts program after the departure of director Kathy Vargas several years ago, this promises to be the gallery to watch for a new wave of consistently professional community-based exhibitions and programs.

INSTITUTE OF TEXAN CULTURES

801 S. Bowie, San Antonio 78205
210-458-2300
www.texancultures.utsa.edu

The Institute of Texan Cultures, created as the Texas Pavilion at HemisFair in 1968, operates as a campus of the University of Texas at San Antonio. It is an educational center dedicated to exploring the diverse cultures represented in the state. Exhibits often include art, which is presented in support of the broader goals of the institute.

INSTITUTO DE MEXICO

600 Hemisfair Plaza Way, San Antonio 78205
210-223-1500

The Instituto de Mexico, supported by Mexico's Minister of Foreign Affairs, promotes Mexican culture through exhibitions, concerts, lectures, and literary projects. As many as thirty exhibitions a year in the Instituto's galleries feature works by Mexican artists and—only during San Antonio's contemporary art month (July)—works by local and Latin American artists. The new facility faces the convention center, while a nearby annex known as Casa Mexicana offers additional programming in two small galleries.

MUSEO AMERICANO

101 S. Santa Rosa, San Antonio 78205
210-299-4300 (for the Alameda, the museum's parent
organization) www.thealameda.org

Construction began in August 2002 for the new Museo
Americano, scheduled to be completed late in 2004. The
museum, already designated as a Smithsonian affiliate and
the official Texas State Latino Museum, is located in Market
Square. Exhibitions will focus on Latino art, history, and
culture. The facility will also feature a museum shop and public
sculpture garden.

SAN ANTONIO ART LEAGUE MUSEUM

130 King William, San Antonio 78204
210-223-1140
www.saalm.org

The Art League, a volunteer-run facility, is headquartered in a restored nineteenth-century carriage house in the King William District. It is San Antonio's oldest arts organization. The galleries feature excerpts from the permanent collection (works by local and regional artists), an annual art competition, holiday art fairs, and other locally based shows.

UNIVERSITY OF THE INCARNATE WORD SEMMES GALLERY

Fine Arts Building
4201 Broadway, San Antonio 78209
210-829-3853

This small university gallery exhibits work by San Antonio area artists. Visitors can enter the gallery directly without wandering through the building.

UNIVERSITY OF TEXAS AT SAN ANTONIO

UTSA ART GALLERY
6900 North Loop 1604 W., San Antonio 78249
210-458-4391

SATELLITE SPACE
Blue Star Arts Complex
115 Blue Star, San Antonio 78204
210-212-7146

DOWNTOWN GALLERY
UTSA Downtown Campus Durango Building
I-10 and Durango

The UTSA Art Gallery in the Arts Building on campus and the off-site Satellite Space within the Blue Star Arts Complex present contemporary art exhibitions of works by regional and national artists as well UTSA students and faculty. The Art Building galleries are closed during the summer. The Satellite Space, which is open primarily on weekends, also provides opportunities for curatorial projects by graduate students in art history. The Downtown Gallery has limited weekday hours and a more conservative exhibition program than the other two galleries.

CENTRAL TEXAS

CENTRAL TEXAS, WITH ITS ROLLING HILLS AND relatively temperate climate, attracts more than its share of visual artists, but it has been oddly reluctant to support major visual arts institutions. Not until the Jack S. Blanton Museum of Art opens its new facility on the University of Texas campus in Austin in 2005 will the Central Texas area finally have its first freestanding general art museum. Until the end of 2004, the museum will continue presenting exhibitions in the first-floor and mezzanine galleries in the University Art Building. It will then close temporarily in preparation for the move.

The Blanton, formerly known as the Archer M. Huntington Gallery, has been around for some time, but in the past decade the museum has increased its holdings considerably, most notably through acquisition of the Suida-Manning and Leo Steinberg Collections, and revitalized its contemporary art programming.

The Blanton's treasures are complemented by those at the Harry Ransom Humanities Research Center, another UT institution with extensive collections that include art, ephemera, literary archives, photography, and film. For thirty years the two institutions shared the Humanities Research Center building at the corner of Guadalupe and 21st Streets; the Blanton exhibited its permanent collections on the first and second floors, and the HRC exhibited in small galleries created on the upper floors. Only recently, after the Blanton withdrew from the building, have the HRC collections stepped out from behind the Blanton's shadow.

The Austin Museum of Art provides first-rate exhibitions of contemporary and Modern art at its temporary downtown location and at the original Laguna Gloria site on West 35th Street. With few exceptions, AMOA offers a stellar array of

emerging and established artists (primarily Americans), including members of the local community of working artists. But the museum can't seem to take two steps forward without stumbling back when it comes to building a new museum of its own. The more-than-twenty-year effort is once again stalled.

In addition to the UT exhibition galleries and AMOA, Central Texas offers an eclectic assortment of small, single-focus exhibition spaces devoted to numerous interests, ideas, and individuals of note. What the area's institutions share is their determined individuality. Together with the Blanton, the HRC, and the AMOA, they provide a broad spectrum of visual experience for visitors to the region.

In Austin, the Umlauf Sculpture Garden and Museum showcases the work of sculptor Charles Umlauf (1911–1994) in an urban park setting. The Elisabet Ney Museum preserves the studio and living quarters of that artist (1833–1907), as well as a selection of her sculptures. Women and Their Work focuses, as the name implies, on art produced by women. Mexic-Arte presents Latino artists, MedAid's Gallery 106 specifically showcases Cuban Art, and the George Washington Carver Museum (set to reopen in 2004) offers a community-based African American perspective. Arthouse at the Jones Center, once known as the Texas Fine Arts Association, is the oldest statewide visual arts organization and focuses, as it always has, on the work of contemporary Texas artists.

In San Marcos, the Wittliff Gallery of Southwestern and Mexican Photography applies a regional template to the medium of photography, while Kerrville's National Center for American Western Art, home of the Cowboy Artists of America Museum, presents painting, sculpture, and works on paper with

a particular nostalgia for the Old West. Art Center Waco and Temple's Cultural Activities Center are tuned to the interests and needs of their own respective communities. Similarly, university art department galleries in the region, most notably Baylor University's Martin Museum of Art and University Gallery, which has a modest collection, and UT's Creative Research Laboratory, with a new East Side location, create programs for campus communities.

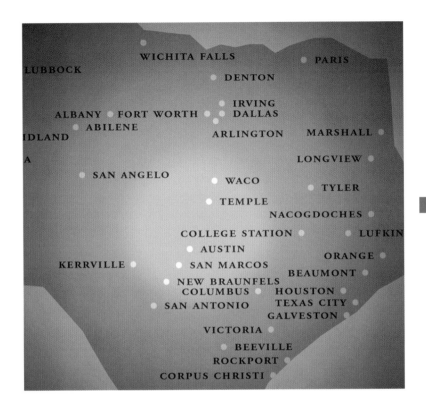

AUSTIN

ARTHOUSE AT THE JONES CENTER
AUSTIN MUSEUM OF ART
AUSTIN MUSEUM OF ART AT LAGUNA GLORIA
CREATIVE RESEARCH LABORATORY
ELISABET NEY MUSEUM
GALLERY 106
HARRY RANSOM HUMANITIES RESEARCH CENTER
JACK S. BLANTON MUSEUM OF ART, UNIVERSITY OF TEXAS
MEXIC-ARTE MUSEUM

UMLAUF SCULPTURE GARDEN AND MUSEUM
WOMEN AND THEIR WORK

KERRVILLE
NATIONAL CENTER FOR AMERICAN WESTERN ART:
 HOME OF THE COWBOY ARTISTS OF AMERICA MUSEUM

SAN MARCOS
WITTLIFF GALLERY OF SOUTHWESTERN AND
 MEXICAN PHOTOGRAPHY

TEMPLE
CULTURAL ACTIVITIES CENTER

WACO
ART CENTER WACO

Also of Interest

AUSTIN
GEORGE WASHINGTON CARVER MUSEUM AND CULTURAL CENTER
JULIA C. BUTRIDGE GALLERY AT THE DOUGHERTY ARTS CENTER
LA PEÑA GALLERY
NANCY WILSON SCANLAN GALLERY,
 ST. STEPHEN'S EPISCOPAL SCHOOL
TEXAS FOLKLIFE RESOURCES GALLERY

NEW BRAUNFELS
NEW BRAUNFELS MUSEUM OF ART AND MUSIC

WACO
MARTIN MUSEUM OF ART AND UNIVERSITY GALLERY,
 BAYLOR UNIVERSITY

ARTHOUSE AT THE JONES CENTER

700 Congress Ave., Austin 78701
512-453-5312
www.arthousetexas.org

Art center

Arthouse, formerly known as the Texas Fine Arts Association (TFAA), offers a steady diet of cutting-edge contemporary exhibitions and ideas celebrating the art and artists of Texas and presents Texas-based work in a national context.

Tue.–Fri. 11 a.m.–7 p.m. (Thu. till 9 p.m.),
Sat. 10 a.m.–5 p.m., Sun. 1 p.m.–5 p.m.

Free

Arthouse at the Jones Center (exterior), January 2003. Photo by Jack Plunkett.

DETAILS

Arthouse features work by both emerging and established artists, and encourages new curatorial voices as well, such as Regine Basha, Alejandro Diaz, Erina Duganne, and Alexander Dumbadze. Exhibitions at the Jones Center include painting, drawing, sculpture, installation, video, and new media that echo national trends. Some exhibits, such as Frances Colpitt's "Glow: Aspects of Light in Contemporary American Art," are organized by Arthouse, while others originate elsewhere. "Trenton Doyle Hancock: The Life and Death of #1," for example, came to the Jones Center from the Contemporary Arts Museum in Houston. "New American Talent," Arthouse's annual juried exhibition, showcases emerging artists from throughout the country. But the primary focus has always been on Texas.

Founded as the Texas Fine Arts Association, Arthouse—the name was changed in 2002—is the oldest statewide visual arts organization dedicated to promoting the growth, development, and appreciation of contemporary visual art. It was established in 1911 to preserve the legacy of sculptor and arts advocate Elisabet Ney (1833–1907). Exhibitions were held for many years at Ney's studio-turned-museum (see Elisabet Ney Museum listing).

In the early forties, Clara Driscoll, a TFAA charter member better known as the "savior of the Alamo," offered her Laguna Gloria property and former home on West 35th Street to the organization. In order to accept the gift, TFAA gave the Ney Museum to the city of Austin in exchange for funding (see the Austin Museum of Art at Laguna Gloria listing). In 1961 TFAA transferred the operation of the museum to Laguna Gloria Art Museum, Inc., while maintaining offices in the old carriage house on the grounds and presenting juried exhibitions—usually two a year—in the museum galleries. As is the case today, many of these exhibitions traveled to other venues throughout the state.

Thirty years later, TFAA decided to physically separate itself from Laguna Gloria in order to expand its exhibition schedule and further promote its goals. In the mid-1990s the board purchased a two-story nineteenth-century building at Congress Avenue and Seventh Street, five blocks from the state capitol building, and hired Dallas architect Gary Cunningham to direct the renovation of the space.

Cunningham brought a bit of New York's urban art aesthetic to Austin by exposing the building's structure (and some pieces of its past history), creating offices, an entry space, and two distinct exhibition areas that adhere

AUSTIN

305

ARTHOUSE AT THE JONES CENTER

to the same aesthetic as the art exhibited there. The first floor was opened to the public in November 1998, and plans are afoot to renovate the second floor and roof deck in the next couple of years. The exterior of the building maintains a Modernist department store façade, welcoming the projection of videos (for special occasions) onto its smooth, expansive exterior wall. True to the retail building's roots, the Jones Center, named for Albany residents Ann and Rex Jones in recognition of a gift made in their honor, routinely features artwork in a storefront window. Visitors can preview the exhibition through the glass before venturing inside.

HELPFUL HINTS

Parking in downtown Austin is almost always a problem, so wear comfortable shoes and be ready for a potentially lengthy trek from your car.

823 Congress Ave., Austin 78701
512-495-9224
www.amoa.org

Fine arts museum

The museum's galleries, which are located at street level in a downtown office building, routinely present twentieth- and twenty-first-century works by artists of regional and national acclaim in a professional and entertaining manner. One-person exhibits (artists Keith Carter, Alex Katz, Julie Speed, and Gerardo Suter are among those who have been featured) and group shows are selected to appeal to a diverse audience.

Tue.–Sat. 10 a.m.–6 p.m. (Thu. till 8 p.m.), Sun. noon–5 p.m.

Adults $5, seniors and students $4, members and children under 12 free, Thu. everyone free

Museum shop

AUSTIN MUSEUM OF ART

DETAILS

For the last twenty-five years, the Austin Museum of Art has explored art and ideas relevant to our time through varied and changing exhibitions and educational programs. Beginning in the late seventies, Laguna Gloria Art Museum, as it was then known, kept pace with national trends and professional standards by presenting a number of exhibitions of New York–based artists such as Carl Andre, Dan Flavin, and Betye and Allyson Saar (see Austin Museum of Art at Laguna Gloria listing). Under the guidance of museum director Laurence Miller, the museum also presented one-person exhibitions by local artists, including Amado Peña, Fannie Lou Spelce, and a series of "new works" exhibitions featuring emerging and established area artists.

Today, in its temporary yet more accommodating downtown galleries, AMOA continues to present a mix of nationally and internationally acclaimed artists along with regional art stars. The exhibition schedule is artfully paced to welcome a broad audience without compromising the quality of individual exhibits. Shows are always beautifully installed. And what was once a meager collection of art of the Americas now includes interesting work by John Alexander, Jim Campbell, Charles Mary Kubricht, Nam Jun Paik, Edward Ruscha, and others assembled by current director and curator Dana Friis-Hansen. The museum's community outreach and educational programs are also highly regarded, and even the museum shop offers unique opportunities for visitors.

But the museum's attempts to build a permanent downtown facility have consistently fallen short. First efforts began in the early eighties when acclaimed architect Robert Venturi was selected to design a new, roughly $17 million museum. A successful bond election in 1983 provided partial funding for the new building, but the plummeting price of oil and real estate in Texas in the mid-eighties (and some political shenanigans by other arts groups and council members) put an end to the museum's momentum. The project was put on hold.

Top: *Blue* by Margo Sawyer, 1998, mixed media, dimensions variable. Austin Museum of Art Collection. Partial gift of the artist, acquired with funds provided by ArtPace, A Foundation for Contemporary Art/San Antonio; Deborah and Tom Green; William F. Stern; Lee M. Knox; Juan and Carmen Criexell, and an anonymous donor.
Bottom: *High Plains* by Charles Mary Kubricht, 1997, acrylic on wood panel, 75" x 105". Gift of 2002 Director's Circle.

In preparation for a second try, the museum established its current downtown presence in the mid-nineties and changed its name from Laguna Gloria Art Museum to AMOA. As the economy heated up and high-tech companies in particular began to take an interest in local cultural institutions, AMOA campaigned to raise four times the earlier goal. The Venturi plans were abandoned and a new architect, Richard Gluckman of New York's Gluckman Mayner Architects, was hired. AMOA purchased the downtown block south of Republic Park, doubling the size of the original building site. In 2000 the museum formally declined use of the remaining $11 million in bond money that the city had earlier allocated for the building. It was an act that anticipated that the museum would become a private institution, outside the control of the city.

But as the fortunes of Austin's high-tech community began to plummet toward the end of the twentieth century, AMOA's plans also faltered. It remains to be seen whether a third effort will succeed. For the time being, the museum's commitment to programming both the original and the downtown sites in a professional manner remains firm.

HELPFUL HINTS

Parking for the museum is available on the street or in the 823 parking garage, with an entrance on Ninth Street. The museum will validate parking tickets for a discounted rate of $2.50 with a purchase in the store or museum admission.

"We here in Texas have eminent statesmen, eloquent orators, prominent professional men, industrial captains, and workers of great ability. But where are our artists? Where is the means to cultivate the artistic eye and hand? Where is the hope without these means of ever seeing the charm, the joy of artistic beauty being cast over this otherwise too humdrum and frivolous existence of ours?"

—ELISABET NEY, ARTIST[1]

AUSTIN MUSEUM OF ART AT LAGUNA GLORIA

3809 W. 35th, Austin 78703
512-458-8191
www.amoa.org

Sculpture park and gallery

The Austin Museum of Art exhibits outdoor sculpture on the Laguna Gloria grounds, including works by T. Paul Hernandez, Nancy Holt, Charles Umlauf, and others. Artist projects are presented inside the restored Clara Driscoll home.

Grounds open Mon.–Sat. 9 a.m.–9 p.m., Sun. 1 p.m.–5 p.m.
Building open daily 1 p.m.–5 p.m.

Free

DETAILS

Laguna Gloria, which means "heavenly lagoon," was so named because the roughly 12.5-acre property is actually a peninsula with the Colorado River along the west side and a lagoon on the south and east. The small Mediterranean-style villa that was known for forty years as Laguna Gloria Art Museum was designed by San Antonio architect Harvey L. Page in 1916. It was built as the home of Clara Driscoll and her husband, Henry Hulme Sevier, founder of the *Austin American.* Best known for her role in saving the historic Alamo from destruction, Driscoll was also a writer, a longtime state Democratic chair, and an accomplished businesswoman.

In 1943 Driscoll donated the house and the lush grounds (which had once been owned by Stephen F. Austin) to the Texas Fine Arts Association. She stipulated that the house be used "as a museum to bring pleasure in the appreciation of art to the people of Texas." In 1961 TFAA deeded the estate to Laguna Gloria Art Museum, Inc., an entity that got its start as the Austin chapter of TFAA. Their agreement permitted the statewide arts organization to continue to present annual exhibitions in the museum galleries until it acquired a downtown location several years ago. In 2002 TFAA changed its name to Arthouse (see Arthouse at the Jones Center listing).

During the seventies and eighties, museum director Laurence Miller interspersed exhibitions by master craftsmen and regional artists, including Austin's Amado Peña and Fannie Lou Spelce, with challenging work by the likes of Carl Andre and Dan Flavin, horrifying some in Austin and delighting others. Windows and doors in the Italianate villa were routinely covered over to allow more wall space for exhibitions, but the place was never well suited to exhibiting art because of its lack of security and climate control. The galleries' intimate scale made it difficult to show larger contemporary works. In the early eighties, the museum board turned its attention to finding a more appropriate and accessible downtown location. While the goal of constructing a new downtown facility has yet to be achieved, the renamed Austin Museum of Art now operates its primary exhibition program in temporary space at 823 Congress (see Austin Museum of Art listing). Meanwhile, the historic Driscoll home has been renovated and recently reopened to the public. Artists will be invited to create site-specific projects in the house, and sculpture will continue to be exhibited on the grounds.

The lovely outdoor amphitheater and the "Temple of Love," a replica

of a classical gazebo built for Driscoll years ago, are available for rental, as are the house and lower grounds, or "Baja" area, that once sheltered artists' booths during the art guild's annual Fiesta, now called the Austin Fine Arts Festival and held downtown. No doubt additional details concerning the history of the site will be available at the front desk when you visit.

HELPFUL HINTS

Laguna Gloria is the perfect stop on a dry, temperate Austin day. When the lake is up and the ducks are swimming, you can rest in the small stone amphitheater and enjoy Austin at its finest. The Museum Art School, located on the grounds in a postmodern pink building, offers an array of classes taught by local artists.

Top: *Temple of Love* at the Austin Museum of Art at Laguna Gloria. Photo: Austin History Center.
Bottom: Austin Museum of Art at Laguna Gloria. Photo: Austin History Center.

CREATIVE RESEARCH LABORATORY

2832 E. Martin Luther King Jr. Blvd., Austin 78702
(located within Flatbed World Headquarters)
512-322-2099
www.utexas.edu/cofa/a_ah/crlab.html

University gallery

The CRL presents an ambitious schedule of contemporary art exhibits, primarily works by students and current and past faculty members of the University of Texas Art and Art History Department such as Michael Ray Charles, Kelly Fearing, Theresa Hubbard, William Lundberg, Michael Mogavero, Margo Sawyer, and Mel Ziegler.

Tue.–Sat. noon–5 p.m. Call to confirm summer and holiday hours.

Wheelchair ramp is located at east entrance.

Free

DETAILS

For many years, University of Texas Art and Art History Department faculty members and students exhibited their work annually in the Archer M. Huntington Gallery, located in the art department building. While the gallery, renamed to honor former UT Board of Regents chairman Jack S. Blanton (see Jack S. Blanton Museum of Art), finalized its commitment to construct a new building, the art department commenced plans to take over exclusive use of the gallery. In doing so, the department established the Creative Research Laboratory, "dedicated to research and production in contemporary art and design." Rather than wait for the 2005 opening of the Blanton Museum, the CRL leased interim space at Flatbed World Headquarters, an industrial warehouse-style venue on Austin's East Side, so it could immediately begin a more ambitious programming schedule.

The CRL opened in 2001. With 71 faculty members, nearly 750 undergraduates, and almost 150 graduate students in the program (UT's art department was ranked among the top ten in the country by *U.S. News and World Report*), there is a deep well of talent from which to draw. Exhibits by art education faculty and local schoolchildren have also been presented. The CRL plans to return its programming to campus after the Blanton Museum is completed.

HELPFUL HINTS

The CRL is easy to find, and parking is plentiful except during opening receptions. Flatbed Press, Flatbed Gallery, Gallery 106 (see Gallery 106 listing), four faculty studios, two studios shared by graduate students in printmaking and transmedia, and a studio for graduate students studying dance and theater are also located in the building.

ELISABET NEY MUSEUM

304 E. 44th, Austin 78751
512-458-2255
www.ci.austin.tx.us/elisabetney

Fine arts museum

The former studio/home of sculptor Elisabet Ney has been preserved for the display of her carved figures and busts and ephemera from the period in which she lived. Ney's portraits in marble of Stephen F. Austin and Sam Houston stand in the state's capitol building.

Wed.–Sat. 10 a.m.–5 p.m., Sun. noon–5 p.m.

Mobility-impaired visitors have access to the ground floor galleries and a video that describes the rest of the building. The hundred-year-old house has narrow stairways up and down, and no elevator.

Free

Top: Elisabet Ney's studio, Formosa, Austin, Texas, ca. 1905.
Courtesy Elisabet Ney Museum, Austin, Texas.
Bottom: *Lady Macbeth* by Elisabet Ney, 1905. Courtesy Elisabet Ney Museum, Austin, Texas.

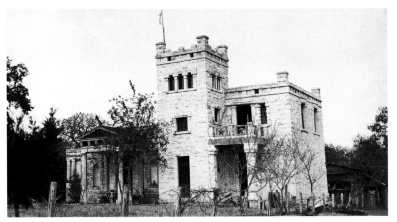

DETAILS

The restored studio and home of this nineteenth- and early-twentieth-century artist provides insight into Elisabet Ney's process as a sculptor, her life and times, and her considerable talent. It contains not only a number of her important works and plaster casts but also a small room where letters and magazine articles from that time are displayed. The artwork exhibited remains constant, although the artifacts may change from time to time. The museum is one of only four nineteenth-century sculptor's studios in this country to be preserved and opened to the public, and it is designated as a state and local historic landmark and a National Trust Associate Site.

Ney (1833–1907) was born in Münster, Westphalia, where her father was a successful stonecutter of statuary and gravestones. Quite modern for the times, Ney studied sculpture in both Munich and Berlin. Before long she was sculpting medallion and bust portraits of notable Europeans of the time, including Arthur Schopenhauer, King George V of Hanover, and Italy's Giuseppe Garibaldi.

When Ney was seventeen years old, she met Edmund Montgomery, a young Scotsman. They courted at a distance for ten years and then married, but she never took his name. The couple moved to the United States in 1871, first to a commune in Georgia (they emigrated to begin a utopian community) and then to a cotton plantation near Hempstead, Texas. Here, at this home they called Liendo—now preserved as a historical site—Ney set aside her life as an artist for a time, giving birth to two sons and concentrating her considerable energies on them. One died of diphtheria when he was two, and it is said she locked herself in a room with the dead baby for nearly twenty-four hours, creating a death mask of the child. The mask is rumored to have been destroyed by her remaining son, who was never fond of his overly attentive mother.

In the early 1880s, Ney was asked to sculpt figures of the state's early heroes Stephen F. Austin and Sam Houston for the 1893 World Columbian Exposition opening in Chicago. Although twenty years had passed since she had worked, her talent hadn't diminished. Only Houston was finished in time for the exposition, and only the plaster cast, but later both were realized in marble. They stand today in the Texas State Capitol building and in the National Statuary Hall in Washington, D.C. In order to work on the commissions, the artist built the studio she called Formosa in Austin's Hyde Park. She was then fifty-nine years old. The first phase, completed in 1892,

is reminiscent of a Greek temple. With the second phase, begun ten years later, she added more modeling space, living quarters, and a Gothic tower containing a study for her husband, who she hoped would follow her to Austin.

In the last decade of her life, Ney created a number of portraits of important Texans—governors, legislators, university presidents, and personal friends. Her last work was the dramatic figure of Lady Macbeth, completed in 1905. (The marble is in the Smithsonian Museum of American Art, and the cast is at Formosa.) Ney suffered a heart attack two years later while working and died in her studio the next month. She is buried at Liendo.

An ardent supporter of the arts, Ney spent nearly as much time advocating on their behalf as she did working in the studio. After her death, friends (including her only student, Nannie Huddle) saw to it that the studio, living quarters, furnishings, and remaining works were preserved as a museum. It became the home of the Texas Fine Arts Association, established to honor Ney's commitment to the arts, until Clara Driscoll donated her estate Laguna Gloria to the organization in the 1940s. At that time TFAA gave the house and grounds to the City of Austin in exchange for funding (see the Arthouse and the Austin Museum of Art at Laguna Gloria listings). The sculptures belong to UT's Harry Ransom Center. In the 1980s the studio and house were renovated through the efforts of an ambitious "friends" association and other community groups.

HELPFUL HINTS

Hyde Park is one of Austin's most delightful old neighborhoods, and Elisabet Ney's studio, listed on the local, state, and National Register of Historic Places, is one of its greatest treasures. Art classes are offered through the Sculpture Conservatory (512-371-7606), an independent entity headquartered nearby.

*"The more our sensibility for the
loveliness of things is nurtured and
the more lovely our surroundings are made,
the more lovely and joyful our souls will grow."*

—ELISABET NEY, ARTIST[2]

GALLERY 106

2832 E. Martin Luther King Blvd., Austin 78702
(located within Flatbed World Headquarters)
Additional works exhibited by appointment at Casa Cubana,
1217 Castle Hill, Austin 78703
512-472-1219
www.medaid.org

Art gallery

An innovative initiative of the U.S. Latin American Medical
Aid (MedAid) Foundation, Gallery 106 promotes and exhibits
works by contemporary international artists living in Cuba.
Art sold through the gallery benefits both the artist and the
cultural outreach program of the MedAid Foundation.

Tue.–Sat. 10 a.m.–6 p.m. and by appointment

Wheelchair ramp is located at east entrance.

Free

DETAILS

The MedAid Foundation was formed in 1995 to deliver licensed medical supplies to Cuba and Latin America to "build bridges between the peoples of the United States and developing countries." The foundation provides licenses for individuals who wish to travel to Cuba from the United States to hand-deliver medical supplies to hospitals and clinics. (Since its inception, close to $4 million in aid has been provided.) Founders became interested in establishing a cultural initiative as well so that the group not only made deliveries to the Cuban people but also exchanged ideas. Gallery 106 was created to enhance this cultural exchange. Interestingly, purchasing art from Cuba is not prohibited by the U.S. embargo.

The idea was given a kick-start when, on August 6, 2000, MedAid supporters leased a small gallery space within Flatbed World Headquarters. In less than a month MedAid hired a curator to travel to Cuba, purchase art, accompany the art from Cuba to Texas, and install the first exhibition—"Cuba: Arte Entre Vecinos"—which opened on Thursday, August 31. Since that time, Gallery 106 has hosted a series of exhibitions, some by emerging artists and others by artists who are well known in both Cuba and America, such as KCHO (Alexis Machado Leyva), émigré Eduardo Muñoz Ordoqui, and others. When necessary, the gallery pays for both the artists and their work to make the trip through Miami to Austin for exhibitions. A small catalog or brochure is produced for each show.

Unlike the practice at most nonprofit galleries and museums, Gallery 106 artworks are often sold. Half of the money goes to the artist, and the rest goes to the foundation to defray the cost of the program. The underlying purpose, however, says Fran McGee, who oversees the gallery, is not to sell works but to exchange ideas and imagery and support the production of these artists. To that end, Gallery 106 also cosponsored a successful art auction in Havana during the 2002 Cuban Biennale and anticipates repeating the effort. The gallery has also sent American artists and their work to Cuba for exhibitions, which were then imported to Texas.

In Austin, works are routinely displayed in a wide, well-traveled hallway space and a small enclosed room near the Flatbed printshop. Additional Flatbed space is also occasionally available to the gallery. Casa Cubana, a small house open by appointment only, serves as a tiny events center, archive, storage place, and exhibition facility.

Diptych II: The Baptism (serie "Gris") by José Angel Toirac, oil on canvas, 37" x 52¼" each canvas. Private collection of Fran Magee.

HELPFUL HINTS

Call ahead if you want the attention of a Gallery 106 representative on-site as you view exhibitions. The industrial-chic environment at Flatbed is shared by the Creative Research Laboratory (see CRL listing), Flatbed Press, and Flatbed Gallery, whose representatives are more likely to be in the building.

21st and Guadalupe, Austin 78705
512-471-8944
www.hrc.utexas.edu

University cultural archive and gallery

The HRC at the University of Texas in Austin holds millions of literary and cultural treasures, including one of the finest photography collections in the world and more than 68,000 original works of art. The oldest known photograph, *View from the Window at Le Gras* (1826), by Joseph Nicephore Niepce, and the Gutenberg Bible are the first objects to greet visitors entering the galleries.

Tue.–Fri. 10 a.m.–5 p.m. (Thu. till 7 p.m.), Sat.–Sun. noon–5 p.m. Reading room hours Mon.–Fri. 9 a.m.–5 p.m., Sat. 9 a.m.–noon

Free

HARRY RANSOM HUMANITIES RESEARCH CENTER

Marie Spartali by Julia Margaret Cameron, 1868. Gernsheim Collection, Harry Ransom Humanities Research Center, The University of Texas at Austin.

DETAILS

The Harry Ransom Center's strength in photography was established initially with the 1963 acquisition of the Gernsheim Collection, which was then reputedly the largest privately owned photohistorical archive. Holdings now include prints, negatives, archives, and memorabilia of important photographers of the nineteenth and twentieth centuries, as well as photographic apparatus and a growing library of books and journals on theory, technique, art, and the history of photography—totaling about five million objects in all. "We've got both quantity and quality," says Roy Flukinger, senior photography curator.

Peter Mears, curator of art, says that many of the artworks—paintings, sculpture, and works on paper—initially came to the collection because the subject, rather than the artist, was notable. Examples include numerous writers' portraits and Elisabet Ney's sculptures of famous Texans housed at Austin's Elisabet Ney Museum (see Elisabet Ney Museum listing). But there are also objects, such as those in the Nickolas Muray Collection, that hold their own as important works of art. Paintings by Miguel Covarrubias, Frida Kahlo, Diego Rivera, and Rufino Tamayo are among this collection's best-known works. The Carlton Lake Collection's strength is in the several hundred works by and about Jean Cocteau and his connections in theater, literature, ballet, and music.

The HRC was originally established in the mid-fifties to hold literary treasures (the galleries prominently feature objects from these collections as well as art) until Harry Huntt Ransom (1908–1976) led the initiative to collect more broadly in the humanities. It was Ransom who opened the door for the center's extensive art and photography collections. In 1983 the building was renamed the Harry Ransom Humanities Research Center in honor of the former English professor, dean, vice president, provost, president, and finally chancellor of the University of Texas System.

Before 2003, selections from the HRC collections were most often displayed in a series of small, hard-to-find spaces carved out of the upper floors of the Ransom Center and in the Leeds Gallery in the Flawn Academic Center. This less-than-ideal situation arose because shortly after the building was completed in 1972, James and Mari Michener offered to UT's Blanton Museum—then known as the University Art Museum—selections from their collection of twentieth-century paintings on condition that they be immediately exhibited to the public. The gift was accepted and displayed

on the first floor of the new HRC because there was no alternative gallery space on campus. The Blanton also displayed its collection of Latin American works and other objects on the building's second floor and used the basement for storage. As a result, for nearly thirty years the HRC collections remained essentially hidden from the public. It was only when the Blanton's holdings were removed in anticipation of a new museum building that the HRC reclaimed use of its own building (see Jack S. Blanton Museum of Art listing).

Today the HRC's first-floor galleries, designed by Lake/Flato Architects of San Antonio, finally provide a pleasant, accessible environment for the collections they were originally intended to showcase.

HELPFUL HINTS

The HRC turns its back on busy Guadalupe Street and a shoulder to 21st Street. Its main entrance faces campus. As part of the recent renovation, etched-glass panels depicting objects from the collection and signatures of famous authors were affixed to the building's corners, providing passersby with a tantalizing hint of what is inside. The HRC clearly welcomes visitors, but the limited number of parking places on the street and the crowded nearby parking garages do not.

"When all is said and done—directors and curators have moved on, public programs are over, research and publication have been completed— what remains is the very heart and soul of an art museum, the works of art themselves."

—ERIC S. MCCREADY, FORMER DIRECTOR, ARCHER M. HUNTINGTON ART GALLERY (NOW THE BLANTON MUSEUM OF ART)[3]

JACK S. BLANTON MUSEUM OF ART

UT Art Building
23rd and San Jacinto, Austin 78712
512-471-7324
www.blantonmuseum.org

University museum

Until it closes temporarily (most likely in January 2005) in preparation for its move to a new building, the Blanton Museum is committed to exhibiting excerpts from its holdings, including the Suida-Manning Collection of Renaissance and Baroque art and the Leo Steinberg Collection of prints. Changing exhibitions will also continue to address the museum's interest in contemporary and Latin American art.

Mon.–Fri. 9 a.m.–5 p.m. (Thu. till 9 p.m.), Sat.–Sun. 1 p.m.–5 p.m. Print room hours by appointment for general public.

Free

Top: *Missãol Missães (How to Build Cathedrals)* by Cildo Meireles (Brazilian, b. 1948), 1987, mixed media installation. Museum purchase with funds provided by the Peter Norton Family Foundation, 1998. Courtesy of Blanton Museum of Art. Bottom: *Flora* by Sebastiano Ricci (Italian-Venetian, 1659–1734), ca. 1712–1716, oil on canvas. The Suida-Manning Collection, acquired with support from the Effie and Wofford Cain Foundation, 1999. Courtesy of Blanton Museum of Art.

DETAILS

The Jack S. Blanton Museum owns one of the leading public collections of contemporary Latin American art in the United States, representing more than five hundred of the most significant artists from Mexico, South and Central America, and the Caribbean. It also holds more than 15,000 prints and drawings from the fifteenth through twentieth centuries, the largest and most historically balanced collection of its kind in the Southwest. The Suida-Manning Collection of Renaissance and Baroque art, a privately assembled cache of old master paintings and drawings, and the Leo Steinberg Collection of prints, spanning five centuries, are the most notable recent acquisitions. Now all that remains is completion of a suitable building where the work can be properly exhibited. It has been a long time in coming.

In 1927 philanthropist Archer M. Huntington gave the university 4,000 acres of land by Galveston Bay to fund an art museum. Eleven years later the university established the College of Fine Arts, and funds from the Huntington endowment were used to support art exhibitions held in buildings throughout campus. It wasn't until the college completed its new art building in 1963 that a dedicated art gallery was established where the modest collection of a few hundred works of art could be displayed to the public. And soon after the university received gifts of Latin American art from John and Barbara Duncan and the Mari and James Michener Collection of twentieth-century American paintings, that space became inadequate.

In 1972 the museum moved its permanent collection to the first two floors of the newly constructed Humanities Research Center (see Harry Ransom Humanities Research Center listing) on the other side of campus, while continuing to program changing exhibitions in the Art Building. In the early 1980s the museum's name was changed to the Archer M. Huntington Art Gallery, and talk of building a freestanding museum building began in earnest. More than twenty years passed before the groundbreaking took place.

After a false start in the late nineties (Swiss architects Herzog and de Meuron resigned after a year's effort in the face of complaints from two of the UT System's regents), the museum hired the Boston firm Kallmann McKinnell and Wood Architects in October 2000 and broke ground two years later. The 135,000-square-foot building is due to open in 2005. Located on the edge of campus at the intersection of Martin Luther King

Boulevard and Speedway, it was designed, at the regents' request, to recall the predominant Mediterranean style of the campus established in the early days of the university by Paul Cret and Cass Gilbert. The new facility will include a 100,000-square-foot building with multiple galleries, a print and drawing study center, and a smaller administration and education building, to be separated from each other by a plaza. It was named for Jack S. Blanton, past chairman of the University of Texas Board of Regents and longtime supporter of the arts in Texas. The Blanton, according to museum staff, will represent a "cultural gateway" between the University of Texas and the city of Austin.

In the meantime, the Harry Ransom Center has reclaimed the first two floors of its building so that it can for the first time properly display its own collections. The Blanton Museum is presenting exhibitions only in the Art Building galleries until the new building is complete, and student and faculty exhibitions, which used to be shown in that space, have been moved off campus. The art department gallery, now called the Creative Research Laboratory (see listing), is located in rented space on the East Side.

HELPFUL HINTS

Street parking close to the Art Building is rarely available, but there is a parking garage one block north of the building, on San Jacinto. Another campus parking garage will serve the new museum. Beginning in January 2005, call to see if the museum has closed in preparation for the move. After October 2005, there may be new hours and an admission charge for non-members.

MEXIC-ARTE MUSEUM

419 Congress Ave., Austin 78701
512-480-9373
www.mexic-artemuseum.org

Fine arts museum

Mexic-Arte presents a diverse assortment of traditional and contemporary exhibitions and programs that reflect Mexican, Latino, and Latin American art and culture.

Mon.–Thu. 10 a.m.–6 p.m., Fri.–Sat. 10 a.m.–5 p.m.

Adults $5, seniors and students $3, children under 12 free

Museum shop

DETAILS

Works by emerging and established artists from throughout this country and Latin America are most often the focus in Mexic-Arte's front gallery, located in a historic downtown building. Exhibitions have included "Brazilian Visual Poetry," curated by Austin-based artist Regina Vater, and the annual "Young Latino Artists Exhibition." Historic exhibitions have included "Santo Niño de Atocha: Faith, Art, and Culture," a selection of nineteenth- and twentieth-century retablos and ex-votos from Zacatecas, and Día de los Muertos (Day of the Dead), which becomes an annual opportunity for a downtown parade, performance, and special exhibitions. The back gallery, low-ceilinged and intimate, is most often used to showcase individual artists making interesting and often experimental work. This "Diversity and Emergence Series" has been sponsored by an NEA grant.

While Mexic-Arte's primary focus is temporary exhibitions by contemporary artists, the museum also maintains a collection of documentary photographs chronicling the history of the Southwest, prints from Taller de la Grafica Popular (1940–1970) and José Guadalupe Posada, Mexican masks, and pre-Columbian figures. All in all, the museum has come a long way since its modest beginnings.

During the early eighties, when organizations such as La Raza Unida, LUCHA, and Mujeres Artistas del Sudoeste, were making their mark on the social fabric of Austin, three artists—Sylvia Orozco, Pio Pulido, and Sam Coronado—got together to create what they called a "forum for artistic expression through multicultural interaction." In 1983 the three began presenting exhibitions in a 300-square-foot gallery inside a downtown warehouse. Before long they were placing art throughout the warehouse and also creating exhibits in satellite locations around the city. Within its first two years, Mexic-Arte initiated a collaboration with DiverseWorks in Houston, developed a sister-museum relationship with the Diego Rivera Studio Museum in Mexico City, and began working with the Consulate General of Mexico in Austin.

In 1988 Mexic-Arte moved to a four-story Congress Avenue building constructed in 1869 as a U.S. Army headquarters. By 1993 a City of Austin inspection determined that the upper stories were unsafe for public use. The offices and visual arts programs were condensed, and the public is not permitted above the first floor. In 2000 the city council provided $740,000 for purchase of the building in exchange for a fifty-year service contract guar-

Adelita con su Soldado (Adelita with Soldier) by Agustín Casasola, sepia photograph. Permanent collection, Mexic-Arte Museum.

anteeing that Mexic-Arte will provide a two-week exhibit for underserved teens and will renovate the building. As this book is being written, plans for repairing and expanding the museum have been neither finalized nor funded.

HELPFUL HINTS

It is impossible to guess when construction might begin on the building, so call before dropping by. Parking is limited in downtown Austin, but the gift shop alone is worth the effort to find a place to leave your car, and the overall quality of exhibitions is impressive. Consider combining a visit to Mexic-Arte with a stop at Arthouse at the Jones Center and AMOA downtown, both only a few blocks away.

*"All art which is lasting
has a certain religiousness about it.
It must be felt, it must be personal
and it must have its own conviction."*

—CHARLES UMLAUF, ARTIST[4]

UMLAUF SCULPTURE GARDEN AND MUSEUM

605 Robert E. Lee Rd., Austin 78704
512-445-5582
www.umlaufsculpture.org

Museum and sculpture park

More than one hundred works by sculptor Charles Umlauf (1911–1994) are presented in both outdoor and indoor settings. In addition, works by a number of Umlauf's former students are exhibited from time to time.

Wed.–Fri. 10 a.m.–4:30 p.m., Sat.–Sun. 1 p.m.–4:30 p.m.

Adults $3, seniors $2, students $1, children under 6 free, last Thu. of the month $1.

Museum shop

DETAILS

Chicago sculptor Charles Umlauf and his wife, Angeline, moved to Austin in 1941, and he taught for forty years at the University of Texas. During this time the prolific artist created a huge body of both public art and small-scale sculptures that range from abstract to expressionistic depictions of human and animal forms. In 1985 the Umlaufs donated his studio, their home, and 168 pieces of sculpture to the City of Austin. The museum has increased its holdings of Umlauf sculptures over the years, but does not actively collect. Sculptures on the grounds are rarely rearranged, while works inside the gallery rotate, albeit infrequently. Occasionally work by Umlauf's former UT students such as David Everett, Luis Jimenez, and Ben Woitena, who themselves have become respected sculptors, is also exhibited. Regional artists are invited to speak at the museum in January/February of each year as part of a lecture series about sculpture.

The museum opened to the public in June 1996. The city added six more acres of land to the Umlauf gift, and the Friends of the Umlauf Sculpture Garden and Museum, led by Austin activist Roberta Crenshaw, raised the money to build the museum and prepare the grounds. Lawrence Speck, the former dean of the UT School of Architecture, designed the building with a successful nod to the Texas vernacular. Visitors proceed from the parking area through a dogtrot to an expansive porch with multiple ceiling fans. On a nice day the impulse is to continue directly to the garden paths punctuated with sculpture. There, visitors may wander freely among trees and native plantings along carefully mapped and annotated pathways or on self-guided tours.

The museum itself, a limestone edifice with windows facing the woodsy setting, is modest in scale but offers a comfortable space for viewing Umlauf's small and midsize sculptures on pedestals while peering out into the garden from the air-conditioned comfort of the interior. In 1995 a small learning center was added, and a video about Umlauf runs there continuously during museum hours. Formal classes are left to the other art museums in town, although museum docents conduct school tours of the museum and grounds and "touch tours" for the visually impaired. The museum has also developed a program in conjunction with the University

Icarus by Charles Umlauf, 1965, bronze. Courtesy of Umlauf Sculpture Garden and Museum.

of Texas to instruct Elderhostel participants on how to wash, wax, and care for outdoor sculpture. When the Umlauf house and studio on the upper grounds become available to the museum, the staff will gain much-needed office and storage space.

HELPFUL HINTS

On all but the hottest Texas days, the sculpture garden provides a unique and welcoming haven for visitors. A site with a vine-covered trellis overlooking the lily pond and a sculpture called *The Lovers* is often used for weddings. The porch, with nearby catering kitchen, easily accommodates receptions, and there is a small parking lot for guests.

Wild Boar by Charles Umlauf, 1979, bronze. Courtesy of Umlauf Sculpture Garden and Museum.

WOMEN AND THEIR WORK

1710 Lavaca, Austin 78701
512-477-1064
www.womenandtheirwork.org

Art center

As its name implies, Women and Their Work promotes recognition and understanding of women's contributions to culture. All one-person exhibitions and most group shows are restricted to work by women artists who are attuned to national trends in contemporary art.

Mon.–Fri. 9 a.m.–5 p.m., Sat. noon–4 p.m.

Free

Gift shop

DETAILS

From a one-room office over a drugstore on Guadalupe Street in the late seventies, W&TW moved to galleries at 1501 W. Fifth Street and then to the current location. Today the slick storefront gallery offers a steady stream of single-artist and group exhibitions. Most are selected by an advisory panel of board members in response to applications submitted by artists and curators. But even fund-raisers, membership shows, and the omnipresent gift shop that greets visitors as they enter the space adhere to high aesthetic standards.

Equally effective in representing the commitment to excellence here have been the publications produced by the organization. W&TW catalogs include the names and imagery of some of the most interesting visual artists in the state, including Helen Altman, Frances Bagley, Mary McCleary, Melissa Miller, Regina Vater, Dee Wolff, and many more. Work by established artists from outside the state is also exhibited on occasion.

In 1977 three women artists in Austin—Rita Starpattern, Deanna Stevenson, and Carol Taylor—organized the six-week Festival of Women Artists, the first of its kind in Texas, which led to the incorporation the following year of the Center for Women and Their Work. From the beginning the organization promoted the efforts of female practitioners working in dance, theater, music, and literature, as well as in the visual arts and film, from all over the country, with an emphasis on Texas. Marsha Tucker, director of the New Museum in New York City, was tapped to curate "Women in Sight," the first statewide juried visual art exhibition for women ever held in Texas. In 1981 the group received the first grant ever awarded in Texas by the NEA Visual Arts Program.

HELPFUL HINTS

Women and Their Work, within half a dozen blocks of the state capitol, is easy to spot with its recently updated exterior signage. Metered parking is usually available nearby; if not, be sure to avoid towaway zones. But don't avoid Women and Their Work.

Women and Their Work (exterior). Photo by Mara Levy.

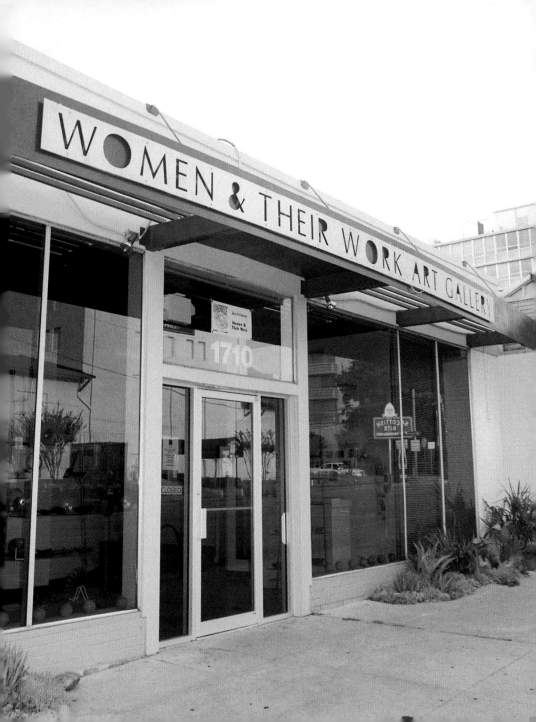

NATIONAL CENTER FOR AMERICAN WESTERN ART
HOME OF THE COWBOY
ARTISTS OF AMERICA MUSEUM

1550 Bandera Hwy., Kerrville 78028
830-896-2553
www.caamuseum.com

Fine arts museum

This museum explores the American West through the eyes of a unique group of contemporary painters and sculptors and by exhibiting historical objects, photographs, and the art of established past masters such as Remington and Russell.

Tue.–Sat. 9 a.m.–5 p.m., Sun. 1 p.m.–5 p.m. Memorial Day– Labor Day also open Mon. 9 a.m.–5 p.m.

Adults $5, seniors over 65 $3.50, children under 12 $1, members free. Group rates available.

Museum shop

DETAILS

Although this venue is no longer known simply as the Cowboy Artists of America Museum, work by CAA members depicting familiar scenes of the Old West remains the core of the exhibition program and collections. The Cowboy Artists of America was started in 1965 by four artists: Joe Beeler, Charlie Dye, John Hampton, and George Phippen. Each member—today the group claims more than two dozen—is at once a representational artist and a cowboy, or a cowboy-at-heart, who relies on the American West for inspiration. The group also meets once a year for a trail ride and campout and for an exhibition of work by active members.

In the early eighties, a number of Kerrville-area ranchers, businessmen, and collectors of work by CAA members approached the organization and offered to build a home for members' work. Oilman William F. Roden of Midland donated a ten-acre piece of property adjacent to Kerrville's River-hill Country Club, and museum supporters hired the San Antonio firm of Ford, Powell, and Carson to design the museum. The building subsequently became the last public facility to be influenced by the distinguished Texas architect O'Neil Ford, a master of regional-style architecture.

Described by one source as "something of a hacienda, something of a fort, something of a pueblo," the stone edifice rests comfortably in its Hill Country setting, although houses have begun to intrude on what must once have been a secluded hilltop. Two small structures, originally built to serve as visiting-artist studios, are instead used for office space. An educational pavilion was added to house the museum's summer program for high school students.

The museum's interior, from its exquisite brick boveda ceilings to the endcut mesquite wood or polished Saltillo tile floors, is a gem. An interior courtyard brings natural light into the center of the building without intruding on the galleries. The size of the main gallery, originally flanked by smaller rooms on either side, was doubled in 2003, and an art storage vault was added to accommodate the museum's growing collection, which now numbers some 700 works. The museum also offers a children's activity area. A library with 5,000 books and periodicals serves as an extensive repository of information about Western life, as well as art, and doubles as a conference room. Before long, the museum hopes to extend its influence beyond the community of Kerrville through traveling exhibitions, museum publications, and possibly a satellite gallery.

HELPFUL HINTS

Kerrville is a beautiful destination, whether you go there to visit the museum, deliver children to a nearby summer camp, or simply escape the hustle and bustle of the state's bigger cities. If you're not a fan of Western art, you can still enjoy the outing by visiting the terrific museum shop (some items available on the Web) and admiring O'Neil Ford's building. (Recent additions have also been designed by Ford, Powell, and Carson.)

An Honest Day's Work by Fred Fellows. Courtesy of National Center for American Western Art.

WITTLIFF GALLERY OF SOUTHWESTERN AND MEXICAN PHOTOGRAPHY

Albert B. Alkek Library, Seventh Floor
Texas State University–San Marcos
601 University Dr., San Marcos 78666
512-245-2313
www.library.txstate.edu/swwc/wg

University gallery and photographic archive

The Wittliff Gallery collects and exhibits photographic materials representing the cultures of Mexico and the Southwestern United States from the nineteenth century through the present with an emphasis on contemporary imagery.

Hours and days vary during the academic year according to the university schedule. Call for information.

Free

Because of the hilltop location, wheelchair-bound visitors must navigate a series of ramps from the parking garage area to the elevators in the library lobby.

Top: *Fat Stock Show, San Angelo, Texas* by Russell Lee, 1940. Courtesy of the Wittliff Gallery, Texas State University, San Marcos.
Bottom: *Prague, Oklahoma, 1939* by Russell Lee. Courtesy of the Wittliff Gallery, Texas State University, San Marcos.

DETAILS

The Wittliff Gallery exhibits a wide variety of photographs, including documentary images and artworks by twentieth-century masters of the medium. Highlights of the collection include scores of photographs by Texas great Russell Lee (as well as his first camera and his last painting) and work by noted Mexican photographers Manuel Alvarez Bravo, Graciella Iturbide, and Mariana Yampolsky. The gallery collects selected photographers in depth, among them Kate Breakey, Keith Carter, and Rocky Schenck, and publishes books about their work through an agreement with the University of Texas Press. Three exhibits a year are presented in the galleries, and these

Sleeping Swan by Keith Carter, 1995. Courtesy of the Wittliff Gallery, Texas State University, San Marcos

are often made available to other institutions. Exhibitions include one-person and group shows, primarily drawn from a collection that includes a literary archive as well.

In 1986 Bill and Sally Wittliff, in collaboration with Southwest Texas State University (now Texas State University–San Marcos), created the Southwestern Writers Collection to house important works by the region's leading writers, filmmakers, and musicians. The collection includes books, manuscripts, papers, diaries, photographs, letters, mementos, and artifacts by such writers as J. Frank Dobie, John Graves, Larry L. King, Sam Shepard, William Broyles, Jr., Gary Cartwright, and Beverly Lowry, as well as the *Texas Monthly* magazine archives. In 1991 the Writers Collection, which included photographic portraits of authors and pictures relating to the contents of the writing, was opened to the public on the seventh floor of the university's Alkek Library. Five years later the photography gallery opened. Works featured include photographs accumulated by the couple over the years as well as photographs taken by Bill Wittliff, a successful screenwriter whose credits include *The Perfect Storm, Legends of the Fall,* and the television adaptation of *Lonesome Dove.*

When entering the Writers Collection, visitors turn right to explore Texas letters and left for two rooms filled with art. The galleries, with their dark wainscoting, Mexican tile floors, and shallow arched portals, set just the right tone for the multidisciplinary experience of cultures in the South, Southwest, and Mexico. The seventh-floor extension of the library, dotted with study tables and bookshelves, benefits greatly from Writers Collection photographs, which tend to spill out of the gallery and into shared space.

HELPFUL HINTS

Look for the easy-to-spot Alkek Library high on a campus hill and try to remember that the trek from your car to the seventh-floor gallery is always worth the effort. Save time for the Southwestern Writers Collection treasures as well as the photography galleries. And consider visiting the art department gallery in the new Joann Cole Mitte Art Building at 749 Comanche Street.

CULTURAL ACTIVITIES CENTER

3011 N. Third, Temple 76501
254-773-9926
www.cacarts.org

Visual and performing arts center

Exhibitions most often include works by regional artists selected to appeal to the tastes of the surrounding community.

Mon.–Thu. 8 a.m.–5 p.m., Fri. 8 a.m.–4:30 p.m.

Free

DETAILS

In an effort to promote local interest and participation in the arts, the CAC presents exhibitions by regional artists and exhibits art by, or of particular interest to, the community's children. The success of a spring arts festival arranged by two local women back in 1958 led to the founding of the CAC, whose current building, completed in 1978, is located near Temple's convention center. A new wing was completed in 2003.

The small Carabasi Gallery greets visitors as they enter the original building. The McCreary Gallery, a hallway that runs behind that space, and the Upstairs Gallery (also a narrow hallway) accommodate small exhibitions, frequently highlighting local talent, including faculty or students from area schools. The Saulsbury Gallery, the largest exhibition area, is a wide, high-ceilinged serpentine passageway from the entry foyer to the new addition and includes the entrance to the building's Mayborn Auditorium. And the newest gallery is a discrete space beyond a new banquet hall, which, because it is *not* a throughway, is likely to host the center's most adventuresome exhibitions.

The center owns roughly 150 items, which are held in the Daniel and Felicitas Sternberg storage facility and include, for the most part, paintings and miniature opera sets produced by Felicitas Sternberg, an artist and set designer. The annual spring "Protégé Exhibit" presents work by students selected by faculty from Baylor University, Temple College, and other area schools. In 2002 the CAC collaborated with its neighbors along I-35—Art Center Waco and the Martin Museum at Baylor—to present a three-part show by Karl Umlauf, Baylor's prolific artist-in-residence. *Orpheus*, a bronze sculpture created by Richard Hunt of Chicago, stands outside against a backdrop of Texas granite from the former Temple National Bank Building. It was purchased with a National Endowment for the Arts grant and local matching funds.

HELPFUL HINTS

If you're traveling on I-35, look for signs for the Mayborn Convention Center, which shares the fifteen-acre site with the CAC.

"An art museum is more than a building, it is a component of the community."

—JOSEPH KAGLE, JR.,
FORMER DIRECTOR, ART CENTER WACO[5]

1300 College Dr., Waco 76708
254-752-4371
www.artcenterwaco.org

Art center

Expect anything from Tex-Mex tableaux with a twist by
Bob "Daddio" Wade to Indian textiles and nationally juried
exhibitions of work by emerging artists.

Tue.–Sat. 10 a.m.–5 p.m., Sun. 1 p.m.–5 p.m.

Adults $2, students, teachers, and children 12 and under $1

Upstairs classrooms are not wheelchair accessible.

ART CENTER WACO

DETAILS

It is difficult to predict exhibitions at Art Center Waco. Former director Mark Tullos shifted the emphasis of this non-collecting institution away from the standard display-and-explain approach toward the exploration of ideas and issues of community interest through the presentation of a wide range of objects and multidisciplinary programs. Through this idea-based (rather than object-centered) approach, the center hopes to help create a positive image for a city whose reputation was tarnished by violence at the Branch Davidian compound and then overshadowed by the White House West, President Bush's nearby Crawford ranch.

The Art Center was founded in 1972 as a project of the Waco Junior League in cooperation with the city of Waco. Although its original location was downtown, it soon moved to the William Cameron family's former summer home, a Mediterranean-style stucco building with tile roof. Located on the grounds of McLennan Community College, the old house, built in 1924, inhabits a bucolic two-and-a-half-acre setting apart from other school buildings. The interior has been subdivided for offices, a gift shop, and several modest-sized galleries. Upstairs there are classroom studios. A lovely courtyard is occasionally used to display outdoor sculpture, as are the expansive grounds where Charles Umlauf and Robert Wilson, among others, are represented.

Paul Harris, one of the center's earliest directors, established a strong reputation for displaying the work of Texas artists. A later director, Joe Kagle, renewed the Junior League's original commitment to education by creating the nationally recognized International Museum School, a gallery established within a local elementary school (a converted boiler room!). Kagle also oversaw the purchase of downtown property within easy reach of other Waco museums, including the Martin Museum of Art and University Gallery at Baylor, the Dr Pepper Museum, and the Texas Ranger Hall of Fame and Museum. In April 1999 the Art Center selected Rick Sundberg of Olson Sundberg Kundig Allen Architects in Seattle, Washington, to design the new facility and anticipated launching a $14 million campaign, half for endowment and half for the building itself. The economic slowdown in the late 1990s put the project on hold.

HELPFUL HINTS

The current location requires a ten-minute drive from the center of Waco. Signage is good and parking is plentiful.

GEORGE WASHINGTON CARVER MUSEUM AND CULTURAL CENTER

1165 Angelina, Austin 78702
512-472-4809
www.ci.austin.tx.us/carver

The Carver Museum is devoted to exploring the history and culture of African Americans in Austin and beyond through the collection and presentation of artifacts, memorabilia, and art objects. The museum will open its new addition to the public late in 2004.

JULIA C. BUTRIDGE GALLERY

Dougherty Arts Center
1110 Barton Springs Rd., Austin 78704
512-397-1469
www.ci.austin.tx.us/dougherty/gallery

The Julia C. Butridge Gallery is a city-owned community gallery that features work by local artists, artisans, and arts organizations. The 18-square-foot gallery also doubles as the foyer for the Dougherty Arts Center's theater and arts school, guaranteeing a steady stream of visitors for artists displaying their work.

LA PEÑA GALLERY

227 Congress Ave., Austin 78701
512-477-6007
www.lapena-austin.org

Since 1981 La Peña has been organizing cultural gatherings to celebrate Latino artists, musicians, writers, and performing artists and to support community projects. A storefront gallery on Congress Avenue—an easy walk from Mexic-Arte and Arthouse—hosts changing art exhibitions that occasionally spill over onto the walls of Las Manitas Avenue Café down the street. Shows have featured everything from work by local schoolchildren and emerging and established artists to wooden hearts decorated by volunteers with varying degrees of artistic talent but no shortage of enthusiasm for La Peña's annual fund-raiser, "Toma Mi Corazon."

NANCY WILSON SCANLAN GALLERY

Helm Fine Arts Center, St. Stephen's Episcopal School
2900 Bunny Run, Austin 78746
512-327-1213, ext. 139 or 144

The Scanlan Gallery has hosted an eclectic assortment of
exhibitions, including American Impressionism, Asian art, and
works by graduates of St. Stephen's Episcopal School. Nestled
on the edge of the school's lovely Hill Country campus, it offers
surprisingly good year-round exhibits.

TEXAS FOLKLIFE RESOURCES GALLERY

1317 S. Congress Ave., Austin 78704
512-441-9255

Texas Folklife Resources describes itself as a "cultural organization dedicated to the presentation and preservation of the folk arts and folklife of the Lone Star State." In a small entry gallery, TFR presents changing art exhibitions that support that mission. These have ranged from rough-hewn chain-saw art to slick photographs depicting the black blues scene.

NEW BRAUNFELS MUSEUM OF ART AND MUSIC

1259 Gruene Rd., New Braunfels 78130
830-625-5636
www.nbmuseum.org

What began in 1992 as a gallery for Hummel "collectibles" in an old savings-and-loan building has morphed into an ambitious museum devoted to the exploration of the state's music and contemporary art scenes. Located since May 2003 in a new barn-size exhibition hall a short walk from historic Gruene Hall, the NBMA&M promises to deliver an interesting mix of nostalgia and new art over time. As an affiliate of the Smithsonian Institution the museum also has access to an array of traveling exhibitions. Admission is free.

MARTIN MUSEUM OF ART AND UNIVERSITY GALLERY

Baylor University
Hooper-Schaefer Fine Arts Center
1401 S. University Parks Dr., Waco 76798
254-710-1867
www3.baylor.edu/Art/

Exhibitions are organized to support Baylor University's studio and art history classes and most often include works by faculty and other area artists or selections from the relatively modest-sized but broad-based collection.

ASO MARFA MIDLAND ODESSA ALPINE EL PASO MARFA MIDLAND ODESSA ALPINE

THE FEW, WILDLY DISSIMILAR ART DESTINATIONS TO be found in West Texas are scattered across a vast, largely unsettled landscape. El Paso, nearly the center point between Houston and Los Angeles, lies so far west of the rest of Texas that it exists in a different time zone. The stark beauty of distant mountains and the proximity to Juárez, Mexico, just on the other side of the Rio Grande, uniquely shape the culture of the city, the fourth-largest in the state. Tiny Marfa first gained nationwide notice in the early eighties after Donald Judd, a world-famous artist, moved there and installed his Minimalist sculptures in two artillery sheds outside of town. Since then, his Chinati Foundation has lured both international art tourists and Texas real estate speculators to Marfa, where they can commune with his cubes, bask in the light of Dan Flavin's installations, and frequent the downtown bookstore, which sells cappuccino. In Midland and Odessa, on the other hand, Central Standard Time prevails, George W. Bush is the most famous former resident, and it is the oil business that creates identity and affects the day-to-day life of residents.

In other words, it is hard to identify a tie that binds the art outposts of West Texas other than their remoteness from the rest of the state. For three of the museums this isolation has resulted in an effort to provide encyclopedic art experiences for populations that might otherwise not be exposed to art. At the El Paso Museum of Art, the permanent collection spans eight hundred years of art practice and is always on display, along with a wide range of changing exhibitions. Odessa's Ellen Noel Art Museum's collection doesn't have the same depth or range as the one in El Paso, but it does provide a diverse assortment of traveling exhibitions to attract and educate the community. Midland's Museum of the Southwest lures local audiences with

its children's museum, planetarium, and the historic home that houses its mostly regional art collection and changing exhibitions.

The University of Texas at El Paso Art Galleries, on the other hand, welcomes local audiences and tourists who have a particular taste for contemporary art. And the Chinati Foundation courts art world insiders such as those from Houston, New York, and London who book tours in advance of their arrival.

And so the region as a whole offers a broad range of aesthetic experiences, from thirteenth-century European paintings (the Kress Collection at the El Paso Museum of Art) to Dan Flavin's multi-barrack fluorescence at Chinati or the UTEP Gallery's ambitious selection of emerging and established artists. But it takes a major commitment of time to reach all of these facilities unless you're traveling by private plane. Before sampling the West Texas art scene, consider the season carefully, keeping in mind the occasional November snowstorm in Midland and the 100+ summer temperatures in El Paso and Marfa, and prepare to spend a lot of time in the car.

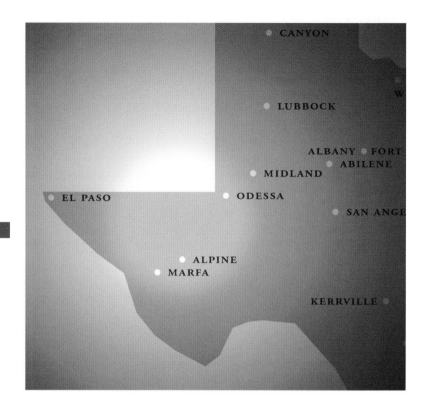

EL PASO
EL PASO MUSEUM OF ART
UNIVERSITY OF TEXAS AT EL PASO ART GALLERIES

MARFA
CHINATI FOUNDATION

MIDLAND
MUSEUM OF THE SOUTHWEST

ODESSA
ELLEN NOEL ART MUSEUM OF THE PERMIAN BASIN

Also of Interest

ALPINE
MUSEUM OF THE BIG BEND

EL PASO
BRIDGE CENTER FOR CONTEMPORARY ART

374

*"I don't even know if painting
is a profession or if writing is a profession.
I think it's something like preachers call[ing]
themselves professionals. In a sense maybe,
painters and writers are a type of preacher
preaching about the structure and beauty,
or ugliness, of the world."*

—TOM LEA[1]

One Arts Festival Plaza, El Paso 79901
915-532-1707
www.elpasoartmuseum.org

Fine arts museum

The museum explores the region's diverse cultures by
presenting an ambitious array of changing exhibitions and
selections from its permanent collection of art from Europe,
Mexico, and the United States.

Tue.–Sat. 9 a.m.–5 p.m., Sun. noon–5 p.m.

Free

Museum shop

EL PASO MUSEUM OF ART

DETAILS

The El Paso Museum of Art's permanent collection numbers more than 5,000 objects and provides a major cultural resource for the region. The Samuel H. Kress Collection, which includes fifty-seven paintings and two sculptures, with works by Canaletto, Artemisia Gentileschi, Jusepe de Ribera, and Francisco de Zurbarán, came to the museum in 1957. This gift was the spark that turned the International Museum of El Paso—until then a small "attic museum," or repository for the books, tapestries, paintings, furniture, clothing, and other personal treasures donated by local citizens— into a real art museum. With the acceptance of the collection, the museum building and grounds were deeded to the city in exchange for the establishment of an annual appropriation for museum operations, as well as the construction of two new wings for the building. The museum was renamed the El Paso Museum of Art, and in 1961 the Kress Collection was opened to the public.

Today the museum also owns an extensive collection of American painting and sculpture from the early nineteenth through twentieth centuries, including early American portraits by Rembrandt Peale, Thomas Sully, and Gilbert Stuart; American Impressionist works by William Merritt Chase and Childe Hassam; Modernist works by Milton Avery, John Marin, and Max Weber; and works by artists of the Southwest. El Paso artist Tom Lea, now deceased, is represented by a significant number of paintings, works on paper, and a 5,000-square-foot gallery in the new building named in his honor. The museum loaned one of Lea's paintings, *Rio Grande,* to the White House at the request of George W. and Laura Bush.

Over the past decade, the El Paso Museum has become increasingly committed to collecting work by contemporary artists, particularly those of the region, such as Susan Davidoff, James Drake, Gaspar Enríquez, Joseph Havel, Luis Jiménez, James Magee, and Annabel Livermore. The museum also owns more than 2,500 works on paper, a collection of Mexican colonial art created between the seventeenth and nineteenth centuries, and Mexican retablos. The museum is firmly committed to serving the culturally diverse audience of El Paso and environs, one that is 70 percent Hispanic. Two exhibitions—"Idol of the Modern: Pierre-Auguste Renoir and American

Vaquero by Luis Jiménez, 1980, fiberglass, 198" x 144" x 120". Collection of Frank Ribelin. Courtesy of the artist, © Luis Jiménez.

Painting" and "Crossing Over: Photographs and New Video Installations by El Paso Native Willie Varela"—presented simultaneously in 2002–2003 exemplify at once the breadth of the museum's exhibition policy and the size and flexibility of its new quarters.

The museum outgrew its original home on Montana Street years ago. In 1989 the El Paso Art Museum Association and the city purchased the downtown Greyhound bus station located near the Camino Real Hotel and El Paso's Performing Arts Center. Seven years later, construction began on the $8 million renovation project, which was completed in 2000. A local firm, BKM Architects, was charged with the design of the 104,000-square-foot museum, which is comparable in size to the Los Angeles Museum of Contemporary Art. Perspectiva, another El Paso firm, designed the outdoor plaza.

The first floor of the building features a large museum shop, an orientation area, classrooms, an extensive library, and a gallery for works from the contemporary collection. Upstairs, the collections are installed in a logical and entertaining manner. Dynamic changes in wall color help mark the experience of moving forward through eight hundred years of artistic practice and several different cultural perspectives.

HELPFUL HINTS

Street parking (or parking at the nearby convention center) is usually available, although visitors staying at the Camino Real Hotel and approaching on foot have the advantage.

Inside, the museum shop offers a particularly great assortment of artful toys and trinkets for children. Also available in El Paso is the University of Texas at El Paso Art Galleries on the UTEP campus.

Fox Fine Arts Center
University of Texas at El Paso, El Paso 79968
915-747-5181
www.utep.edu/arts

University art gallery

The art gallery supports the university's art department by exhibiting innovative contemporary visual art for the benefit of both students and the broader community.

Mon.–Thu. 8:30 a.m.–5 p.m.

Free

UNIVERSITY OF TEXAS AT EL PASO ART GALLERIES

DETAILS

Exhibitions in the UTEP Art Galleries used to be planned and installed by art department faculty members, but since 1982 a series of paid directors have organized one-person and group shows by nationally and internationally recognized artists such as Enrique Chagoya, Margo Sawyer, and Kumi Yamashita. Another exhibition, "Transnational by Design," included projects by four foreign-born graphic designers living and working in the United States. These shows are presented in the Main Gallery and usually include the opportunity to interact with the artist and to hear lectures related to the work being exhibited.

The Main Gallery hosts approximately seven exhibitions a year (with an August break) and the smaller Glass Gallery—so named because two of the walls are windows, one overlooking campus and the other facing toward Juárez—is used primarily, although not exclusively, for B.F.A. and M.F.A. thesis exhibitions.

Both galleries are located in the Fox Fine Arts Center, which is relatively easy to spot on campus. A Modernist building constructed in the 1970s, it appears pale and boxy compared to nearby structures patterned after the gracefully styled temples of Bhutan. Visitors can enter the 850-square-foot Glass Gallery directly from outside but must wander through the halls and down one flight of stairs (or use the elevator) to find the Main Gallery, a high-ceilinged, windowless box of about 1,500 square feet.

HELPFUL HINTS

Getting onto campus is the first challenge, and finding parking is the next. You and your car may cruise about for a very long time. Finding both galleries is the final test, but all of this is worth the effort to see the cutting-edge contemporary exhibitions that have become the norm at UTEP.

CHINATI FOUNDATION

1 Cavalry Row, Marfa 79843
915-729-4362
www.chinati.org

Fine arts museum

Chinati showcases work by John Chamberlain, Dan Flavin, Donald Judd, Ilya Kabakov, and other internationally recognized contemporary artists.

The collection is accessible by guided tour only.

Regularly scheduled tours Thu.–Sun., Section I at 10 a.m., Section II at 2 p.m.

Call at least one week in advance to schedule tours on Tue. or Wed. Groups larger than six also need to make advance reservations.

Adults $10, seniors and students $5

An extra charge may be added for specially scheduled tours. Special assistance from staff is necessary to assure wheelchair accessibility.

DETAILS

The singular vision of artist Donald Judd turned old Fort D. A. Russell and select buildings in downtown Marfa (population approximately 2,500) into a permanent home for his art and that of artists whose work he admired, work usually seen in formal museum settings. Judd installed one hundred mill-aluminum cubes in two artillery sheds and used a sprawling patch of land as a setting for a series of concrete cubes sizable enough to stand in. Six U-shaped barracks are devoted to a single multiple-unit neon installation by Dan Flavin, conceived during the early days of the foundation and completed in 2000 after both Judd and Flavin had died. Huts previously used to hold World War II prisoners now serve as small galleries for exhibitions that rotate from time to time. The concrete-and-gravel floor, elegant courtyard, and carefully framed views in an old gymnasium—now called the Arena—present one of many opportunities to experience Judd's prowess as an architect.

In the mid-seventies, when he came to Marfa, Judd was already an internationally acclaimed Minimalist (a term he didn't much like) and an art and architecture critic. Supportive of his vision to provide a permanent and unique home for art, the Dia Foundation helped him purchase Marfa's 340-acre fort and a 24,000-square-foot building downtown. In 1979 the Art Museum of the Pecos, as it was originally called, was launched. The foundation paid Judd a salary and underwrote fabrication costs for a number of his works. It also donated twenty-five crushed car metal sculptures by John Chamberlain (on view today in a downtown building) to the new museum. Later, when the Dia withdrew funding because of its own financial woes, Judd threatened to sue. He received an out-of-court settlement that included $1 million and Dia's Marfa holdings. In 1986 Judd renamed his museum Chinati after a nearby mountain range.

Camp Marfa, as Judd's fort was first known, was once a cavalry outpost used to guard the U.S. border with Mexico. (Claes Oldenburg and Coosje van Bruggen's sculpture *Monument to the Last Horse* pays homage to that heritage.) Around 1920, U-shaped barracks, the commanding officer's quar-

Top: Detail, 100 untitled works in mill aluminum by Donald Judd, 1982–1986. Permanent collection, the Chinati Foundation, Marfa, Texas. Photo by Florian Holzherr, 2001.
Bottom: Detail, 15 untitled works in concrete by Donald Judd, 1986. Permanent collection, the Chinati Foundation, Marfa, Texas. Photo by Florian Holzherr, 2001.

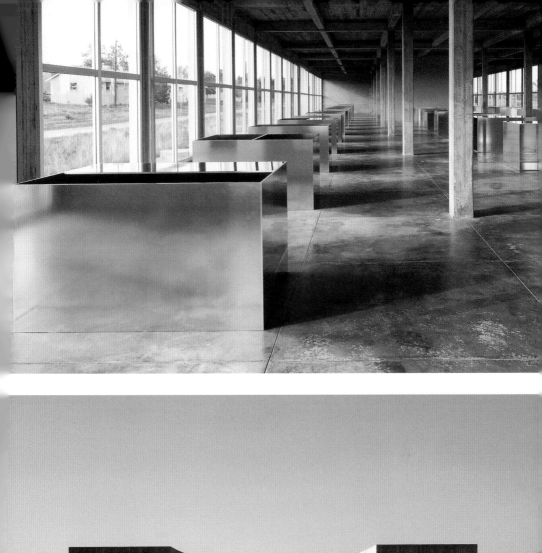

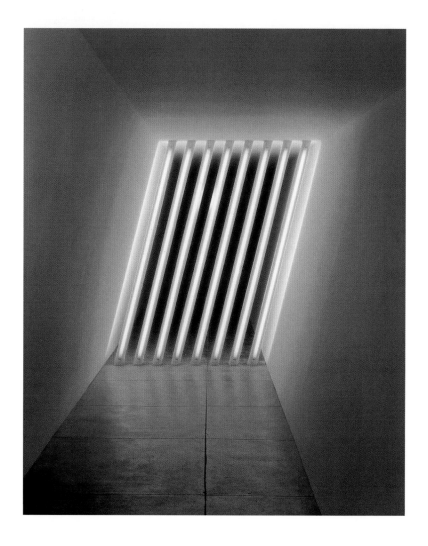

Above: Detail, Untitled (Marfa project) by Dan Flavin, 1986. Permanent collection, the
Chinati Foundation, Marfa, Texas. Photo by Florian Holzherr, 2001.

ters, and another eighty support buildings were constructed. Additional structures were built in the late thirties. During World War II, the barracks housed some two hundred German prisoners of war, and after the war the old fort was finally retired from active duty.

Given the unusual nature of the facility, with its multiple buildings and multi-acre site—the John Chamberlain Building is located downtown—visitors are required to take a guided tour rather than wander on their own. The only exception to the rule is in October, when Chinati holds its annual open house. Staff and volunteers are then stationed throughout, and people from the community hobnob during the weekend with the visiting art mob, ogle the art, enjoy mariachi bands, and dine together, traditions begun by the founder, who seemed otherwise uninterested in attracting visitors.

Judd died unexpectedly in 1994, and the Chinati Foundation continued under the directorship of his longtime companion, Marianne Stockebrand. It now boasts a high-profile board, five hundred museum members, and a track record of presenting annual symposia that draw international audiences. The Judd Foundation, a separate entity, owns the artist's home, studio, and other facilities in downtown Marfa. Tours of these buildings may be scheduled in advance by calling 915-729-4406.

HELPFUL HINTS

People come from around the world to observe the interaction between art and landscape in Marfa. Begin by visiting the Web site for directions to Marfa and nearby accommodations. This is definitely a plan-ahead trip and one to avoid during the middle of summer and periods of extreme cold. Visitors spend significant time outdoors moving between buildings.

"Somewhere a portion of contemporary art has to exist as an example of what the art and its context were meant to be. Somewhere, just as the platinum-iridium meter guarantees the tape measure, a strict measure must exist for the art of this time and place."

—DONALD JUDD, ARTIST AND FOUNDER OF CHINATI[2]

MUSEUM OF THE SOUTHWEST

1705 W. Missouri, Midland 79701
915-683-2882
www.museumsw.org

Fine arts museum, children's museum, and planetarium

The Museum of the Southwest collects and exhibits American art, including Audubon prints and regional works by artists from New Mexico and Texas.

Tue.–Sat. 10 a.m.–5 p.m., Sun. 2 p.m.–5 p.m.

Galleries are wheelchair accessible, but administrative offices are not.

Free (except for planetarium)

Christmas gift shop

DETAILS

The Museum of the Southwest owns more than 1,000 works, consisting primarily of American art with an emphasis on artists of the Southwest. Collection highlights include paintings by members of the Taos Society of Artists and a complete portfolio of engravings by Karl Bodner (ca. 1840). One gallery is dedicated to selections from the museum's collection of 150 hand-colored engravings by John J. and John W. Audubon (85 of these are regional animals rather than the more familiar birds). Texans Otis Dozier and Everett Spruce are also represented, and several sculptures are exhibited on the grounds.

Of the twelve to eighteen changing exhibitions a year, six are contemporary shows, two are year-long exhibits from the collection, and some are community-interest shows (student art, and so on). The museum also collaborates occasionally with the Ellen Noel Art Museum in nearby Odessa. The museum was founded in 1965 and opened a year later as an art and science museum dedicated to the preservation of the history, art, and culture of the American Southwest. It was moved to the Turner Mansion two years later. The house was designed by Texas architect Anton F. Korn and built in 1934 on a nearly five-acre plot in the heart of what is now the Historic District of Midland. Master craftsmen from across the country were hired, and some of their handiwork remains, such as the beautiful iron railings upstairs. Galleries occupy several restored rooms original to the house, a large enclosed patio, and the three galleries in the South Wing, an addition to the original structure.

The Marian Blakemore Planetarium opened in 1972, and the Fredda Turner Durham Children's Museum, which is quite wonderful, has been in place since 1989, although the programming and money to support it came later.

HELPFUL HINTS

To best experience selections from the collection and other exhibitions, visitors should avoid mid-November and all of December, when much of the museum is given over to the display of Christmas trees, holiday teas, choirs, dollhouses, and a Christmas shop.

ELLEN NOEL ART MUSEUM OF THE PERMIAN BASIN

4909 E. University Blvd., Odessa 79768
325-550-9696
www.noelartmuseum.org

Fine arts museum

The museum's small collection is bolstered by an ambitious schedule of changing exhibitions, most often work by contemporary artists.

Tue.–Sat. 10 a.m.–5 p.m., Sun. 2 p.m.–5 p.m.

Free

Museum shop

DETAILS

The Ellen Noel Museum programs twelve to fifteen varied exhibitions a year—at least two at a time. Among the offerings are traveling exhibitions, borrowed collections, juried shows of area artists, an annual exhibition of student art, and two exhibits a year based on the collection. Anna Jaquez's miniature narratives, Susan Cronin's whimsical bronze sculptures, and Keith Carter's photographs have been exhibited over the past couple of years. The museum owns roughly 150 objects of varying quality.

The museum's unique outreach program for the visually impaired, which includes a "sensory garden," special audio tours, raised signage, and volunteers specially trained to assist sight-impaired visitors, has distinguished it among Texas museums. The George and Milly Rhodus Sculpture and Sensory Garden, in particular, provides opportunities for all visitors to "see" the art. The interior spaces are light-filled, pleasant, and remarkably cohesive despite the various additions and renovations the museum has undergone over time.

Originally known as the Odessa Art Museum, it was renamed the Art Institute of the Permian Basin before opening to the public in 1985, and then renamed again in 1996, for Ellen Witwer Noel, one of the museum's original donors and most generous supporters. When times were good (and oil prices high), the museum soared. On the other hand, for eighteen months during the mid-1980s volunteers staffed the museum because there was no money to support a paid staff. In the early 1990s, a director was once again hired to rebuild the museum's reputation, staff, and programs, and to refurbish the building itself. By 1997, the museum had nearly doubled in size and added a state-of-the-art humidity- and climate-control system.

HELPFUL HINTS

The museum is located on land owned by the University of Texas of the Permian Basin. Its modern exterior is enhanced by a large sculpture by Giacomo Manzu and a generously sized parking lot.

*"Good art threatens established taste but,
by persuasion, gradually changes it."*

—**MICHAEL KIMMELMAN,** *New York Times* **ARTS WRITER**[3]

MUSEUM OF THE BIG BEND

Sul Ross State University (Entrance 2), Alpine 79832
915-837-8143
www.sulross.edu/~museum

The goal of this museum, which has a seventy-year history in the region, is to reflect the history and culture of the Native Americans, Spanish, Mexicans, and Anglo-Americans who inhabited the area. It accomplishes this aim by exhibiting historical artifacts and by mounting exhibitions that explore these themes through the eyes of Texas artists.

BRIDGE CENTER FOR CONTEMPORARY ART

In 2003, the Bridge, an arts center begun by a group of artists in 1987 with seed money from the City of El Paso, found itself in a transitional phase. Although forced to abandon its downtown gallery space because of a lack of funding, artists and board members began to program exhibitions throughout the city, both on private property and in borrowed public spaces. They hope eventually to secure a permanent home for the organization. It is impossible to predict whether the momentum of long years of service to the arts community and the creative energy of its current supporters can guarantee this outcome, but visitors to El Paso should make an effort to inquire about ongoing programming initatives.

PANHANDLE AND PLAINS

HUNDREDS OF MILES SEPARATE AMARILLO, CANYON, and Lubbock in the Panhandle from San Angelo (located south in the Great Plains) and Abilene, Albany, and Wichita Falls (situated in the North Central Plains). Lubbock has about 200,000 residents, Albany has approximately 2,000, and the other cities fall somewhere in between in size. And so you may reasonably wonder if the museums in this chapter have anything at all in common. But they do. They are united by a deeply felt pride in the origins of their respective communities, and that pride is evidenced by the ubiquitous presentation of historical artifacts and imagery alongside fine art collections and exhibitions. To be involved in the arts in the Panhandle/Plains is to be a cultural historian.

The earliest urge to create a museum in the Texas Panhandle began in 1915, in Canyon, where locals were already collecting historical objects and displaying them in a small library. The library burned in 1921, but citizens formed the Panhandle-Plains Historical Society and began collecting with renewed passion. Ultimately, they built a sprawling 200,000-square-foot museum for their acquisitions, which included more than 5,000 art objects, particularly nineteenth- and twentieth-century Texas and Taos school works to complement historical artifacts of the same place and period.

The Museum of Texas Tech University in Lubbock, founded as the West Texas Museum Association in 1929, offers everything from a giant Tyrannosaurus rex skeleton to the Diamond M Collection of work by illustrators and artists who portray the Old West—expect to see N. C. and Andrew Wyeth, Frederic Remington, Charles Russell, and W. H. D. Koerner. Of the two million objects in its collection, some 3,500 are art objects,

and the rest relate to the broader mission of supporting the "educational, scientific, cultural, and research elements of Texas Tech University." The Buddy Holly Center, also in Lubbock, links the musical history of the region and the visual arts. The center bears the name of Lubbock's most famous (although certainly not only) songster and exhibits the city's collection of Buddy Holly memorabilia alongside changing exhibitions of cutting-edge contemporary art.

Although the Amarillo Museum of Art, located on the campus of Amarillo College, does not collect or exhibit historical objects of the region, its exhibitions nevertheless also reveal something of the history and values of the surrounding community. Soon after the museum opened in 1972, local collectors of Modernist American works began donating paintings, and later the museum accepted examples of Asian art. Consequently, the museum explores, through its collections, the visual tastes and community values of its patrons. In doing so it reveals the aspirations of a certain segment of the local population (primarily those who prospered from farming and agribusiness), while expanding the aesthetic experience of others.

Abilene's Grace Museum, which began as the Abilene Museum of Fine Art in 1937, joined forces with the city's preservation league during the late 1980s to renovate the historic Grace Hotel. The building reopened in 1992 as the Grace Cultural Center, home to an art museum, children's galleries, and an entire floor dedicated to the history of the area, with ample focus on the Texas and Pacific Railroad. The old hotel lets the historic ballroom and balustrade, for instance, tell their own genteel tales.

The Old Jail Art Center in Albany is housed in a nineteenth-century stone jailhouse. Contemporary exhibition galleries have

been added over time, but small works are still presented in the original cramped quarters that once housed gunslingers and cattle thieves. The museum's permanent collection includes everything from Modigliani's *Girl with Braids* to the Lambshead Ranch collection of boots, saddles, and branding irons. The museum also preserves a fine regional archive.

Of course, not every museum listed in this chapter celebrates its community's history with the same gusto. The Wichita Falls Museum and Art Center usually keeps its smattering of donated historical objects—mostly broken furniture and ranching equipment—in storage. In the summer of 2002, on the other hand, the museum exhibited a lovely assortment of quilts from its collection. In 1985 the San Angelo Museum of Fine Arts opened in the old Quartermaster Building at Fort Concho National Historic Landmark, but now it occupies a new building that serves as the centerpiece for downtown redevelopment. The museum does not own nor does it routinely display historical artifacts, yet the New York City architects selected for the project topped the museum's modern limestone edifice with a copper roof that looks something like a saddle or, perhaps, the top of a Conestoga wagon. They too recognized that in the Panhandle and Plains area, communities take comfort in referencing the past, even as they plan for the future.

*"Museums are celebratory—
they celebrate us."*

399

—GARY EDSON, DIRECTOR,
MUSEUM OF TEXAS TECH UNIVERSITY[1]

PANHANDLE AND PLAINS

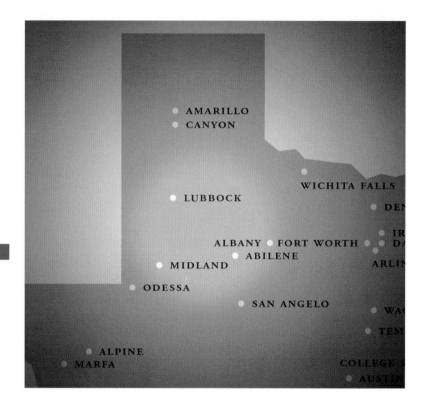

ABILENE
CENTER FOR CONTEMPORARY ARTS
GRACE MUSEUM

ALBANY
OLD JAIL ART CENTER

AMARILLO
AMARILLO MUSEUM OF ART

CANYON
PANHANDLE-PLAINS HISTORICAL MUSEUM

LUBBOCK
BUDDY HOLLY CENTER
MUSEUM OF TEXAS TECH UNIVERSITY

SAN ANGELO
SAN ANGELO MUSEUM OF FINE ARTS

WICHITA FALLS
WICHITA FALLS MUSEUM AND ART CENTER

Also of Interest

LUBBOCK
LANDMARK ARTS: THE GALLERIES OF TEXAS TECH UNIVERSITY

WICHITA FALLS
MIDWESTERN STATE UNIVERSITY ART GALLERY

CENTER FOR CONTEMPORARY ARTS

220 Cypress, Abilene 79601
325-677-8389
www.Abilene.com/art/cca

Alternative space and art studios

The Center for Contemporary Arts supports local artists by exhibiting their work in the center's galleries and leasing studios on the building's upper floors.

Tue.–Sat. 11 a.m.–5 p.m.

Free

Wheelchair access to the second floor requires a ride in the freight elevator.

DETAILS

The center is a non-collecting facility with three distinct galleries for changing exhibitions. The first gallery is used for solo shows by artist members or group exhibitions that may include other working artists. Members' interests range from traditional portraiture and landscape painting to the offbeat assemblages made with found objects by Van LeBus. This main gallery, a large box with windows facing the street and high ceilings, comfortably accommodates a wide variety of exhibitions. The curator of photography presents monthly photo exhibits in the back gallery, a smaller interior space reserved for that medium. Artists' studios (which are often open to visitors) dominate the upstairs, while a large common area in the middle of the second floor is reserved as a gallery for members only.

The organization began in the mid-eighties when a number of Abilene artists banded together to form the Texas Artists' League for the purpose of sharing ideas, exhibiting work, and securing affordable studio space. The group changed its name to the Center for Contemporary Arts when it began to meet in downtown Abilene next door to its current facility, a straightforward brick building that once was home to a department store. The center moved to 220 Cypress in 1993, benefiting from the largesse of the building's owner, who is also a patron of the arts. Today the nonprofit group employs a small paid staff and receives funding from a number of private foundations and various government entities. Artist members (who number approximately forty-five) are selected by peer review and pay dues of $100 a year. Studio rents vary, and priority is given to artist members. Community memberships are also available.

HELPFUL HINTS

"Artwalk," an evening festival of the arts coordinated by the center, takes place on the second Thursday of every month. The Web site reports that three galleries, two museums, eleven specialty shops and businesses, and six eateries participate in the event, suggesting that this might be a lively time for a first visit. Whenever you go, don't miss the Grace Museum, within easy walking distance of the center.

ABILENE

404

GRACE MUSEUM

102 Cypress, Abilene 79601
325-673-4587
www.thegracemuseum.org

Fine arts, children's, and history museum

The Grace Museum, located in the historic Grace Hotel,
presents an ambitious schedule of changing exhibitions of
regional, national, and international scope.

Tue.–Sat. 10 a.m.–5 p.m. (Thu. till 8 p.m.)

Adults $5, seniors, students, and military $4, children 4–12 $3,
children 3 and under and members free.
Free to the public Thu. 5 p.m.–8 p.m.

Grace Museum (exterior). Photo by Steve Butman.

On the first and second floors of the Grace Museum a number of galleries present both selections from the museum's collection and borrowed works. The museum owns an eclectic assortment of objects—approximately 1,100 paintings, original prints, and photographs by American regionalists. Also represented are examples of European and American Modern and contemporary work. The twenty to twenty-four temporary exhibitions presented each year are impossible to predict, having ranged in the past from "Russian Impressionism, 1930–1980" to "These Boots Are Made for Gawking! The Texas Boot Story," with a sprinkling of shows featuring contemporary Texas artists thrown in for good measure. The museum also houses an area for children, one floor of exhibits devoted to the history of the region, an outdoor courtyard, and a ballroom. In short, it is a successful amalgam of different community interests and agendas.

In 1937 the Women's Forum and other community leaders founded the Abilene Museum of Fine Art (AMFA) to provide locals with access to "art exhibitions of national and international scope, lectures on art, and a collection of art and art objects." The first artwork was acquired in 1939, and the collection has grown ever since. Over time, the AMFA also began to focus on the history of Abilene from 1900 to 1945. In 1964 the museum moved to Oscar Rose Park, its first permanent location.

In 1986 the AMFA collaborated with the Abilene Preservation League in a campaign to restore the former Grace Hotel, which had been abandoned years before. Together the two organizations raised $4.8 million. In June 1989 the AMFA changed its name to Museums of Abilene, Inc. (MOA) and became a museum that housed an art and history collection and a children's hands-on, self-discovery museum. The Junior League of Abilene took on the responsibility of designing and raising money for the children's museum.

The MOA opened its new facility, the Grace Cultural Center, in February 1992. A $7.5 million gift to the museum's endowment from the Dodge Jones Foundation has all but assured the long-term financial stability of the multidisciplinary facility and has attracted additional governmental and private support. The museum has become the centerpiece of redevelopment in the downtown district and serves as a nucleus for cultural activity in the heart of the city. Interestingly, while it offers programming and education in the arts and humanities for citizens of all ages in Abilene and a twenty-

two-county area, the primary reason people come to the Grace, according to museum studies, is to visit the children's museum.

One of the oldest structures in Abilene, the Grace was built in 1909 by Colonel W. L. Beckham, who named the hotel for his daughter. It was located across the street from the Texas and Pacific Railway depot, which ensured its early success, as did the Mission-style building's elegant entertaining areas. (Today the courtyard, loggia, historic ballroom, and rooftop terrace may be rented for private events.) When the terrace and fourth floor were added in 1930, the hotel was renamed the Drake. The hotel's subsequent decline paralleled that of the railroad, and finally it sat empty for almost fifteen years—until the citizens of Abilene reclaimed this downtown treasure.

HELPFUL HINTS

A covered garage and open-air spaces for parking are available on the west side of the building. The Grace can easily be spotted from a distance, especially at night, topped as it is now with a three-sided red neon sign. More modest ground-level signage identifies the red-brick building as "The Grace Cultural Center."

Changing art exhibitions, an array of period rooms reproduced in detail, the Railroad Gallery, and a small but delightful children's museum provide something for everyone at the Grace, and the Center for Contemporary Arts is just down the street, at 220 Cypress.

*"We call ourselves the football team
of the school of art."*

—KEN BLOOM, FORMER DIRECTOR, LANDMARK ARTS:
THE GALLERIES OF TEXAS TECH UNIVERSITY[2]

OLD JAIL ART CENTER

201 S. Second, Albany 76430
325-762-2269
www.oldjailartcenter.org

Fine arts museum

The Old Jail Art Center's permanent collection includes Asian,
American, European, and regional art, as well as ranching
memorabilia. It also presents changing exhibitions, which
complement interests expressed through the permanent
collection and feature work by emerging Texas artists.

Tue.–Sat. 10 a.m.–5 p.m., Sun. 2 p.m.–5 p.m.

Free

Marshall R. Young Sculpture Courtyard, Old Jail Art Center, Albany, Texas; in foreground, *Conversation* by Pericle Fazzini, 1954, bronze. Gift: Meadows Foundation, 1985.005. Courtesy of Old Jail Art Center.

DETAILS

The Old Jail Art Center collection, more than 1,800 objects, includes work by internationally acclaimed artists Paul Klee, Amedeo Modigliani, and Pierre-Auguste Renoir; American art stars Thomas Hart Benton, John Marin, and Grant Wood; and a wide selection of regionalists from the Fort Worth Circle. It also has an assortment of ancient Chinese tomb figures and a collection of pre-Columbian art. One entire gallery—the Sallie Reynolds Matthews Room—houses furniture and artifacts from Sallie and her son Watt Matthews's ranch, including boots, saddles, branding irons, and a selection of Laura Wilson's black-and-white Lambshead Ranch photographs taken in the 1980s. Temporary exhibitions have included challenging new works by some of the finest artists working in Texas today, as well as images of the West timed to coincide with the Fort Griffin *Fandangle,* Albany's annual musical history of Shackelford County, written originally by Robert E. Nail.

In 1940 Nail purchased Shackleford County's old limestone jailhouse to use as a writing studio. He paid $25 for the building and $375 for the land. When he died, the property was passed on to his nephew Reilly Nail. A little more than a decade later, Reilly and his cousin Bill Bomar, a working artist who was part of the Fort Worth Circle, decided to combine their substantial art collections and those of their mothers to create a public museum in the old building. Nail and Bomar, who had traveled widely, were intent on securing a place for the preservation of art and culture in the tiny community, a gesture that seems all the more amazing because it brought Nail back to Albany from New York City to oversee the task. Additional collections were promised to the museum and delivered after its opening in December 1980.

Worn limestone blocks inside the museum mark the entrance to the original structure, built for $9,000 in 1878. Each stone bears the mark of a Scottish mason—*M* or *E* or *X* or a triangle—so the laborers could be paid for the work they had done. With the help of two successful capital campaigns, the OJAC grew from 1,000 to 14,000 square feet, encompassing a number of different galleries, a historical archive, a research library, administrative offices, and storage space. The exterior grounds include a fenced sculpture court, a fountain, and trees that cement the image of the museum as both a cultural and an emotional oasis in this otherwise hardscrabble landscape.

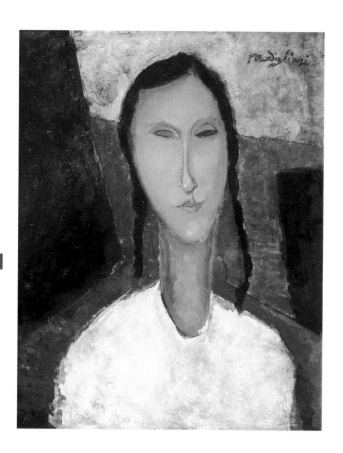

HELPFUL HINTS

Begin by smiling at the receptionist, who will probably be nicer to you than your oldest and best friend and tell you more about Albany, Texas, than you would ever think to ask. Better yet, visit in June and stay the evening to see the annual production of *Fandangle*.

Young Girl with Braids by Amedeo Modigliani, 1918, oil on canvas mounted on board. Old Jail Art Center, Albany, Texas. Gift: Bill Bomar, 1981.124.

2200 S. Van Buren, Amarillo 79109
806-371-5050
www.amarilloart.org

Fine arts museum

The Amarillo Museum of Art, located on the Washington Street
campus of Amarillo College, provides a wide range of
visual arts experiences that have included second- through
ninth-century Buddhist and Hindu sculptures,
twentieth-century photography, and an assortment of
artistic styles and periods in between.

Tue.–Fri. 10 a.m.–5 p.m., Sat.–Sun. 1 p.m.–5 p.m.

Free

AMARILLO MUSEUM OF ART

DETAILS

The original mission of the museum, once known as the Amarillo Art Center, did not include collecting, but shortly after the venue opened its doors in 1972, supporters began donating works of art. In 1993 trustees changed the name to formally acknowledge the museum's growing collection, which numbers roughly 1,500 objects today. Visitors will likely find a sampling of AMOA's collection: seventeenth- through nineteenth-century European paintings, early- to mid-twentieth-century American Modernists (among them Georgia O'Keeffe, Helen Frankenthaler, John Marin, and Louise Nevelson), photography by Russell Lee and his colleagues, Asian art, and Middle Eastern textiles. These are interspersed with changing exhibitions of contemporary work. The sixteen to eighteen different exhibits presented each year result in a somewhat chaotic but nevertheless interesting interaction of objects.

The museum's 1972 opening marked the culmination of a successful partnership between a number of local citizens (many of them wealthy and well-traveled collectors of Modernist works) and Amarillo College. These patrons of the visual arts joined forces with the college, which had secured bond money to create a campus arts complex. The modern brick concert hall, theater, music building, and the museum were designed by Edward Durell Stone, whose previous credits included the John F. Kennedy Center for the Performing Arts in Washington, D.C. Museum proponents raised a million dollars in cash—the largest capital campaign in the area at the time—toward construction of the museum itself and a portion of the common areas. They then deeded the museum building to the college, which pays utilities, repair, maintenance, and the director's salary. The museum pays for programming and for the care and acquisition of the collection.

The 24,000-square-foot facility is divided into three public floors, with a fourth (basement) level for art storage. Natural light drifts softly into the building's central three-story atrium from a skylight and pierced endwalls. The second- and third-floor galleries are arranged on either side of this open center. The first floor includes staff offices and prep space, two studio classrooms, and the atrium gallery. Brick walls, fabric-covered walls, and brick floors provide a busy backdrop for the diverse assortment of objects the museum presents.

HELPFUL HINTS

A number of outdoor sculptures point the way to the arts complex, making it easy to find, although visitors may use the adjacent campus lot only on weekends.

Buddha figure (Java), ninth century, carved sandstone, 44" x 42" x 25"

PANHANDLE-PLAINS HISTORICAL MUSEUM

2503 Fourth Ave., Canyon 79015
806-651-2244
www.panhandleplains.org

Fine arts collection housed within a larger museum

The Panhandle-Plains Historical Museum, located on the campus of West Texas A&M University, is really five museums in one, with exhibitions dedicated to petroleum, Southern Plains lifeways, paleontology, transportation, and art of the Southwest before 1945, including the Santa Fe, Taos, and Texas schools.

Labor Day–Memorial Day: Mon.–Sat. 9 a.m.–5 p.m., Sun. 1 p.m.–6 p.m. Memorial Day–Labor Day: Mon.–Sat. 9 a.m.–6 p.m., Sun. 1 p.m.–6 p.m.

Adults and children 13 and up $4, seniors $3, children 4–12 $1, children 3 and under free

Museum shop

The Approaching Herd by Frank Reaugh, 1902, oil on canvas, 23¼" x 48½" inches.
Panhandle-Plains Historical Museum Research Center, Canyon, Texas.

DETAILS

The Panhandle-Plains Historical Museum owns approximately 5,000 art objects in all, most notably paintings, drawings, and prints by New Mexican artists Ernest L. Blumenschein, W. Herbert Dunton, and Nicolai Fechin, as well as Texans Harold Bugbee, Jerry Bywaters, Merritt Mauzey, and Julian Onderdonk. Of particular interest to some may be *Red Landscape* (1918, oil on board), the museum's only work by Georgia O'Keeffe, despite the numerous landscapes produced by the artist during her stay in Canyon. Named for the breathtaking Palo Duro Canyon, the town is located between Amarillo and Lubbock in the middle of the Panhandle.

Around 1915, when O'Keeffe came to teach at Normal College (precursor to today's West Texas A&M University), local citizens were already collecting historical objects and exhibiting them in a small library. After the library burned in 1921, the Panhandle-Plains Historical Society was founded, its members determined to build a more secure building to house their treasures. Pioneer Hall, the centerpiece of today's museum, was finished in 1933, and whole collections were soon donated to the museum. These included regional furniture, textiles, historical objects, and, almost by accident initially, art. Today a separate curator devotes full time to that collection alone.

With its rich assortment of objects, the museum served as the de facto Texas state history museum until the 2001 opening of the Bob Bullock State History Museum in Austin. In fact, a number of items borrowed from the Panhandle-Plains Historical Society, which owns the collections, have been on display at the Bullock. The Canyon museum's buildings belong to West Texas A&M University and are situated on that campus. Pioneer Hall is clad in Texas limestone and features on its façade fine decorative stonework, carvings, and cast-aluminum bas-reliefs depicting Western themes and Panhandle flora and fauna. Famous West Texas cattle brands surround the entrance. The building was awarded a State Antiquities Landmark designation in 1983 for its unique Art Deco architectural style. You might say that the building itself is part of the collection, inasmuch as it includes the murals painted by Ben Carlton Mead and Harold Bugbee that adorn each of the main entries.

The Amarillo firm of Rittenberry and Carter designed the original building and most of its additions. More than 200,000 square feet of exhibition space are now available, about 10,000 of which are devoted to the visual arts, in the form of four large galleries, a number of small ones, and case-

work along a hallway. The latest renovation provided relatively direct access to the art galleries from the main door. Visitors no longer have to wander through a hundred years of oil patch history before arriving at the first art gallery. The overall look of the museum is "Prairie Deco" with a bit of international style thrown in.

HELPFUL HINTS

Oil patch dioramas and video histories play just down the hallway from paintings that glorify the gritty men and women who won the West. You can ogle the beadwork and authentic costumes of area Indians and then see how the painter chose to portray them. In other words, make extra time to venture beyond the art galleries and back again for broader insight. Also of interest may be the museum shop's selection of books, including the *Dictionary of Texas Artists, 1800–1945,* compiled by Michael R. Grauer, the museum's longtime curator of art, and Paula L. Grauer.

*"The meaning of a work of art
is bound to the life of its maker.
In one way or another,
the work reflects the drive,
the vision, the personality,
and the values of the artist."*

—CONNIE GIBBONS, FORMER DIRECTOR,
BUDDY HOLLY CENTER[3]

BUDDY HOLLY CENTER

1801 Avenue G, Lubbock 79401
806-767-2686
www.buddyhollycenter.org

Art center

The center explores the synergy between the visual arts and music through permanent display of the city's collection of Buddy Holly memorabilia, temporary exhibitions related to music, and challenging visual arts exhibitions that showcase contemporary work by artists of the region and beyond.

Tue.–Fri. 10 a.m.–6 p.m., Sat. 11 a.m.–6 p.m.

Free

Buddy Holly Gallery only: general admission $5, seniors $3, tours for more than 20 people $2 per person, children under 12 and members free

Gift shop

DETAILS

The Buddy Holly Center, which opened in 1999, is a unique venue housing both permanent and temporary exhibits of music memorabilia, as well as a contemporary art gallery. The center's Fine Arts Gallery of Lubbock presents up to fifteen exhibitions a year, including a national photography competition, an annual Day of the Dead exhibit, and other locally originated and traveling exhibitions. On occasion, exhibits such as Linda McCartney's "Sixties: Portrait of an Era" (the late photographer's photos of leading musicians of the sixties) engage music and art fans alike.

The City of Lubbock originally established the Lubbock Fine Arts Center in 1984 to provide artists with rental space to show their work. Several years later, about the time the city purchased the Buddy Holly Collection and was exploring ways to make it available to the public, the center began looking for a way to move and grow. The two needs converged in an old train depot owned by the city.

The depot was built in the late 1920s by architect Wyatt C. Hedrick, who had employed a similar Spanish Renaissance Revival style when designing key buildings at Texas Technological College in Lubbock (now Texas Tech University). Abandoned by the Fort Worth and Denver South Plains Railway Company, the building was restored in 1973 and converted into the Depot Restaurant and Bar, which was listed on the National Register of Historic Places in 1990. The city purchased the building after the restaurant closed and eventually hired Austin architect Heather McKinney in association with Driskill/Hill Architects of Lubbock to transform it into an art center.

The architects restored the wooden freight platform, maintained the clay tile roof, limestone details, and thick brick walls, and added a new wing to create a U-shaped footprint. A brick-paved outdoor gathering area—the Meadows Courtyard—nestles in the middle. Several galleries of varying sizes are arranged end to end in the original building (the west wing), providing 2,500 square feet of exhibition space. Each high-ceilinged gallery retains just enough details belonging to the original building (wooden floors, a wonderful old safe, a weathered door) to give it personality without detracting from the ability to showcase contemporary art. In the trainmaster's office and

Buddy Holly Center (exterior)

public waiting rooms the windows are blocked by freestanding display walls to restrict direct sunlight. A wide hallway ramps up from the art wing past the ample gift shop. The east wing contains the lobby and music memorabilia exhibition spaces, including the guitar-shaped Buddy Holly gallery.

HELPFUL HINTS

Don't miss the gift shop, where you can purchase Buddy Holly memorabilia, Texas music, art, and books. The clever casework was designed and constructed by local artists.

**MUSEUM OF
TEXAS TECH UNIVERSITY**

Fourth and Indiana Ave., Lubbock 79409
806-742-2490
www.museum.ttu.edu

University museum with collections in the arts,
humanities, and sciences

The Museum of Texas Tech University pays ample attention
to the visual arts, presenting selections from the museum's
art collections and a wide variety of traveling exhibitions that
highlight painting, sculpture, and fine crafts throughout the
ages. Some galleries are reserved for science exhibits, and
others are devoted to the history of the area.

Tue.–Sat. 10 a.m.–5 p.m. (Thu. till 8:30 p.m.),
Sun. 1 p.m.–5 p.m.

Museum shop

Free

DETAILS

Art exhibitions at the Museum of Texas Tech University have featured everything from frescoes borrowed from the Vatican (summer 2002) to 1950s fashions. Six to eight different exhibitions are presented annually. In 2003 alone, exhibitions included a collection of Modern and contemporary African American art, handcrafted functional objects, a retrospective exhibition of work by printmaking professor Lynwood Kreneck, and works by several photographers. The 3,500 artworks owned by the museum include the Mills Collection, a selection of prints by artists such as Jerry Bywaters, Peter Hurd, Rockwell and Norman Kent, Merritt Mauzey, and Saul Rabino. The museum also holds a Southwestern art collection of Texas and Taos artists; contemporary works by artists, including David Bates, Jesús Moroles, and Isaac Smith, and African art and artifacts.

Perhaps the museum's greatest strength is the Diamond M Fine Art Collection of works by major American illustrators and artists, assembled by C. T. and Claire McLaughlin and donated to the museum by the Diamond M Foundation. It includes works by W. H. D. Koerner, Julian Onderdonk, Howard Pyle, Frederic Remington, Charles Russell, Andrew Wyeth, N. C. Wyeth, and others, providing visitors with an intriguing look at the Old West. These works are exhibited in the museum's Diamond M Wing. Sculptures, including two by Glenna Goodacre, are exhibited in the Jones Sculpture Court and outside on the museum's expansive lawn.

The museum was founded as the West Texas Museum Association in 1929, shortly after Texas Technological College was chartered. Promoted by the citizens of Lubbock, the facility has always been located on the Tech campus. The university provided land and the Texas Legislature allocated money for construction of the first phases of the original building in 1936. The upper two floors were completed in 1950. Several years later Peter Hurd, a New Mexican artist, completed a mural that encircled the rotunda. His son-in-law, Peter Rogers, was selected to execute a mural for the current building.

In 1970 the museum moved to its current and larger site, an outpost on the northwest edge of the Tech campus. From a distance the building's distinctive, curvilinear profile evokes the sweeping mesas of Blanco Canyon.

The Astrologer by N. C. Wyeth. Museum of Texas Tech University.

All of the structures on the museum campus are made of a distinctive buff brick (referred to by insiders as TTU Museum brick) and were designed by the local firm MWM Architects. The university owns the museum buildings and pays operating expenses, including staff salaries.

HELPFUL HINTS

If you like your art mixed with dinosaurs and the history of the region, then this is the museum for you. It is hard to ignore (why would you want to?) the full-size Tyrannosaurus rex and Triceratops skeletons and exhibits about Lubbock history in the DeVitt Wing, which abuts the art galleries.

Museum of Texas Tech University (exterior--view from front)

SAN ANGELO MUSEUM OF FINE ARTS

One Love St., San Angelo 76903
325-653-3333
www.samfa.org

Fine arts museum

The San Angelo Museum brings an eclectic array of exhibitions to Concho Valley communities with an emphasis on contemporary Texas work.

Tue.–Sat. 10 a.m.–4 p.m., Sun. 1 p.m.–4 p.m.

Adults $2, seniors and children $1, students, military, and members free

Museum shop

DETAILS

The San Angelo Museum of Fine Arts presents a diverse assortment of exhibitions each year, taking seriously its role as the only fine arts facility readily available to residents of the Concho Valley and surrounding area. Texas artists dominate the exhibition schedule (including a biannual exhibition of work by Angelo State University faculty). The museum has also exhibited Chinese folk paintings and works by William Hogarth (1697–1764). Two alternating events, the San Angelo National Ceramic Competition and an invitational ceramics exhibition that is international in scope, have led to the formation of a growing ceramics collection. The collection is stored in specially constructed glass cases that are on view to the public at all times, an unusual, community-friendly decision for an art museum.

Designed by the New York architectural firm Hardy Holzman Pfeiffer and completed in 1999, the museum building, identified with three-foot-high magenta neon letters on the exterior that read "Art Museum," is the centerpiece of the museum's collection and possibly of the town itself. The distinctive saddle-shaped copper roof (some think it resembles a Conestoga wagon) quickly became a San Angelo landmark, and the museum's award-winning logo echoes the roof's curve and the five distinctively placed windows on either end. "There's a playfulness about our building we want to maintain," says founding director Howard Taylor. The quirky roofline, Texas limestone exterior, petal-shaped rooftop sculpture garden, lime-green window trim, and mesquite floors are a delight.

Community leaders chartered the museum in 1981. It was first located at Fort Concho, a National Historic Landmark. The old fort's Quartermaster Building was renovated to accommodate art exhibitions. In 1994 the museum opened a children's art museum in the historic Cactus Hotel. Also in the mid-1990s, the museum acquired an acre and a half of land on the river opposite downtown and made plans to build a new facility. A unique partnership with Angelo State University provided a significant portion of the funds necessary to build the museum in exchange for the creation of ASU ceramic studios within the facility and occasional access to the galleries for exhibitions.

Top: San Angelo Museum of Fine Arts (exterior)
Bottom: *AS* by Gina Bobrowski, 1993, Eighth Annual Ceramic Competition winner of first prize, 35" x 39" x 14". Collection of the San Angelo Museum of Fine Arts.

While the floor plan is somewhat confusing—there are dual entries and galleries located on multiple levels—the clear message of this lively building is that looking at art can be fun, and everyone is welcome. Plans are afoot to one day move the children's museum to an adjoining site.

HELPFUL HINTS

The building invites exploration beyond the formal galleries. Don't miss the rooftop sculpture garden, community hall, ceramic studios, and outdoor kilns. Even art preparation areas and administrative offices are accessible to curious visitors.

WICHITA FALLS MUSEUM AND ART CENTER

2 Eureka Circle, Wichita Falls 76308
940-692-0923
www.wfmuseum.org

Fine arts museum, children's museum, science museum, and planetarium

The Wichita Falls Museum and Art Center's exhibits often include works from or relating to its collections, which include original prints, children's book illustrations, and more.

Tue.–Fri. 9:30 a.m.–4:30 p.m. (Thu. till 7:30 p.m.), Sat. 10:30 a.m.–4:30 p.m.

Adults $4, seniors, students, and military $3.50, children $3

DETAILS

The Wichita Falls Museum's collection includes a wonderful selection of original twentieth-century prints by regional and nationally prominent artists such as Jennifer Bartlett, David Bates, Romare Bearden, Sam Gummelt, Kenneth Hale, Alice Neel, and Dan Rizzie. The museum's holdings encompass quilts, Caldecott Medal–winning children's book illustrations, and an assortment of historical objects (broken furniture, farm and ranch tools), photographs, and paintings. Temporary exhibitions have included everything from American quilts and early-nineteenth-century lithographs of the American West to photographs of Vietnam. These are paired with science, history, and art exhibits tailored for children.

Museum founders believed deeply that the citizens of Wichita Falls, two hours from the nearest city of size, needed a "family place," a multifunctional facility that offered science, history, and fine arts experiences to children and adults alike. The building opened in 1967 with a planetarium, the entry rotunda, offices, and exhibition galleries. After a tornado damaged it in 1979, the facility was expanded in 1980 and again ten years later. Plans are in motion now for a merger with nearby Midwestern State University. The museum's modern buff-brick building with façade overlaid with stone archways is located on acreage near the banks of Sikes Lake, only a mile from campus.

HELPFUL HINTS

Because of the anticipated merger, it is difficult to predict future programming, except to reassure visitors that art and science programs will continue to play a major part.

"We're in the business of edu-tainment—
making education."

—TOM JONES, DIRECTOR,
MUSEUM OF THE SOUTHWEST, MIDLAND[4]

LANDMARK ARTS: THE GALLERIES OF TEXAS TECH UNIVERSITY

18th and Flint, Lubbock 79409
806-742-1947
www.art.ttu.edu/artdept/lndmrk.html

"Landmark Arts" refers to a number of small galleries within the Texas Tech University School of Art building. The largest (Landmark Gallery) exhibits contemporary work, often featuring artists from across the country. The SRO-Photo Gallery, a hallway with casework located on a subterranean floor of the building, exhibits the work of photographers and is run by graduate students under university supervision. Other spaces are reserved for student work.

MIDWESTERN STATE UNIVERSITY
ART GALLERY

Fain Fine Arts Center
3410 Taft Blvd., Wichita Falls 76308
940-397-4264
http://finearts.mwsu.edu/art/

Midwestern State University Art Gallery, established in 1979 within the Fain Fine Arts Center, exhibits the work of senior art majors, art faculty, and visiting artists from around the state. Approximately six exhibitions are mounted annually. The exhibition program actually begins on the grounds surrounding the Fine Arts Center, where sculptures are positioned on all sides of the building, hinting at what goes on inside.

NOTES ON QUOTES

PREFACE

1. "Writers on Writing: Keeping Work at Bay," *New York Times,* August 26, 2002.

INTRODUCTION

1. Alison de Lima Greene, Introduction to *14th Annual Exhibition of Works by Houston Artists* (Houston: Museum of Fine Arts, Houston, 1938), reproduced in *Texas: 150 Works from the MFAH* (Houston: Museum of Fine Arts, Houston, 2000), 15. Time line created for Dallas Art Museum 100th anniversary, 2003.

I. NORTH CENTRAL TEXAS

1. Press release, Nasher Sculpture Center.
2. Interview with author, July 9, 2002.
3. *New American Art Museums,* Whitney Museum of Art exhibition catalog, 1982.
4. Jim Schutze, "Art Park," *Houston Chronicle,* April 9, 1997.
5. Nell E. Johnson, comp., *Light Is the Theme: Louis I. Kahn and the Kimbell Art Museum* (Fort Worth: Kimbell Art Foundation, 1975), 53.

6. *A Century of Sculpture: The Nasher Collection* (New York: Solomon R. Guggenheim Foundation, 1997), 32.

7. Andrew Martin, "Ando the Artist," *Fort Worth Star Telegram,* June 18, 2000.

8. Frank D. Welch, *Philip Johnson and Texas* (Austin: University of Texas Press, 2000), 102.

9. "About the Museum" (orientation booklet), Sid Richardson Collection of Western Art, 12.

10. *Buildings, Projects, Writings,* 1984. Quote appears in Andrew Martin, "Ando the Artist," *Fort Worth Star Telegram,* June 18, 2000.

2. EAST TEXAS

1. Art Forum, May 2002.

2. Michael Kimmelman, Interview with the artist, *New York Times,* April 27, 2001.

3. UPPER GULF COAST

1. Interview with author, October 30, 2002.

2. "The Artcar Museum" (brochure).

3. Interview with author, October 30, 2002.

4. Interview with author, October 31, 2002.

5. Visitor's Guide, The Museum of Fine Arts, Houston, 415.

6. Calvin Tomkins, "The Benefactor," *The New Yorker,* June 8, 1998.

7. Interview with author, November 5, 2002.

8. *Finders/Keepers* (exhibition catalog) (Houston: Contemporary Art Museum, Houston, 1997).

9. Frank D. Welch, *Philip Johnson and Texas* (Austin: University of Texas Press, 2000), 100.

4. SOUTH TEXAS

1. Interview with author, May 10, 2002.

2. Frank D. Welch, *Philip Johnson and Texas* (Austin: University of Texas Press, 2000), 100.

3. *Legacy: A History of the Art Museum of South Texas* (catalog) (Corpus Christi: Art Museum of South Texas, 1997), 13.

4. Mounted on entry wall, ArtPace, San Antonio.

5. Molly Dinkins, Dick De Jong, and Jim Cullers, *The Leeper Years* (video) (San Antonio: Marion Koogler McNay Museum, 1994).

6. *Legacy: A History of the Art Museum of South Texas* (catalog) (Corpus Christi: Art Museum of South Texas, 1997), 26.

7. Molly Dinkins, Dick De Jong, and Jim Cullers, *The Leeper Years* (video) (San Antonio: Marion Koogler McNay Museum, 1994).

5. CENTRAL TEXAS

1. The Mission of Art, 1893.

2. Proposal for the establishment of an Academy of Art in association with the University of Texas, 1893.

3. *The Huntington at 25: The Gallery Collects, Selected Acquisitions 1983–1987* (catalog) (Austin: Blanton Museum of Art, 1988).

4. Umlauf Sculpture Garden and Museum brochure.

5. Interview with author, June 30, 1999.

6. WEST TEXAS

1. Rebecca Craver and Adair Margo, eds., *Tom Lea: An Oral History* (El Paso: Texas Western Press, University of Texas at El Paso, 1995), 138.

2. Chinati Foundation Web site.

3. Michael Kimmelman, "How Even Pollock's Failures Enhance His Triumphs," *New York Times,* October 30, 1998.

7. PANHANDLE AND PLAINS

1. Interview with author, October 2000.

2. Interview with author, October 2000.

3. *Retrospection 15* (catalog), 1999.

4. Interview with author, November 2000.

INDEX